Dat

GUEVARA, A FORGOTTEN RENAISSANCE AUTHOR

ARCHIVES INTERNATIONALES D'HISTOIRE DES IDEES
INTERNATIONAL ARCHIVES OF THE HISTORY OF IDEAS

Series Minor

4

ERNEST GREY

GUEVARA, A FORGOTTEN RENAISSANCE AUTHOR

GUEVARA, A FORGOTTEN RENAISSANCE AUTHOR

by

ERNEST GREY

MARTINUS NIJHOFF / THE HAGUE / 1973

PRINTED IN THE NETHERLANDS

CONTENTS

ACKNOWLEDGMENTS

This book in its original form was accepted as a doctoral dissertation by the Department of Romance Languages and Literatures at Harvard University in 1965. In the preparation of the thesis I received Professor Stephen Gilman's unfailing support. I wish to thank both him and my other professors at Harvard from whom I received valuable suggestions during that undertaking. I am also indebted for the many courtesies extended by Harvard libraries. And, finally, my gratitude goes to my wife without whose constant help this work would not have been possible.

INTRODUCTION

In many ways, Fray Antonio de Guevara (1480?-1545) is the forgotten man of the Spanish Renaissance. This century has seen the publication of four of his works, *Aviso de privados* (Paris, 1912), *Menosprecio de Corte* (Madrid, 1952), *Epístolas familiares* (Madrid, 1950), and *Una Década de Césares* (Chapel Hill, North Carolina, 1966). A good modern edition of his most important work, *Libro áureo de Marco Aurelio,* is available only in a scholarly French magazine (*Revue Hispanique,* 76 [1929]), and its enlarged version, *Relox de príncipes,* can be found in its entirety only in the major libraries of the civilized world. Yet, once this writer was the most popular author of Europe whose works were considered the most widely read after the Bible, according to a frequently quoted statement of Merik Casaubon. Regardless of one's personal opinion about the merits of his books, no one will quarrel with the proposition that additional studies dealing with the writings of Guevara are desirable.

The acceptance of Guevara's writings, in spite of their popularity, was by no means unanimous. The purpose of this book is to present a detailed history of the differing reactions to the author and to explore their background and causes. We shall also note how the polemics about Guevara reflect the changing intellectual climate of the passing centuries. Since fray Antonio is a very prolific writer, we shall draw our illustrations from his secular works and limit our attention to such areas as were not covered by Costes' general survey of his literary efforts, María Rosa Lida's penetrating study, or individual articles on special problems connected with the author.

I. GUEVARA IN HIS TRADITION

A. HISTORICAL MODEL

The first thought that would occur to anyone who reads the title of Guevara's first and most frequently mentioned book, the *Libro áureo de Marco Aurelio*, is that it must be a collection of aphorisms from the *Meditations* or possibly a translation of that work from Greek into Spanish. A comparison of dates will show, however, that this cannot be the case, and that the great Emperor's work did not serve as a model for the *Libro áureo*. The *Meditations* was first printed in 1558 by Wilhelm Xylander (Holtzemann) who used a manuscript found in the library of the Palatinate of Heidelberg.[1] As fate would have it, the Medici library of Florence where Guevara claimed to have found the valuable manuscript which he supposedly translated did, in fact, possess a manuscript copy of the authentic writings of Marcus Aurelius. However, Costes states that there is not even one point of contact between that manuscript and Guevara's book.[2] What, then, is the connection between the Spanish author and Marcus Aurelius?

The prologue and *argumento* usually provide some clues regarding the purpose, origin, and publication of a book. Guevara states in the prologue of the *Libro áureo* that he wants to present the life story and the views of a ruler who combined the qualities and virtues that Charles V should emulate. Thus our author continues a long medieval tradition, the literary genre of advice to princes, many examples of which are listed by María Rosa Lida de Malkiel. To stay within Spanish tradition, she

[1] René Costes says: "C'est en 1558 que Guillaume Xylander publia, d'après un manuscrit de la Palatine de Heidelberg et sur l'indication du bibliophile Conrad Gessner, le recueil authentique des Pensées de Marc-Aurèle. *Antonio de Guevara. Son oeuvre,* p. 41.

[2] "La bibliothèque des Médicis se trouvait en effet posséder en manuscrit des véritables *Pensées* de Marc-Aurèle, et l'on se souvient que Guevara prétendait avoir rencontré le sien dans la bibliothèque de Cosme de Médicis. Mais on ne peut songer une minute que Guevara ait soupçonné l'existence du manuscrit de Florence: il n'y a pas un seul point de contact entre ce manuscrit et le *Libro áureo*." *Loc. cit.*

names the author of *Castigos y documentos,* Juan Manuel's *Libro de los estados,* and Diego de Valera's *Doctrinal de príncipes.*[3] From the point of view of date, Erasmus' *Institutio principis christiani,* written in 1516 for young Charles of Ghent, stands closest to Guevara's *Libro áureo.* Marcus Aurelius was a logical choice as a model, for he had ruled over a far-flung empire, had followed the teachings of the Stoa, and, in addition, was partly of Spanish origin.

In the *prólogo general* to the *Relox de príncipes,* the enlarged version of the *Libro áureo,* Guevara goes even further. By placing all the experiences of Marcus Aurelius at the disposal of Charles, he intends to be to the king what once Xenophon was to Cyrus, and Aristotle to Alexander the Great. It is interesting to note that not too long after the generation of Charles V, the chief physician of Philip II, Francisco Hernández, aspired to similar glory: "Sueña Francisco Hernández con una fama imperecedera que le anima a seguir. Cuando escribe a Felipe, su rey, una carta comparándole con Alejandro el Grande por haber mandado escribir esta historia natural del Nuevo Mundo, él piensa ser el nuevo Aristóteles que lleva a cabo la hazaña." [4]

The prologue to the *Libro áureo* also points out that little information is available about the wise Emperor. Herodian wrote a little about him, Eutropius less, Lampridius much less than the previous biographers, and Julius Capitolinus somewhat more. To make matters worse, whatever they put down, they wrote from hearsay and not as eyewitnesses. In contrast, Guevara offers to Charles V a detailed account of the *vita* of Marcus Aurelius, compiled by the very teachers of the sovereign, Junius Rusticus, Cinna Catulus, and Sextus Cheronensis and supplemented by letters of the Roman Emperor himself. How did the author discover such a storehouse of valuable information? During his tenure of chaplaincy at the court, he occupied his time with the study of antiquity. One day he noted a reference to a certain manuscript and a letter included therein. His curiosity aroused, he could not rest until he traced it to the library of Cosimo Medici in Florence. After getting hold of it, he saw that it contained the above-mentioned material, part of it written in Greek, the rest in Latin. First, he had to translate the Greek text into Latin, from that into *romance,* and finally change it from the vernacular into *alto estilo.* In addition he had to compare the Latin version with other Latin notes, eliminate many useless details, and substitute for them some

[3] See her essay, "Fray Antonio de Guevara. Edad Media y Siglo de Oro español," *Revista de Filología Hispánica,* VII (1945), p. 357.
[4] José Miranda, "España y Nueva España en la época de Felipe II," in Germán Somolinos d'Ardois' *Vida y obra de Francisco Hernández* (México, 1960), p. 147.

of his own information. This process cost him many sleepless nights, the missing of many meals, and the endurance of winter's freeze and summer's heat.

Costes noticed that one of the historians mentioned in the prologue, Julius Capitolinus, actually wrote a biography of Marcus Aurelius. He adds that Guevara took from it the names of three teachers of Marcus Aurelius, Junius Rusticus, Cinna Catulus, and Sextus of Cheronea, dropping one teacher's name in the process.[5] María Rosa Lida also mentions only cursorily the collection of biographies called *Historia Augusta,* where the life story of Marcus Aurelius is included.[6] It is important for our purpose to look into the *Historia Augusta* and explore the question of what suggestions, if any, Guevara may have garnered from the biography of Marcus Aurelius written by Julius Capitolinus or from other *vitae* contained in the collection.

The numerous biographies of emperors, pretenders, and tyrants stretching from Hadrian to Carus (from approximately 75 A. D. to 300 A. D.) are ascribed to Aelius Spartianus, Julius Capitolinus, Aelius Lampridius, Vulcatius Gallicanus, Trebellius Pollio, and Flavius Vopiscus. Together they are referred to as the *Scriptores Historiae Augustae.* Modern scholarship has arrived at no definite conclusion as to the true authorship of the collection. From their dedicatory passages it would appear that all six of them lived in the time of Diocletian and Constantine (third century A. D.). Recent investigators, however, assign these documents to the fourth, fifth, and even sixth century A. D.[7]

Although the connection of the *Historia Augusta* with Guevara's writings has been mentioned only briefly by others, we feel that it was important and should, therefore, be examined in some detail. The most important among the lessons that fray Antonio learned from the *Historia Augusta* was the amplification of biographical material—a time-honored practice among biographers. Livy included in his history long harangues which his heroes may or may not have delivered. This was an accepted convention, and the speeches were usually not out of character with the person who supposedly delivered them. Suetonius went one step further and amplified his *De XII Caesaribus* with anecdotes, documents, and gossip. Since he was Hadrian's secretary, he had access to the imperial archives and was in a position to insert authentic documents and various

[5] *Op. cit.,* p. 39.
[6] *Op. cit.,* pp. 354 and 369.
[7] A summary of the results of modern investigation is available in Michail Rostovtzeff's *Gesellschaft und Wirtschaft im Römischen Kaiserreich,* II (Leipzig, n. d.), pp. 146-47.

reliable letters to illustrate his profiles.[8] Some of the biographers that came after him were not so scrupulous. Most frequently mentioned is Marius Maximus, the author of a series of imperial biographies from Nerva to Elagabalus. His work, which is not extant, is known only through numerous references made to it by the *Scriptores Historiae Augustae,* who treated it as a source of official documents. David Magie asserts that there is no basis to believe that Marius Maximus had entrée to official archives and, therefore, considerable doubt must be entertained about the genuineness of the documents, letters, and speeches which are quoted from his biographies. The letters and speeches of his contemporary, Junius Cordus, deserve even less credence than those of Marius Maximus.[9]

The idea of furnishing details of the private life of the emperors also stems from Marius Maximus, says Magie. It seems that once he abandoned the secure region of facts, he allowed his imagination to run riot. However, in this, too, he was outdone by Junius Cordus, who records even the amount of food consumed by the emperor, the type of clothing he wore, and other trivial and not always edifying details.[10] As we reach the *vitae* in the *Historia Augusta,* we encounter not only the imitations of the above models but also the addition of new elements.

First of all, we note the presence of hypocrisy. Flavius Vopiscus has the presumption to criticize Marius Maximus as "homo omnium verbossissimus qui et mythistoricis se voluminibus implicavit," even though the degree of unreliability is considered to be higher in the *Historia Augusta* than in Marius Maximus.[11] Furthermore, they refer scornfully to Junius Cordus as a gossip-monger.[12] In the conversation between Junius Tiberianus and Vopiscus, the latter castigates Livy, Sallustius, Tacitus, and Trogus as liars in the hope of strengthening his own authenticity by denigrating the character of others.[13] In the same conversation with the prefect of the city, the duty of the historian is specified. He has to search in archives for reliable documents, find autobiographical notes of the emperors, consult foreign sources, and provide proof even from old coins. He also has to collate material gathered from various sources. In a word, *diligentia* and *curiositas,* careful research should be carried out by the historian with absolute impartiality. High-sounding phrases,

[8] See Introduction to *The Scriptores Historiae Augustae,* ed. and Introduction by David Magie, The Loeb Classical Library (New York, 1921), pp. XVII-XIX.

[9] *Ibid.,* p. XIX.

[10] *Ibid.,* p. XVIII.

[11] Firmus, 1, 2.

[12] Clodius Albinus 5, 10.

[13] Aurelianus 2, 2.

like *tacere non debui, tacendum non est* are usually followed by the recounting of some unimportant detail.[14] This reminds one of a favorite *topos* of exordium listed by Curtius, "The possession of knowledge makes it a duty to impart it." [15]

The high ethical purpose of the *scriptores* is frequently stressed. They present the facts of the past and the deeds or misdeeds of the emperors' predecessors in order that the emperor and others who come to read them may draw a lesson therefrom and may know what to imitate and what to avoid.[16] Another very significant factor is the citing of authorities sometimes for the sole purpose of impressing the reader with their expertise: "Zur Renommisterei der Scriptores Historiae Augustae passt das gelehrte Mäntelchen, des sie sich umhängen: nicht nur werfen sie, wie ein Blick in die Quellenübersicht lehrt, mit zahlreichen griechischen und lateinischen Autorennamen um sich, sie zitieren selbst ihrer Materie fern liegende Dichter und Schriftsteller, wie Livius Andronicus, Plautus, Ennius, Caecilius, Lucilus, Varro." [17] They make it a point to let the reader know that they understand Greek. Once they quote a Greek sentence and translate it into Latin; [18] but the remainder of the time they are satisfied with giving an explanation of well-known Greek terms, such as "paraeneseos hoc est praeceptionum," [19] "Nemesis id est uis quaedam Fortunae." [20]

Finally they hesitate to record the history of living emperors, for the latter are so important as to demand a higher style – use of rhetoric – such as "nam Diocletianus et qui sequuntur, *stilo maiore* dicendi sunt" or "Supersunt mihi Carus, Carinus, et Numerianus: nam Diocletianus, et qui sequuntur, *maiore stilo* dicendi sunt." [21] Hermann Peter, one of the German experts on the *Historia Augusta*, finds the same idea in the *Breviarium* of Eutropius, dedicated to emperor Valens: "... nam reliqua *stilo maiore* dicenda sunt; quae nunc non tam praetermittimus, quam ad maiorem scribendi diligentiam reseruamus." [22]

[14] Maximinus *pater* 33, 3.
[15] *European Literature and the Latin Middle Ages,* p. 87.
[16] Aurelianus 22, 4.
[17] Pauly-Wissowa, *Real-Encyclopädie der classischen Altertumswissenschaft,* article "Historia Augusta," XVI, 2065.
[18] Alexander Severus 18, 5.
[19] Avidius 3, 7.
[20] Maximus et Balbinus 8, 6.
[21] Hermann Peter, *Die Scriptores Historiae Augustae* (Leipzig, 1892), p. 21: "Diese gelehrte Richtung unterscheidet sie von den Epitomatoren, mit denen sie sonst die ängstliche Scheu teilen sich mit den Thaten lebender Kaiser zu befassen, die einen höheren Stil, also Rhetorik verlangten: vgl. Lampr. Hel. 35, 5 f., Vopisc. Car. 18, 3 ff., Bonos. 15, 10 ..."
[22] *Ibid.,* p. 18, quoting from Eutropius 10, 18.

True, on other occasions the *scriptores* give the impression that the devices of rhetoric and unadorned truth do not go together and emphasize their own policy of adhering to the facts. However, Peter who analyzed their writings has come to the conclusion that such protestation should not be taken at all seriously, especially in the biographies of Pollio and Vopiscus: "Indes eben bei diesen beiden sind solche Worte am wenigsten ernst zu nehmen; es sind Phrasen der Rhetorenschule, deren angebliche Bescheidenheit der Darstellung selbst zur Folie dienen soll." [23]

What we have just reported demonstrates that Guevara owed to the *Historia Augusta* not only the general framework of his *Libro áureo* but also many of its characteristic features. Guevara proudly refers to his rhetorical devices as *alto estilo*; he cites anecdotes and statements from spurious sources; he bandies about names of nonexistent persons; he points out the difficulties endured in the preparation of his work; he fills his book with anecdotes and moral teachings instead of historical facts.[24] Thus the disintegration of true biography initiated by Marius Maximus reaches its climax in Guevara's *Libro áureo*. It is intriguing to note that in an age where the authenticity of the *scriptores* was accepted at face value by the highest authorities in these matters, Guevara sensed that these biographies were spurious and considered them excellent models for his novelistic *vita* of Marcus Aurelius. Included in a list of historians which Vives recommends to students desiring to learn about the past are the following *scriptores*: "Aelius Spartianus, Capitolinus, Lampridius, Volcatius Gallicanus, Trebellius Pollio, Flavius Vopiscus ab Adriano ad Carinum." [25] Melchor Cano places the *scriptores* on a level with some of the outstanding historians of Antiquity: "Sunt enim, ut dixi, in profanis auctoribus non pauci, quorum ingenuitas & verecundia sic hominum sermone celebrata est, ut nemo illos unquam sic mendaces, & in fingendo impudentes existimaverit. Quales sunt Caesar, Val. Max. Terentius Varro, Livius, Cornelius Tacitus, Seneca, Ammianus Marcellinus, Eutropius, Flavius Vopiscus, Paulus Diaconus, Lucius Florus, Polybius, Dionysius Halicar, Julius Capitolinus, Cornelius Nepos, Strabo, alique plures, Latini praesertim auctores." [26]

Angela Bellezza lists all the editions of the *Historia Augusta*. The seventh edition after the invention of printing, a copy of the one done by Aldus Manutius in Venice three years earlier, came to light in Florence in 1519.[27] This might have been the edition Guevara used, since he

[23] *Loc. cit.*
[24] All these facts are illustrated in Pedro de Rhua's *Cartas censorias.*
[25] *De tradendis disciplinis, lib.* V, *cap.* 1 in *Opera omnia*, VI, pp. 389 and 397.
[26] *De locis theologicis*, p. 332.
[27] *Historia Augusta. Parte primera: Le edizioni*, pp. 31-32.

mentions the Cosimo Medici library in Florence where he discovered the alleged manuscript. This impression is fortified by the fact that the Florence edition includes the speech of Elagabalus at the meeting of the *meretrices*, "Oratio Heliogabali Romanorum imperatoris, habita in concione ad meretrices, quam a Leonardo Aretino compositam plerique credunt." [28]

Whoever wrote the address first printed in the Venice edition of the *Historia Augusta* possessed a free and worldly spirit. Light humor and joyous abandon fill every line. We have to visualize a large military camp as a background. The Emperor stands on the rostrum and feasts his eyes on the attentive audience. This audience, however, is not one of fierce soldiers but of fair courtesans. The illusion and double-entendre of a great general's rousing speech to battle-scarred troops are maintained throughout. The very beginning sets the tone, "Incredibilis me libido habet commilitones. Uehementem in me ardorem concitari sentio, cum multitudine uestra circunseptum me undique, stipatumque conspicio." [29] Elagabalus then explains why he addresses them as *commilitones* – they, too, are warriors in the army of Cupid. The Emperor dwells on the etymology of the word *meretrix*. He ends with a rhetorical climax which sounds somewhat like a parody of a genuine leader's courageous words about fighting on the beaches and in the streets: "Quare excitemini precor, alacriter, ac prompte operi uestro incumbite, ... per uicos, per platea, per fora, per campos, per theatra, per ipsa denique immortalium deorum templa discurrite, capite, rapite, seducite omni tempore omne genus hominum, omnis quidem aetatis, sed praecipue adolescentes." [30]

The *Libro áureo* contains a collection of nineteen letters which follow the life story of Marcus Aurelius. They are represented as being letters belonging to the Emperor. Five of them (XIV, XV, XVII, XVIII, and XIX) are addressed to *meretrices*. Guevara did not borrow directly from the exhortation of Elagabalus but wrote letters to Roman *enamoradas* which show the same type of humor. It should be pointed out that the *Libro áureo*, for understandable reasons, did not carry Guevara's name, and the letters in question do not appear in the second version, the *Relox de príncipes*. Later in a missive to Don Fadrique de Portugal Guevara manifests embarrassment at having translated the love letters of Marcus Aurelius instead of the *Meditations* of St. Augustine or the *Colloquies*

[28] *Ibid.*, p. 32.
[29] The complete address of Elagabalus runs from fol. 275v to 280r in the Florence ed. of the *Historia Augusta*, prepared by Aldo Manutio in 1519. The sentence referred to is on fol. 275v.
[30] *Ibid.*, fols. 279v-280r.

of St. Anselm.[31] This, however, did not prevent him from discussing the history of the three famous courtesans, Lamia, Flora, and Laida.

Apparently Don Enrique Enríquez sent the engravings of three women with the titles St. Lamia, St. Flora, and St. Laida to the bishop and asked him who they were, when they had lived, and through what martyrdoms they had earned their beatification. Don Enrique kept these engravings in his private chapel and said a few Ave Marias to them every day. The idea of mistaking a courtesan for a *beata* also occurs in Salas Barbadillo's *La ingeniosa Elena, hija de Celestina*.[32] This is another example illustrating Guevara's readiness to tackle a wide range of subjects, especially if they had a humorous appeal. This interest in the lower classes, the peripheral segment of society, brings him close to Fernando de Rojas who raised an eternal monument to Celestina and her circle.

It was a long road from Caesar to Guevara, from authentic history to entertaining tales. The alleged correspondence of the Stoic philosopher with the *enamoradas* very clearly illustrates this retrograde evolution. From the point of view of genuine biography, the bishop of Mondoñedo is the last link in the chain that begins with Livy and Suetonius.

B. SELECTED IDEAS FROM THE *LIBRO ÁUREO* AND THE *RELOX DE PRÍNCIPES*

We have seen that the basic pattern of the *Libro áureo* derives from the *scriptores*. Once the outer shell, the vessel that contains the material, is defined, a few words should be said regarding the contents which filled that vessel. Here, too, we may say that Guevara learned the method of filling gaps with anecdotes where facts were lacking. He also utilized moral teachings as a method of expanding the available material. This

[31] *Epístolas familiares*, I, 438. All references are to the edition prepared by José María de Cossío (Madrid, 1950). Throughout this book we reproduce the punctuation of the editors.

[32] This incident is found in the Seville adventure of Elena and Montúfar, pp. 138-147 of the Madrid, 1907 ed. We should note that there were other medieval versions of the three celebrated courtesans. François Villon's *Ballades des dames du temps jadis* names Flora, Thais, and Archipiada. Ernest Langlois' article "Archipiada" in *Mélanges de philologie romane dédiés à Carl Wahlund* (Mâcon, 1896, pp. 173-179) puts forward the ingenious identification of Archipiada with Alcibiades. Apparently Boetius mentions the latter as a model of beauty, and, consequently, it was assumed in the Middle Ages that he was speaking of a woman. The original article was unavailable, and we used the review of the article in the *Comptes rendus* of *Romania*, 26 (1897), pp. 103-104. Apparently the Spanish version of the three courtesans adheres more faithfully to the antique tradition than does the French which contains two corruptions: Thaïs instead of Lais and Archipiada instead of Lamia.

he carried to such a degree that the vessel almost burst. In the *Libro áureo* Guevara preserves the basic structure found in the *vita* written by Julius Capitolinus: the antecedents of Marcus Aurelius; his youth and education; his marriage and elevation to the seat of power; his achievements and laws; his victories over enemies; and finally his death and testament. The procedure Guevara followed can best be observed in the first version where some of the ideas that later grew into separate works appear in a fetal state. Let us illustrate Guevara's *modus operandi* with a few examples.

In the selection of instances to be examined, we have tried to avoid topics that have been dealt with previously by noted experts. In the *Historia Augusta* the biography of Marcus Aurelius devotes considerable space to the education of the young Marcus Annius Verus, as he was called in this period of his life. His instructors are named, many of them familiar from other sources. It seems that Junius Rusticus was the most important influence on the future Emperor. He turned him away from the teachings of other schools acquainting him with the Stoic system which he was enthusiastically to espouse during his whole life. Even as a child Marcus Aurelius was supposed to have slept on the ground and to have adopted other rigorous customs proper to the true philosopher. By and large the account does not stray too far from the area of fact and probability.

How did Guevara handle the story of Marcus Aurelius' education? He begins by availing himself of precedents found in the *Historia Augusta*. We are acquainted with the teachers surrounding the promising adolescent. From Guevara's wide reading in Roman customs, anecdotes are added concerning education of youth in Rome. We are told, for instance, that on the streets of Rome everyone carried a sign of his profession – the orator a book, the gladiator a sword, the smith a hammer – so that it was clearly evident that everyone lived off his own work and not *del sudor ageno*.[33] These lively anecdotes are at times interrupted by lofty and impressive orations the mature Marcus Aurelius delivers on the subject at hand.

Then suddenly in the midst of these Roman surroundings we stop and rub our eyes. We see that what Annius Verus, the father of the Emperor, was worried about is the familiar topic known as *sapientia et fortitudo* in the Middle Ages and continued as the contrast or combination of Arms and Letters in the Renaissance:

[33] *Libro áureo*, p. 34. All references are to the Foulché-Delbosc edition in *Revue Hispanique*, 76 (1929).

Su padre Annio Vero quiso que su hijo Marco, dexadas las armas, siguiese el estudio; y por cierto es de pensar que fue esto hecho mas por la cordura del padre que no por la couardia del hijo. Si los hechos delos muertos no engañan alos que somos biuos, y el caso se iuzga por iuyzios claros y se sentencia por personas maduras, hallaremos que pocos han sido los que se han perdido por letras, y muy menos los que se han ganado por armas. Reboluamos todos los libros y pesquisemos por todos los reynos, y en fin dirannos auer pocos en sus reynos muy dichosos en armas, y iuncto con esto tener muchos muy famosos en letras.[34]

Curtius remarks that nowhere else was the happy combination of soldier and scholar so successfully realized as in Spain during the Golden Age. Obvious examples are Garcilaso de la Vega, Cervantes, and Lope de Vega.[35] Here Guevara makes his own contribution to this discussion. This reference to the contemporary commonplace is completely buried under an avalanche of Roman names so that it is hard to recognize it. However, some anachronisms, such as Marcus Aurelius' studying the seven liberal arts, warn us that Guevara has mixed medieval lore into his biography. We further learn that, as a youth, Marcus Aurelius, like Sempronio and his master, ". . . aguardaua cantones, ruaua calles, pintaua motes, ogeaua ventanas, tañia guitarras, escalaua paredes, despertaua liuianos en mi tierna edad . . ." [36] occupations which would be most unusual in Marcus Aurelius' Rome. The point we are trying to make is that Guevara successfully made a mélange of three epochs: that of Marcus Aurelius, that of the Middle Ages, and that of the Renaissance.

It is fascinating to observe, while we are still discussing imperial education, how Guevara can build a complete story on the record of one small occurrence. Aelius Lampridius mentions in the *vita* of Commodus Antonius (2, 6-7) that young Commodus could not endure honorable teachers but yearned for evil ones, and, when these were dismissed by Marcus Aurelius, the youth became sick. Upon their reinstatement "popinas et ganeas in Palatinis semper aedibus fecit neque umquam pepercit vel pudori vel sumptui." This item inspires four vivid chapters (VI-IX) in the *Libro áureo*. Guevara takes the opposite tack by showing how Marcus Aurelius chose the wisest instructors for Commodus. He invited the best available talent in the realm. When the experts arrived, each one an authority in his field, they had to undergo a rigorous examination. Only fourteen passed, two in each of the seven liberal arts. Those

[34] *Loc. cit.*
[35] *Op. cit.*, p. 178.
[36] *Libro áureo*, p. 291. This is a good example of how Guevara identified himself with Marcus Aurelius. In the autobiographical Introduction to his *Menosprecio de corte y alabanza de aldea* the bishop refers to his own carefree youth in similar terms. (ed. Clásicos Castellanos, p. 10)

who were not successful were awarded gifts as consolation. The winners were invited to live in the royal palace in order that Marcus Aurelius might observe whether or not their ways of life conformed to their teachings.

During the birthday festivities in honor of the emperor, Marcus Aurelius noticed that five of the teachers behaved in a peculiar manner, ". . . pateauan conlos pies. Ladeauanse enlas sillas, palmauan conlas manos, hablauan alto, y reyan demasiado . . ." [37] The emperor delivered a four-page harangue before dismissing them – a punishment certainly out of proportion to the indiscretions they committed. But Marcus Aurelius did not stop here. He summoned the other nine teachers and gave them extensive warnings concerning their duties and responsibilities. Many such examples could be cited, but this will suffice.

Since Guevara as a moralist touches so many areas, it would be very difficult to enumerate the subjects he discusses. Nevertheless, there are certain themes that recur like so many leit-motives in an opera. And, to stay with the metaphor, one theme is frequently interwoven with another, so that the component elements do not stand out clearly, and it becomes a Herculean task to determine whether such elements derive from the Middle Ages, especially the fifteenth century, or reflect his own period.

However, we may begin with fifteenth century examples. The bishop demonstrates an avid interest in pharmacopoeia. True, medieval courtly literature is full of references to the sweet syrup of love, the kind words of the beloved that heal like unguents, and the symptoms of love which is frequently likened to a disease. From the Archpriest of Talavera on, however, the use of cosmetics becomes a moral issue, partly because it serves to deceive the world, and partly because it fosters immorality. No wonder that Celestina is represented as a past master of an art which stands in complete contrast with the otherworldly tenets of the church. Guevara attacks the addiction to cosmetics and warns that death cannot be cheated by such means: "Quien mandara aquellos Barbaros [the people of the idealized *siglo dorado*] xaroparse ala mañana, tomar pildoras ala noche, serenar sueros, tomar ordiates, vntar el higado, hazer lauatorios, sangrarse oy y purgarse mañana, comer de vna cosa y abstenerse de muchas?" [38]

The topic of cosmetics and medicine is related closely to another complaint of serious-minded men of the fifteenth and sixteenth centuries – the flaunting of fancy clothes and jewels. Guevara cites as a counter-

[37] *Libro áureo*, p. 47.
[38] *Ibid.*, p. 234. The expression "bárbaros" refers, of course, to the inhabitants of Guevara's Utopia.

example the glorious self-denial of Roman matrons in the time of Ca-
millus. Of course, what the matrons sacrificed on the altar of patriotism
were not Roman jewels but rather those of the fifteenth and sixteenth
century Spanish ladies, ". . . los chocallos de sus orejas, los anillos de sus
dedos, las axorcas de sus muñecas, las perlas de sus tocados, los collares
de sus gargantas, los joyeles de sus pechos . . ." [39]
Overdressing is even more objectionable when it is done by old men.
The ridiculing of *verde vejez* is one of Guevara's favorite topics. What a
sight to behold those old men, their beards carefully arranged, their hands
bedecked with rings, their shirts open, mother-of-pearl on their hats,
prepared for amorous adventures! [40] The bishop returns to the subject
in his letters to Mosén Rubín of Valencia, a *viejo enamorado,* who sup-
posedly consulted Guevara about marrying a young girl. It is merciless
satire which must have occasioned a great deal of mirth among those who
recognized in it some well-known courtier. Doctor Villalobos, a con-
temporary of Guevara and a kindred spirit, was also attracted to this
subject. Metro XIX of *Los Problemas de Villalobos* asks this question:

> ¿Por que se casa de gana
> Un viejo con mil dolores,
> Y que sufra sus hedores
> Una moza limpia y sana?
> Cuando refrenar presume
> El vicio qu'es del demonio,
> Por consumir matrimonio
> Su triste vida consume.[41]

[39] *Ibid.,* p. 90. This kind of anachronism was widespread in the Renaissance.
Guevara's adorning Roman ladies with Spanish jewels of his day is no different
from Renaissance painters' portraying Biblical figures in Italian dress.
[40] *Ibid.,* p. 236.
[41] Biblioteca de Autores Españoles, XXXVI (Madrid, 1871), p. 420. In the
Introduction to *Algunas obras del Doctor Francisco López de Villalobos,* Fabiè
compares this stanza with the doctor's letter to Secretary Samano (*Carta* XL, pp.
137-140). In that letter Dr. Villalobos relates in a burlesque tone that at the age
of seventy he married a young woman and thereby made himself the laughing
stock of all his friends. He goes on to describe the circumstances of this peculiar
union: like a new St. George he rescued the young woman from the convent of
Aldeanueua ("la boca del dragón") where his daughter had previously died of
hunger. The doctor relates how his new wife regales him with stories about the
evil "confesos" and other naive observations. All in all, however, he has a positive
attitude toward this marriage.
Fabiè thought at first that the second marriage of Charles V's physician was
pure fiction in order to give him an opportunity to tell witty incidents. But the
details related by Dr. Villalobos were too realistic to dismiss the marriage as
imaginary. Fabiè muses disapprovingly about the human frailty of the doctor who,
knowing the difficulties of an old man's marrying a young woman as demonstrated
in the stanza quoted above and the *glosa* attached to it, still could not resist the
desires of the flesh. (pp. 91-92 of the Introduction).

The *glosa* of this stanza is a treatise on the difficulties that an old man who decided to marry a young woman would face. The arguments against such a union are presented with frankness and demonstrate knowledge of the world that could match a modern psychological work. The tone of his reasoning is serious – a departure from most of his letters which are humorous.

In the *Libro áureo* at times, it seems, love triumphs over age and philosophy. There is a whole list of ancient philosophers whom love claimed as victims, beginning with Thales and ending with Gorgias. The most regrettable case, perhaps, was that of Cleóbolo el Curiano who, at the age of eighty, after a distinguished career as a teacher of philosophy at the Academy for forty-five years, tried to scale the wall of a female neighbor's house, only to fall and die like Calisto.[42]

The incompatibility of old age and love had been emphasized by Rodrigo Cota and the Archpriest of Talavera some fifty years before Guevara. In the *Diálogo entre el amor y un viejo* a great deal of emphasis is placed on the description of the ravages of old age. Guevara matches it with a horrible portrait of his own: "Hagohos (sic) saber, si no lo sabeis, pobres viejos, que estais ya tales que teneis los ojos legañosos, las narizes humidas, los cabellos blancos, el oyr perdido, la lengua torpe, los dientes caidos, la cara arrugada, los pies hinchados, las espaldas corcobadas y los pechos ahogados; finalmente, si supiese hablar la sepultura, como a caseros suyos hos podia pedir por iusticia viniesedes a poblar su casa." [43]

All the above-mentioned topics, and we could enumerate many others, are actually facets of major themes. One of those is the author's invective against the world, the theme of *engaño* and *desengaño*. The special problem that the latter presents will become evident if we reflect upon the relation of the baroque to the Middle Ages. Let us illustrate with an example:

La sospechosa fortuna quando a tu puerta hazia almoneda / ella sabiendo lo que vendia & tu conociendo lo que comprauas / dio te lo caro barato / & lo barato te vendio caro: dio te lo agro por dulce / y lo dulce te torno agro / lo malo te dio por bueno: y lo bueno te torno por malo: finalmente engañote en el justo precio: tu no pensando que rescebias engaño. . . . tristes de nosotros / digo los que con el

[42] *Ibid.*, pp. 309-10. The *topos* of the devastating power of *loco amor* rates a separate chapter in Alfonso Martínez de Toledo's *El corbacho*, "Como los letrados pierden el saber por amor" (chap. XVII). His roster of victims includes King Solomon, Aristotle, Virgil, David, and Mosén Bernard de Cabrera (apparently a contemporary). This list appears on p. 58 in Lesley Byrd Simpson's ed. of the Archpriest's work (Berkeley, 1939). The only name that occurs on both rosters is that of Aristotle. From all appearances, Fernando de Rojas took his examples from *El corbacho* (*La Celestina*, ed. Clás. Cast., I, pp. 50-51).

[43] *Libro áureo*, pp. 228-29.

mundo tratamos / Ca no se venden sino mentiras enestra feria: y no se fian sino
sobre prendas de nuestra fama / No se pagan sino con el escote de nuestra vida /
No nos dan cosa por peso y medida: los factores desta feria es une gente vaga-
munda.[44]

Now one may ask: With what are we confronted here? Is this a medieval
allegory or not? Who can question anybody's right to interpret it in this
manner? On the other hand, perhaps this concept is a forerunner of the
magnificent allegories of the baroque, like Calderón's *El gran teatro del
mundo.*

Or let us take the thirty-third chapter of the third book of the *Relox
de príncipes,* ". . . do el auctor prosigue su intento / & con marauilloso
artificio compara la miseria delos hombres con la libertad delos ani-
males." This idea is, of course, not original with Guevara. Stephen
Gilman points out Petrarch's interest in Seneca's Stoic philosophy par-
ticularly in connection with fortune's role in the destiny of man and the
Italian poet's redefinition of fortune in *De remediis utriusque fortunae.*
Then Gilman explains how such a redefinition affects the animal king-
dom:

One result of this definition of fortune as a penalty of being aware is the abso-
lution of the animal kingdom (a kingdom which interested the Stoics in much the
same way as Rojas) from tribute to it: "Quando yo pienso los súbitos e inciertos
movimientos de las cosas humanas, casi ninguna cosa más flaca, ninguna de menos
reposo, hallo que la vida de los mortales. Viendo que a todos los otros animales,
por la simpleza o ignorancia suya, la natura proveyó de maravilloso género de
remedio; y a nosotros solos dando memoria, entendimiento, y prudencia, clarísimas
y divinas partes del alma, ser tornados ya en nuestra destrucción y trabajo . . .
(*Epistolaris Praefatio,* F. Madrid, fol. i).[45]

Guevara's treatment of the subject, on the other hand, is much more in
line with tradition. First the bishop presents the dangers that surround
the birth of a human being compared with the ease with which an animal
enters the world. An animal possesses its defense and weapons, whereas
man comes into the world naked and remains for years completely
defenseless. Human beings have to go through a complicated process
of sowing seeds, weeding, plowing, irrigating, threshing, harvesting, and
baking, before wheat becomes edible, whereas animals can use the food
God provides them without complication and elaborate preparations.
Only man needs the labor of animals in order to sustain himself, whereas
the animal is independent of the labor of others. Again the question
arises: Is the idea a relic of medieval complaints of Adam and Eve on

[44] *Relox de príncipes,* III, fol. 193r.
[45] *The Art of La Celestina,* p. 162.

being expelled from Paradise, in which similar concepts occur, or, again, does this presage the famous soliloquy of Segismundo? Discussing this same thought, Guevara mentions several times that life is a dream: "... quando pienso que tengo algo enel mundo / hallo que todo lo que el tiene es un sueño." [46]

On the same page in the *desengaño del mundo* series we find statements like this: "En cincuenta y dos años de mi vida yo he querido prouar todos los vicios desta vida / no por mas de por prouar si ay en que se satisfaga la malicia humana: y despues de todo mirado: despues de todo pisado: y despues de todo prouado hallo que quanto mas como / mas me muero de hambre: quanto mas beuo / tengo mas sed: quanto mas huelgo me siento mas quebrantado / quanto mas duermo estoy mas desuelado / quanto mas tengo me veo mas cobdicioso: quanto mas desseo mas me atormento: quanto mas procuro menos alcanço." [47] The same problem faces us again: Is this a residue of the *De contemptu mundi*, with which the bishop was most probably very familiar, or do we see here a precursor of the Faustianism of Calderón's *Mágico prodigioso*? This is not so far-fetched if we consider that *nigromancia* was one of the subjects young Marcus Aurelius studied, and, in addition, Guevara did present Marcus Aurelius as a man who had tasted everything that life can offer.

Another constantly repeated concept is that of the *edad dorada*, the realization on the part of Marcus Aurelius and his teachers that they were living in an age of decadence and corruption compared with the glorious past. How did Guevara visualize the Golden Age? He has a sophisticated version of it, in which ambassadors arrive in Rome and admire the majesty of the Capitolium, the dignity of the Senate, the dense crowds at the Coliseum, the glory of a triumphal march, the swift punishment of evil persons, the complete peace of its inhabitants, the diversity of the people who flock there from all corners of the earth, the abundance of supplies in the warehouses and market places, and the efficiency of its officials.[48] On the other hand, the presentation of the Theban philosopher who came to see the Olympic games is also part of the *edad dorada*. The Theban made his own shoes, sewed his own wraps, wove his own shirt, and even wrote the books he used. Someone might say these ideas come from Seneca and Florus. Well and good, but what do we think of the *Villano del Danubio* and other references to pastoral innocence which also characterized this happy period of mankind's

[46] *Relox de príncipes*, III, fol. 164v.
[47] *Loc. cit.*
[48] *Libro áureo*, p. 280.

history? Again, we find the amalgamation of several concepts, some ancient, some medieval, and some completely modern, such as the protest against the plundering of the Indians. What has apparently happened is that Guevara intertwined the well-worn idea of decadence with the strong advocacy of *naturalism*. He spells it out quite frequently: "Creeme una cosa, Antigono, y no dubdes que si los hombres biuiesen como hombres, en que no se desmandasen dela regla de sus *costumbres naturales*, siempre los dioses harian como dioses en no salir de madre para darnos crudos castigos por mano de monstruosos animales." [49]

His long chapters on the feeding of children belong here [50] and so does his *Menosprecio de corte y alabanza de aldea*. Shall we say that when Guevara speaks of the *villano* and the innocence and purity of times gone by, he only voices a typical nostalgia for a past era, but when the pastoral novel or Garcilaso de la Vega show the same sentiments concerning the longing for a bucolic life, that these are modern? Such are the difficulties one encounters while reading Guevara, and these same problems led to the clash of opinions concerning our author.

Similar observations can be made regarding another favorite idea of Guevara, the *corte*. The royal court, one might say, is the quintessence of the *engaño* that pervades this world. It is a topsy-turvy place where the honest man suffers and the unscrupulous prospers. Guevara says it so eloquently that it would do him an injustice to try to paraphrase his sketch of courtly life: "Oy heredas el imperio del mundo y la corte Romana. Bien se yo que ay hartos enlas cortes delos prinçipes, que no saben que cosa es valerse, y tenerse entre tantos engaños como se tractan enlas casas delos prinçipes. Hagote saber que enla corte ay parcialidades antiguas, dissensiones presentes, iuizios temerarios y testimonios euidentes, entrañas de biuoras y lenguas de escorpiones, malsines muchos, pacificos pocos; adonde todos toman voz de republica y cada vno busca la utilidad propria, todos publican buenos deseos y todos se occupan en obras malas . . ." [51] Again we may pose the question: Is it correct to say that when Guevara tells about the court, it is only a rehash of ideas expounded long ago by Walter Map,[52] John of Salisbury,[53] and Aeneas

[49] *Ibid.*, p. 245. Italics are mine. We could cite the bishop's letter to Dr. Melgar (No. 54, *Epist. fam.*, pp. 342-49) where Guevara advocates the use of *natural* medicines.

[50] *Relox de príncipes*, II, chaps. XXXII-XXXV.

[51] *Libro áureo*, p. 181.

[52] *De nugis curialium distinctiones quinque*, ed. Thomas Wright (London, 1850). Map flourished around 1200.

[53] *Policraticus: sive De nugis curialium & vestigiis philosophorum libri octo* (Lugduni Batavorum, 1595).

Silvio [54] in the Middle Ages, but that when Dr. Villalobos complains about the court, he reflects contemporary feelings? While we cannot claim to give definitive answers to these questions, we shall present some of the answers that have been proposed.

C. GUEVARA'S STYLE

Since Guevara's style is the focal point of numerous controversies, it is necessary for us to analyze it in some detail. Eduard Norden who studied the history of antique artistic prose from the sixth century to the period of the Renaissance dedicates a separate section to Guevara in his *Die antike Kunstprosa*.[55] María Rosa Lida also devotes a considerable part of her study to questions connected with this problem.[56] We shall be guided by their ideas to a great extent as we trace the origins of this style of writing.

The beginnings of ornate prose reach back to the Athenian orator Gorgias and his disciple Isocrates who first elaborated on certain devices of artistic oratory which from then on were called the *schemata* of Gorgias. The immediate reaction was twofold: the rhetorical schools of Asia Minor not only accepted them but added emotionalism, while many Greek masters protested against them and set up as their standard "Attic" brevity and simplicity. These two basic attitudes toward style wrestled with each other in the successive schools of rhetoric.

What are some characteristic figures that Guevara uses with such predilection?

Repetition is one of the basic principles which includes many of the subdivisions listed below. It may find expression in the reiteration of a sound, a syllable, a word, a group of words, or even whole paragraphs.

Simple alliteration: *M*entirosos y *m*aliciosos; *r*elámpagos *r*epentinos.[57]

Repetition of initial sounds with a play of transverse alliteration: Pero al fin los hombres crudos, como hombres crudos no saben cosa perdonar, y los dioses piadosos, como dioses piadosos quasi nada quieren castigar.[58]

Repetition of syllables: Libro *áur*eo de Marco *Aur*elio.

[54] *De curialium miseriis epistola*, ed. Wilfred P. Mustard (Baltimore, 1928). It should be pointed out that this work of the later Pope Pius II contains extremely realistic descriptions.

[55] 3rd ed., 2 vols. (Leipzig, 1909), II, 788-795.

[56] *Op. cit.*, pp. 375-386.

[57] *Menosprecio de corte y alabanza de aldea*, ed. Clás. Cast., p. 63 and *Libro áureo*, p. 157.

[58] *Libro áureo*, p. 99.

Anaphora (reiteration of beginning words in successive clauses): Fuí a la corte inocente y tornéme malicioso, fuí sincerísimo y tornéme doblado, fuí verdadero y aprendí a mentir, fuí humilde y tornéme presumptuoso . . .[59]

Repetition of single words: Guárdense, guárdense, guárdense los privados de los príncipes de ser elatos superbos.[60]

Isocolon (balancing the clauses, so that they have the same length): Revuelve muchos libros, platica con otros sabios, dase mucho al estudio, adelgaza el entendimiento, desvelase en el dormir . . .[61]

Parison (the same structure in different clauses, so that noun corresponds to noun, adjective to adjective, verb to verb): De buen consejo siempre se recrece prouecho: y del mucho thesoro siempre se presume peligro.[62]

Quasi-rhymes (*homoioteleuton, similiter cadens, similiter desinens*): Más diré, pues más passé, y es, que unas vezes en gracia y otras vezes en desgracia de los Príncipes me vi, varios géneros de fortuna allí tenté, muchos amigos allí cobré, con crueles amigos allí competí, sobresaltos de fortuna infinitos allí suffrí, alegre y triste, rico y pobre, amado y desamado, próspero y abatido, honrado y affrentado, muchas y muy muchas vezes en la corte me vi.[63]

Combination of *anaphora, isocolon, parison,* and *homoioteleuton*: Guárdense los hombres de no entrar en agua por no se ahogar, de llegar al fuego por no se quemar, de entrar en batalla por no morir, de comer cosas malas por no enfermar . . .[64]

Schema etymologicon (combination of a verb with a noun derived from it): Que cosa mas monstruosa, que por una liuiandad de vn liuiano, se han de aliuianar tantos cuerdos! [65]

Antithesis also can range all the way from the opposition of single words to the opposition of clauses, sentences, and paragraphs.

Antithesis of clauses: Yo erre como muger y flaca, mas tu como hombre y fuerte. Yo erre con la ignorancia simple, mas tu con malicia pensada. Yo erre no sabiendo que erraua, mas tu sabias lo que hazias.[66]

[59] *Menosprecio de corte*, p. 177.
[60] *Aviso de privados o despertador de cortesanos*, ed. Biblioteca Económica de Clásicos Castellanos, p. 172.
[61] *Ibid.*, p. 44.
[62] *Relox* I, fol. LXIIr.
[63] *Menosprecio de corte*, p. 176.
[64] *Aviso de privados*, p. 242.
[65] *Libro áureo*, p. 269.

Antiphrasis (combination of a noun with an adjective that means the opposite): O mundo inmundo . . .[67]

Simple exclamation: O, mi Torquato . . .[68]

Climax (a word is repeated in the next clause, so that the sentence is constructed like a chain): . . . la soledad con la libertad olieron al mundo, y oliendole sentile, y sintiendole seguile, y siguiendole alcancele, y alcan-çandole asile . . .[69]

In contrast to figures of sound, aiming at vocal ornament, the *tropes* refer to figures of thought. They, too, abound in Guevara's works. We shall cite a few examples to illustrate them.

Metaphor: Quando desentrampe mi cuerpo de tus deleites, pense que mi coraçon estaua libre del veneno de tus amores.[70]

Simile: . . . jamas el mundo halaga con prosperidad / sin que amenaze con adversidad: por manera que debaxo de la mayor suerte que es el seys esta la menor suerte que es el as.[71]

Rhetorical question: Quieres tu concierto enlos amores, no siendo tu fiel enlos servicios? Quieres tu seruir de burla, y que te amen de veras? [72]

Traductio (identity of sound combined with difference in meaning): . . . porque solo aquel deue temer ala fortuna que no sabe a que sabe fortuna.[73]

Similitudo (an analogy from a general fact of nature or human life): Y como los ventisqueros del inuierno hagan tener en poco las ruçiadas del verano, y las cosas dela honra nos constriñan oluidar las desdichas dela fortuna, como hombre de alto ingenio y de animo fuerte, quedando el dolor todauia enel coraçon arraigado de dentro, acordo de escamondar las ramas dela tristeza de fuera, fingiendo de fuera alegria, teniendo de dentro dolor. Pues Marco el Emperador, como hombre que se le apedreo toda su viña, en quien tenia su esperança, y despues se contenta con qualquiera rebusca, muerto el infante Verissimo su muy querido hijo, mando traer al principe Commodo su unico heredero.[74]

[66] *Ibid.,* p. 297.
[67] *Relox* III, chaps. XL and XLII, *passim.*
[68] *Libro áureo,* p. 219.
[69] *Ibid.,* p. 230.
[70] *Ibid.,* p. 289.
[71] *Relox* III, fol. 189v.
[72] *Libro áureo,* p. 295.
[73] *Relox* III, fol. 192v.
[74] *Libro áureo,* p. 44.

A mere enumeration of technical devices would never do justice to the style of an artist. Therefore, we shall add a few remarks to the necessarily dry list. Some of the figures of speech in Guevara's books show surprising daring and beauty. In the nineteenth letter of the *Libro áureo* Marcus Aurelius consoles Piramon, his friend, at the death of his sister Ianuaria, ". . . quando la enterrauan muerta a mi sepultauan buio, y que al son de mis lagrimas dançauan tus ojos." [75] To appreciate the poetic quality of his prose, one may read this passage on the vanity of life: "O hijos dela tierra & discipulos de vanidad: agora sabeys que buela el tiempo sin mouer las alas / camina la vida sin alçar los pies / esgrime la fortuna sin mouer los braços: despide el mundo sin dezirnos cosa." [76]

In addition to the traditional devices, Guevara experiments with some unusual techniques. Ernst Robert Curtius allots several pages to the discussion of the famous monologue of Segismundo in the first act of the *La vida es sueño*. Segismundo complains of being robbed of his freedom while to creatures of lower rank, fish, beast, and bird, their liberty is not denied. There is recapitulation at the end of the monologue, an unusual figure which is called "summation schema" by Curtius.[77] He finds an early example in a sixteenth-century Italian poem by Panfilo Sasso. The poet bewails the fact that with the passing of time everything changes but the cruelty of his beloved lady's heart:

> . . .
> Ed io col tempo non posso a pietade
> Mover un cor d'ogni dolcezza casso;
> Onde avanza di orgoglio e crueltade
> Orso, toro, leon, falcone e sasso.[78]

Searching for the origin of the "summation schema," Curtius encountered two instances – both in poetry. The first one occurs in a beautiful poem of Tiberianus, a contemporary of Constantine,[79] and the second in the ninth century German monk, Walafridus Strabo's *De carnis petulantia*.[80]

[75] *Ibid.*, p. 313.
[76] *Relox de príncipes*, III, fol. 163v.
[77] *Op. cit.*, pp. 287-291. These expositions of Curtius appeared in an article entitled "Mittelalterlicher und Barocker Dichtungsstil," *Modern Philology*, 38 (1941), pp. 325-333.
[78] *European Literature and the Latin Middle Ages*, p. 290.
[79] *Ibid.*, p. 196. The poem describes a pleasant site. It begins with the river as a background and ends with a summary of all the ingredients of a *locus amoenus*:
> Amnis ibat inter herbas valle fusus frigida,
> . . .
> Sic euntem per virecta pulchra odora et musica
> Ales amnis aura lucus flos et umbra iuverat.
[80] *Ibid.*, p. 289-291.

It would have surprised Curtius to learn that a hundred years before Calderón, Guevara employs this technique in his prose several times. It is impossible to determine where Guevara came upon it; but we see it in paragraphs like the following:

Poruentura puede nos dar el mundo vida perpetua? Digo que no por cierto porque al tiempo que nos es mas dulce la vida nos saltea de subito la Muerte. Poruentura puede nos el Mundo dar bienes temporales en abundancia? Digo que no por cierto: porque jamas tuuo alguno tantas riquezas / que no fuesse mas lo que le faltaua que no lo que le sobraua. Poruentura puede nos el mundo dar alegria que sea alegria perpetua? Digo que no por cierto: porque sacados los dias que nosotros hemos menester para llorar / y las horas necessarias para sospirar / aun no nos queda vn momento para reyr. Poruentura puede nos el mundo dar salud perpetua? Digo que no por cierto / porque los Hombres de larga vida: sin comparacion son mas las enfermedades que padescen / que no los años que biuen. Poruentura puede nos el mundo dar perpetuo reposo y descanso? Digo que no por cierto: porque si son pocos los dias que vemos al cielo sin nublos: muy menos son las horas que vemos al coraçon sin cuydados. Pues eneste miserable mundo no ay salud perpetua / no ay riqueza perpetua / no ay alegria perpetua / no ay Vida perpetua / queria yo saber que es lo que los Mundanos quieren del Mundo? [81]

As we see, in his prose Guevara does not hesitate to avail himself of a device previously appearing only in poetry, so far as we know, and using it with a certain amount of freedom. In the above example the order of the summation is reversed, and this increases the effectiveness, for the paragraph begins with *vida perpetua* and ends with *vida perpetua*.

It should be pointed out that masters of artistic prose, from Isocrates on, have recognized that in addition to figures and *tropes* the pleasing impression of prose can be enhanced by rhythm. This is the real reason for the *isocolon*. In addition to rhythm, orators have borrowed from poets the use of rhymes. The bishop of Mondoñedo employs both in sections where he feels the moral teachings should be well remembered: "O mundo inmundo / como en breue espacio nos rescibes y nos despides / como nos allegas y nos desechas / como nos alegras y nos entristeces / como nos contentas y descontentas / Como nos ensalzas y nos humillas / como nos castigas y nos halagas: finalmente digo que nos tienes tan embouecidos / y con tus Breuajos tan Entossigados / que estamos sin ti contigo; y teniendo dentro de casa al ladron salimos de fuera a hazer la Pesquisa." [82] In order to really appreciate its effectiveness, we have to imagine how this kind of prose would sound if it were delivered as a sermon. We shall indicate later that one of the reasons for using such

[81] *Relox de príncipes,* III, fol. 190v.
[82] *Ibid.,* III, fol. 190r.

devices was the simple fact that the period of Guevara's creative activity falls on the borderline between the oral and the visual world, when books were still read aloud and moral maxims memorized. Perhaps some of the harsh attacks on fray Antonio's distinctive style would have been tempered had his critics kept this point in mind.

II. GUEVARA AND THE HUMANISTS

A. VIVES

One of the first critics among Guevara's contemporaries was no less a personage than Juan Luis Vives, the foremost Spanish humanist. Three years after the publication of the bishop's *Relox de príncipes,* Vives wrote his *De ratione dicendi* (1532). In the second book he contrasts the grave and sober style with one that is "... (est enim huic contraria) deliciosa, lasciva, ludibunda, quum semper ludit omnibus translationum generibus, et figuris, et schematis, et periodis contortis et comparatis, tum sententiolis argutis concinnisque, molli structura et delicata, salibus, allusionibus ad fabellas, ad historiolas, ad carmina, ad dicta in scriptoribus celebria, in quam orationis formam degeneravit ea quae aulica dicitur, multorum itidem qui se enascentium linguarum studio dederunt." [1] Norden is convinced that Vives alludes here to the *Libro áureo* and the *Relox de príncipes* "wo freilich Guevara nicht genannt, aber für jeden Leser mit absoluter Deutlichkeit bezeichnet ist." [2] Although Vives did not mention Guevara by name, it seems clearly evident that he heartily disapproved of many of the techniques of fray Antonio and others who also employed them.

We must keep in mind that it was not long before Vives' time that many ancient relics and writings came to light in Italy and excited humanists were pouring over newly discovered manuscripts. There was avid interest in learning about the laws, customs, and rites of their Roman forbears. This enthusiasm was bolstered by books such as Flavio Biondo's *Italiae illustratae* or Pomponio Leto's *De antiquitatibus Urbis Romae.* However, it did not satisfy the public merely to read about Roman ancestors; they felt a need to enter into direct contact with the submerged past. One of the less scrupulous writers to capitalize on this genuine zeal was Giovanni Nanni or Annius de Viterbo who claimed to have found the original manuscripts of Berosus, the Babylonian historian, the

[1] *Opera omnia,* II, p. 153.
[2] *Op. cit.,* II, p. 794.

Egyptian Manetho, the Greek Metasthenes, Cato, Fabius Pictor, and others. He called his collection *Antiquitatum Variarum Volumina XVII, cum Commentariis Fr. Joannis Annii Viterbiensis* (1498). Very few voices of doubt concerning the authenticity of his documents were heard.[3] Vives was the first Spanish scholar to denounce the work: ". . . libellus circumfertur Berosi Babylonii titulo de eadem re, sed commentum est, quod indoctis et otiosis hominibus mire allubescit, cujusmodi sunt Xenophontis aequivoca, tum Archilochi, Catonis Sempronii, et Fabii Pictoris fragmenta, quae eodem sunt libro ab Annio Viterbiensi conferruminata . . ." [4] The similarity of this method of approach with that of the *Libro áureo* is obvious. It is certain beyond a reasonable doubt that anyone who recognized the *Pseudo-Berosus* for what it actually was could easily see through the thinly veiled claim of Guevara to have found the original manuscript containing the essence of the *Libro áureo*.

We do not have to look too far for reasons why a man of the serious mentality of Vives would be opposed to the category of works which the *Libro áureo* represents. In the first book of *De causis corruptarum artium* Vives complains of the lack of critical judgment which resulted from the disappearance of ancient grammarians who were able to discern the difference between authentic and spurious teachings.[5] Today, he continues, people attribute to Plato, Aristotle, Boethius, Cicero, and Seneca ideas that would not have occurred to them even in a nightmare. In order to gain greater authority for their books, some people misleadingly use the name of a recognized author with the consequence that the average man gives the same credence to the impostures that only authentic creations deserve.

If we ask ourselves why the strong language with which Vives treats the misrepresentations, we have only to read on in the second chapter of the same book where he discusses what happened to sacred history. The recording of the glorious deeds of famous men brings to his mind a renewed bitterness that he feels whenever he reflects how carefully some of the reliable historians tried to preserve for posterity all the feats of Hannibal, Scipio Africanus, Pompeius, and Caesar, whereas just the opposite happened to the numberless martyrs and saints of the Catholic

[3] For a discussion of the acceptance of Annius de Viterbo's inventions by Spanish historians, such as Nebrija, Florián de Ocampo, and others, see Raimundo Lida's article "Sobre Quevedo y su voluntad de leyenda," *Filología*, VIII (pp. 274-275), especially n. 3 where bibliography for further study of this problem is listed. From this group we consulted George Cirot's *Les histoires générales d'Espagne entre Alphonse X et Philippe II (1284-1556)*, Bordeaux-Paris, 1904, pp. 66-75, and R. B. Tate's "Nebrija the Historian," *BHS*, XXXIV (1957), pp. 125-146.

[4] *De tradendis disciplinis, lib.* 2, ch. 5 in *Opera omnia* VI, pp. 393-394.

[5] *Op. cit.,* VI, pp. 44-45.

religion and to the early history of the Church: "... nam quae de iis (Apostolis, Martyribus, et Divis) sunt scripta, praeter pauca quaedam, multis sunt commentis foedata, dum qui scribit, affectui suo indulget, et non quae egit Divus, sed quae ille egisse eum vellet, exponit, ut vitam dictet animus scribentis, non veritas; fuere, qui magnae pietatis loco ducerent, mendaciola pro religione confingere, quod et periculosum est, ne veris adimatur fides propter falsa et minime necessaria, quoniam pro pietate nostra tam multa sunt vera, ut falsa tamquam ignavi milites, atque inutiles, oneri sint magis quam auxilio." [6] Vives probably has in mind the numerous books that have been circulating in the hands of believers. Some of them purported to tell the exact time of the second coming of Jesus, such as the *Carmina Sibyllina.* Others like the *Liber de infantia Salvatoris* exploited the curiosity about the *mocedades* of Jesus. The great humanist is especially full of indignation when he mentions the *Legenda aurea* of Jacobus de Voragine. What a disgrace to the Christian religion is that story of saints, called *Legenda aurea,* he protests. It is difficult to understand why it is called "golden," when in fact it was written by a man with a heavy touch and a leaden heart.[7] At the core of his concern lies his Erasmian outlook. The false stories of saints, the unverifiable miracles which were told and retold by generations, and the spurious holy relics have eaten into the fabric of religion. Guevara's adding another fictitious manuscript to the too many that were already accepted as true would only help to undermine the edifice of historical truth just as it would weaken religion itself.

It is interesting to note the relationship that existed between manuscripts and holy relics. In both cases fiction was treated as though it were fact. The following example may help to clarify the point we are trying to make. It is known that during the Middle Ages, if a person wanted to learn about the Trojan War, he would not turn to Homer who was not an eyewitness to the event but to the *Ephemeris de Historia Belli Trojani* of Dictys Cretensis and the *De Excidio Trojae Historia* of Dares Phrygius both of whom claimed to have been actual participants in the famed event.[8] Dictys, the Cretan soldier, was supposed to have fought on the side of the Greeks and the Phrygian Dares on the side of the Trojans, so we gather from the alleged letter of Cornelius Nepos to Sallustius Crispus [9] preceding the diary of Dares and that of Lucius Septimus to his

[6] *Ibid.,* II, p. 400.

[7] *Apud* Adolfo Bonilla y San Martin, *Luis Vives y la filosofía del Renacimiento,* pp. 150-151.

[8] Dictys Cretensis et Dares Phrygius: *De bello trojano,* ed. Anna Tanaquillus Faber (London, 1825).

[9] *Ibid.,* p. 293.

friend, Quintus Aradius Rufinus in front of the *Ephemeris*.[10] Their accounts found complete acceptance with medieval authorities to such an extent that some renowned episodes, like the love story of Troilus and Cressida, actually come from the diaries and not from Homer. Vives was among the first three humanists to point out the spurious nature of the accounts, says E. Collilieux: "Au 16ᵉ siècle ils jouissent encore d'une grande faveur; cependant la doute commence à s'éveiller chez quelques esprits plus clairvoyants que les autres, à savoir Louis Vivès, Guillaume Xylander (Holtzemann) et Joseph Scaliger." [11]

What we wish to point out here is not only the genius of Vives and his preoccupation with apocryphal literature but the way the diary of Dictys was found. The Cretan soldier upon his return from the war compiled the history of the conflict on the basis of his eyewitness notes. When his death approached, he commanded that the papyrus (*tilia* tree) leaves containing the history be placed with him in his tomb. In the thirteenth year of the reign of Nero there was an earthquake at Gnossos which split open the tomb so that the box became visible. Shepherds passing by picked it up thinking that it contained some treasure. When they saw the writings, they took it to their master, Eupraxides, who in turn sent it to the governor of the island. The governor sent the box to Nero. Nero had it interpreted or translated by his experts into Greek. Then he placed the annals in his Greek Library and rewarded Eupraxides with the rights of Roman citizenship.[12]

Collilieux compares this report with the finding of the body of St. Barnabas, as told by the Cypriote monk Alexander *c.* 478 and incorporated later in the *Acta Sanctorum* (1698, II, 418 ff.).[13] The body was discovered in a cave under a cherry tree near Salamis (Cyprus) by Anthemius, the bishop (head of pastors) of that village. He held on his chest the Evangelium of St. Matthew, written on tablets made of Thuia wood. Anthemius took the Evangelium to the archbishop of Constantinople who, in turn, sent it to emperor Zenon. The emperor had it gilded and granted independence to Anthemius. The parallel between the accounts of the finding of the diary of the Trojan War and that of the body of the saint is striking. Vives, as Erasmus before him, believes that apocryphal books and spurious miracles are like useless and cowardly soldiers in a battle. And the battle about religion was raging furiously in his days.

[10] *Ibid.*, pp. 17-18.
[11] *Étude sur Dictys de Crète et Darès de Phrygie*, p. 21.
[12] In the Preface to *Dictys Cretensis*, pp. 15-17.
[13] *Op. cit.*, p. 62. We are citing the incident from the study of Collilieux.

This is the context of his opposition to Guevara's method of treating material from antiquity which was dear to the heart of every humanist.

B. ALFONSO DE VALDÉS

In 1516 Erasmus wrote a collection of social, political, religious, and practical instructions in order to prepare young Charles of Ghent for his future role as a prince. The author gleaned from the best of ancient and medieval wisdom where speculations about the ideal prince and wise administration of a republic abound, and added to it his own convictions concerning genuine, inner religiosity and enduring peace. In 1528 the colloquy entitled "Charon" was first published.[14] This dialogue continues Erasmus' struggle against the folly of war and his strong advocacy of peace – subjects that were not as commonplace in those days as they are today. Almost at the same time (1529), two Spanish authors, Valdés and Guevara, wrote about the same topics. This is not surprising since a world empire that in Juan de Mena's day was only a fond dream, became an actuality in their time. We can easily visualize the animated courtiers discussing the topics of war, peace, and the religious ferment. Due to the intellectual climate prevailing in the court, their ideas coincide in some respects and differ in others. We shall compare their views and shall try to clarify their respective positions.

At the time of rising national states Erasmus maintains his aloofness from the interests of any special country and speaks as someone who has not forgotten the medieval supranational unity of the western part of Europe. He condemns the excuses for wars and their pretense of holiness. In his strong criticism of the Church and his demand for reforms, he suspects the machinations of churchmen as being responsible for the outbreak of hostilities. They promise the help of the God of the Englishmen in their attack on the French, he says, and the aid of the God of the Frenchmen if they go to battle against the Spaniards.

Alfonso de Valdés, the Latin secretary of Charles V, was deeply involved in international politics. He had to cope with the exigencies of day-to-day happenings and, therefore, could not take as detached a view of what was taking place as could his master, Erasmus. His two works, the *Diálogo de las cosas ocurridas en Roma* and *Diálogo de Mercurio y Carón* give us an insight into what we today would call his "ideology." The *Diálogo de las cosas ocurridas en Roma* is an attempt to defend the sacking of Rome by imperial troops in 1527 and to turn the attention

[14] See Preserved Smith, *A Key to the Colloquies of Erasmus* (Cambridge, 1927), p. 44.

of the public away from the ugly occurrence to transcendental or, as he says in the prologue, "invisible" matters. Clement VII, Valdés maintains, suffered just retribution for his behaving as a secular prince and trying to acquire land instead of concentrating his energies on leading the flock entrusted to his care as the vicar of Jesus on earth. At a time when the Turks, the archenemies of Christianity, were battering down the gates of Hungary, Clement VII was meddling in political controversies among France, Spain, England, and the Italian city-states. He lists some of the practices of the Church previously criticized and ridiculed by his master Erasmus. In addition to the familiar superstitions, spurious relics, benefices, papal bulls, and indulgences, he mentions a familiar-sounding "pagan" custom – the staging of a bullfight on St. Bartholomew's Day and the killing of four bulls in the saint's honor.[15] He wants to see a spiritual Church where the worship of the heart is more important than the chalices donated to the temples. Even if one builds a cathedral as large as that of Toledo and even if it is all made of gold, it will not be worth as much as the act of offering one's soul to be God's dwelling place.[16] His reformist zeal carries Valdés to the extreme of desiring "un mundo de nuevo." [17] In the present dialogue, he makes the Arcidiano utter this wish; in the Diálogo de Mercurio y Carón it is Polidoro who hopes that his reforms will result in the creation of a new type of man – ". . . saliessen de alli nuevos hombres." [18] As far as the division of spheres of authority between the Emperor and the Pope is concerned, Valdés restricts the role of the Holy See to the purely spiritual and that of the Emperor to the temporal. The Vicar of St. Peter should interpret the doctrines of the Holy Scriptures and exemplify them by his way of life, decide upon absolution from sin or its denial, and pray and work for peace at all times. The Emperor's office is to defend his subjects, maintain peace and justice, favor the good, and punish the evil.[19] However, in the present crisis of the Church which was caused by the default of its spiritual head, the author calls upon the Emperor to carry out the necessary reform of the Church so that unto the end of the world men shall say, "Jesu Cristo formó la Iglesia y el Emperador Carlos Quinto la restauró." [20]

[15] Diálogo de las cosas . . . , p. 206. In discussing the works of Alfonso de Valdés we are using the Clás. Cast. editions which have Introductions by José F. Montesinos.
[16] Ibid., p. 169.
[17] Ibid., p. 183.
[18] P. 235.
[19] Ibid., pp. 85-86.
[20] Ibid., p. 222.

The *Diálogo de Mercurio y Carón* is also based on contemporary events. As a matter of fact, Valdés inserts actual imperial correspondence into the story. However, the outstanding figure of this dialogue is Polidoro, the ideal king. Polidoro followed the normal course of kings, involving himself in wars with neighboring countries which ended in the desolation of both sides. He felt he had come to a dead end and, convinced that his life up to this point had been useless, he suffered a crisis. His appetite gone, his sleep disturbed, death seemed preferable to life. Then suddenly one of his servants, whom he hardly knew, touched him on the shoulders and told him, "Turn and look into your own soul, Polidoro." Awakened from his blindness, he began to understand the futility of his past life, knelt down, and prayed. What we have here, of course, is the experience of a kind of *alumbramiento*. Whether Alfonso de Valdés is the unknown servant or not, it is difficult to determine. At any rate, after his spiritual awakening Polidoro carried out a program that included, among other things, religious reforms. Even the clergy was obliged to learn a trade so that there were no idlers in the kingdom. Bishops were named according to merit, and they had to reside in their dioceses. The good example set by the king pervaded the whole country. Many people heard about the ideal conditions prevailing in the kingdom and took up residence therein. Hope was held out that even the Turkish problem would be solved by their becoming willingly converted to true Christianity. Just as Mount Zion in prophet Micah's vision was destined to stand out among the mountains and many people flocked to it, so did the light of true Christianity shine in Polidoro's land. It became a "convento de frailes buenos." Regarding war, only in case of extreme necessity does Polidoro contemplate war, for "más vale desigual paz que muy justa guerra." It is sometimes advisable to go to war in defense of the faith. However, one should be very careful, for "debaxo deste hazer guerra a los infieles va encubierta gran ponçoña." [21]

Guevara wrote a great deal about the contrast between the good king and the tyrant, about wars, about conquests, and about true Christianity. If Erasmus urges his readers to return to primitive Christianity, Guevara conjures up the innocent state of man when he led a problem-free life: "Este (Membroth) fue el primero que començo a tyranizar las gentes . . . Y este maldito tyrano dio fin ala edad dorada: enla cual todas las cosas comunes en la republica." [22] He complains numerous times about the

[21] The Polidoro section is found on pp. 184-210 in the Clás. Cast. edition of the *Diálogo de Mercurio y Carón*. The model derives from the *danza de la muerte* but some of the ideas proposed by Polidoro were modern, even revolutionary, in the author's day.
[22] *Relox de príncipes*, I, fol. 36v. The community of property seems to be one of the features of Guevara's Utopia.

bulliciosos who disturb the peace which, according to him, is the natural condition of mankind. All the ills of society stem from greed which drives the *bulliciosos* to exploit the weak.

Although Guevara is a firm advocate of peace, he believes that it is the duty of the prince to defend what he inherited from his predecessors.[23] As a matter of fact, he goes so far as to say that sometimes war is the best solution, ". . . muchas cosas se atajan con una buena guerra que no se pueden acabar con una sospechosa paz." [24] This is in complete contrast to the view of Polidoro. Guevara condemns, however, without reservation any war of conquest. Whoever undertakes it deserves to lose his own holdings.[25] Just as he protests against the powerful man who exploits his weaker neighbor, he also protests against the king who conquers new territories for doing the same type of injustice on a grander scale. The morality that guides a villager in respecting his neighbor's rights should also guide the rulers of the world in dealing with people of other countries as well as those of his own country. This is the message of the *Villano del Danubio*.

Even in the area of religious thought there are some coincidences between the views of Valdés and Guevara. Of course, fray Antonio voted against the Erasmian position during the famous Junta of Valladolid in 1527.[26] Nevertheless, Costes records passages that were suppressed by the Inquisition in the *Oratorio de religiosos* which have an Erasmian flavor.[27] It would be surprising if some of the currents of religious thought in which Franciscans actively participated during this period had left the bishop uninfluenced. His interest in Francisco de Osuna's *Abecedario espiritual* bears out this contention, and the fact that Guevara failed to credit his correct source does not alter the significance of these currents for him.[28]

[23] *Ibid.*, III, fol. 153v: "No se encruelece mi pluma contra todos los principes que tienen guerras: sino contra aquellos que tienen guerras injustas: porque segun dezia trajano: mas vale guerra justa que no pas fingida. Loo / aprueuo y engrandezco alos principes que son cuydadosos y animosos en conseruar lo que les dexaron sus passados . . ."

[24] *Una Década de Césares*, fol. 107r.

[25] *Relox de príncipes*, I, fol. 17r in connection with the defeat of Tendeberto, king of the Franks, by Narsetes, general in the army of Justinian. Guevara makes this observation: "Y no fue esto [the crossing of the border of the Empire by Tendeberto] por cierto sin gran permission de dios: porque muy justo es que qualquiera principe pierda sus reynos por sola justicia diuina: pues el quiere tomar otros reynos / no por mas de por locura humana."

[26] See P. Ángel Uribe, "Guevara, inquisidor del Santo Oficio," *Archivo Ibero-Americano*, 2a época, 6 (1946), pp. 263-68.

[27] *Op. cit.*, pp. 222-23. *Cf.* also P. Fidèle de Ros, "Guevara, auteur ascétique," *Archivo Ibero-Americano*, 2a época, 6 (1946), p. 378.

[28] P. Fidèle de Ros, article quoted in previous note, pp. 380-86.

Both Valdés and Guevara manifest a strong aversion toward court jesters. Polidoro relates in the *Diálogo de Mercurio y Carón*, "... tras esto, eché de mi corte truhanes, chocarreros y vagabundos, quedándome solamente con aquellos de que tenía necesidad." [29] The bishop allots no less than five chapters of the *Relox de príncipes* to the topic, explaining the origin and background of the institution of jesters among whom he includes actors, pantomimes, *maestros de farsas,* and, since the pseudo-Roman atmosphere is still maintained in the book, even the gladiators.[30] The basic objection of both authors stems from a moralistic point of view – the jesters create a climate of levity and even licentiousness, and they distract the attention of youth from useful work. Guevara wants them to be expelled not only from the court but also from the republic because they lead a parasitic life and obtain from the princes generous gifts that should rightfully go to the poor. With his keen power of observation he notes: "... que solo porque diga vn truhan en publico: ha la gala de fulano / viua viua su generosa persona: sin mas ni mas le dan vn sayon de seda: & partidos de alli si entran en vna yglesia no daran al pobre vna blanca." [31]

Judging from the statements of the bishop, the popularity of the *farsas, pantomimos, rodajas,* and *sonetos* must have invaded not only the palaces of the nobles but also the modest huts of the laborers. The *truhán* was uttering witty or malicious remarks at the tables of the great, the entertainers were playing and singing *rodajas* at weddings or accompanying their *donaires* with instruments at the doors, and actors were presenting *farsas* in the plazas. Using the Ship of Fools motive, spread by Sebastian Brant's *Narrenschiff* in the fifteenth century, Guevara has Marcus Aurelius send a long letter to Lamberto, the governor of the island of Hellespontus, announcing to him that he has loaded three ships of fools with his island as a destination. This, he adds, is only a small portion of the fools that populate Rome.[32] It is worth noting the use Guevara makes of this ancient *topos.* According to James B. Wadsworth, most writers of the fifteenth and sixteenth centuries were inclined to use the motive of the ship with her precious cargo in a serious, moralistic sense. Guevara apparently could not resist the temptation to interpret this motive in a humorous vein.[33]

[29] P. 191.
[30] *Relox de príncipes,* III, chaps. XLIII-XLVII.
[31] *Ibid.,* fol. 196r.
[32] *Ibid.,* fols. 196r-197r.
[33] In his *Lyons 1473-1503. The Beginnings of Cosmopolitanism* (Cambridge, Mass., 1962), pp. 98-104.

Both authors stress the danger of the prince surrounding himself with evil, ambitious, and greedy counselors. Fray Antonio uses the occasion to expatiate on the futility of avarice in general, illustrating it with many examples from the past.[34]

Menéndez Pidal in praising the impartiality and sense of justice exhibited by Queen Isabella refers to a booklet in which the queen would mark the merits and qualities of officials. When a vacancy occurred, she used to consult her notes. In this manner, the right man would be assigned to the right job.[35] The ideal king of Valdés also kept a journal in which he would note without regard to favors rendered or lineage the accomplishments of public servants. Whenever a position had to be filled, he did not have to look around for someone because he would have in readiness several well-qualified candidates. By this method, he would spare himself many importunings of ambitious office seekers. This was in line with the age-old Platonic statement that whoever sought an office gave proof that he did not deserve it. Surprisingly enough, Guevara also mentions such a record book whose invention he attributes to Alexander Severus.[36] Since both Valdés and Guevara were not only contemporaries but also members of the court of Charles V, it is not surprising that, although they held differing ideas about religion and the king's role, they thought alike on many subjects. Perhaps the diversity of their views can be explained, at least to some extent, by their temperaments rather than by differences in their basic beliefs.

C. PEDRO DE RHUA'S *CARTAS CENSORIAS*

There is disagreement among scholars regarding the value of Pedro de Rhua's *Cartas censorias*. Américo Castro questions the importance attributed to the errors in Guevara's writings and believes that in spite of the inaccuracies the bishop understood the spirit of classical antiquity much better than Pedro de Rhua did.[38] María Rosa Lida, on the other

[34] *Diálogo de Mercurio y Carón,* p. 190 and *Relox de príncipes,* III, fols. 173v-174v.

[35] *Los españoles en la historia y en la literatura* (Madrid, 1951), p. 60.

[36] *Relox de príncipes,* I, fol. 45r.

[37] A shortened version of this section was published in the Spring 1967 issue of *Symposium* under the title, "Pedro de Rhua's Critique of Antonio de Guevara," pp. 29-37.

[38] *Antonio de Guevara. El Villano del Danubio y otros fragmentos* (Princeton, 1945), p. XII: "The humanities were for him (Guevara) a 'pastime,' which did not prevent him from having a feeling for Antiquity superior to that of Pedro de Rhua and other depositaries of passing and perspectiveless knowledge." This study is a translation of Castro's "Antonio de Guevara. Un hombre y un estilo

hand, sides with Pedro de Rhua: "El altercado expuesto en las tres cartas de Rhua y la réplica de Guevara no es, pues, un debate entre el artista genial y el crítico miope que le rectifica las fechas: puesto que Guevara se abriga en su indiferencia a la verdad para las cosas que no tocan en la fe, su información verbosa y no cribada, de datos y más datos, representa el saber medieval, acumulativo y no crítico, mientras Rhua, el profesor a quien los profesores temen defender, con su claro estilo y su crítica exacta, representa la ciencia moderna." [39]

A reexamination of the polemic between Guevara and Pedro de Rhua may shed some new light on this matter. In 1540 Pedro de Rhua, a professor of humanities from Soria, sends a long letter to Guevara via a clergyman. Rhua reminds the bishop of Mondoñedo of their past association in Avila and expresses admiration for the attainments of the bishop who, like himself, labors in the vineyard of humanities. He apologizes for not writing in Latin, as one humanist should to another, but defends his action with the excuse that he is trying to avoid ostentation: ". . . lo cual quise escrebir en romance, que es lo que nunca uso, y no en latin, en el cual estoy algo mas ejercitado leyendo y escribiendo; porque no paresciese que me movia a escrebir mas por ostentar mi pluma, que por cumplir lo que pretendo como fiel y antiguo servidor." [40]

In this introductory remark of the correspondent there may be a hint of irony. Guevara begins the *Menosprecio de corte y alabanza de aldea* in Latin as if it came to him naturally and, after one page, continues it in Spanish; on another occasion, the bishop begins a letter in Latin and drops it after twelve lines. Only the last letter in the *Epístolas familiares* is written completely in Latin.[41]

The circumstances that prompted the sending of Rhua's communication are, in many ways, more important than the body of the letter itself. The humanist was present when a group of learned men and voluble courtiers discussed and criticized the books recently (1539) published by Guevara. Displeased by this backbiting, he challenged them to state their objections. Some found the style too ornate and affected; they saw in the complicated distributions, expositions, repetitions, contrasts, and other tricks of style school examples from the *Preexercitamentos de Aftonio* (a much used guide-book for rhetorical exercises in

del siglo XVI," *Boletín del Instituto Caro y Cuervo*, I (1945), pp. 46-67, (with perhaps a few minor changes).

 [39] *Op. cit.*, p. 369.
 [40] *Cartas censorias*, Biblioteca de Autores Españoles, XIII, 1, p. 229.
 [41] The letter that begins in Latin and continues in Spanish is No. 19 in the *Epístolas familiares*, I, pp. 124-25. The last letter, written completely in Latin, is No. 43.

the Middle Ages and the Renaissance). Others protested against the frequent mention of his noble lineage. Some deplored the indiscretion of publicly naming the persons whom the bishop castigates in his *Epístolas familiares*; and there were others who noted that the author presented as true history inventions of his mind, frequently running counter to the statements of reliable scholars, and backed them up with spurious authorities. Pedro de Rhua tried to answer these charges as best he could, even though in many cases he had to admit that truth was stronger than friendship. To avoid further criticism, he takes the liberty of calling Guevara's attention to certain inaccuracies in his *Epístolas familiares*.

The whole incident of putting criticism in the mouth of others and defending the author is most probably only a polite literary pretense. We have a curious parallel to it in the "Carta del Bachiller de Arcadia escrita al Capitán Salazar," where the intention is completely clear.[42] The correspondent states that he writes in praise and censure of the chronicle the Captain compiled during the military expedition of Charles V against the Lutherans of Saxony. The Bachiller also reports that he met some hairsplitting critics who, disregarding the respect due to the Captain both on account of his personal qualities and his rank, undertook to downgrade the chronicle. The Bachiller decided to take up arms in defense of the author. He, too, lists the objections of the critics. Like Pedro de Rhua, the Bachiller de Arcadia tried to answer their censures but had to admit the correctness of at least one point they made – how was the Captain able to fight so bravely and at the same time see what was going on behind him? [43]

All this puts the humanist's epistle in the correct light – each critic is actually voicing his own objections. The impression that the corrections of Guevara's errors are, at least in the first letter, of secondary importance is reinforced by the fact that a considerable portion of this letter contains a defense of the town of Soria where the humanist resided and taught. Guevara had spent some time before 1518 in the monastery of Montsarrate which is situated near Soria. Judging from his remarks made about Soria, it must have been an unhappy experience for him. The bishop considers the monastery cold and humid, the land around the area dry and unproductive, and the people of the town malicious.[44]

[42] See *Sales españolas*, pp. 63-99.
[43] *Ibid.*, pp. 65-66.
[44] *Epíst. fam.*, No. 8, I, pp. 58-59. Guevara writes to the Count de Miranda: "Escríbeme también que no será mucho tomar trabajo de enviaros la exposición de aquella palabra [referring to *Jugum meum suave est*], pues me fuistes a ver siendo yo guardián de Soria, de manera que si no lo quisiere hacer de gracia me lo pedís por justicia. No quiero negar que aquella visitación no fué para mi muy

Rhua refutes the charges point by point. The monastery, he maintains, occupies the highest place in the village and can hardly be called humid. As to the fertility of the land, he offers exact statistics of wheat production for that year showing that Soria was able to provide with wheat not only herself but the neighboring provinces as well. Both social classes of Soria, says the professor, are praiseworthy. The *caballeros* are generous, loyal, high-spirited, and of noble conversation, as can be deduced from the special privileges granted to the town by the kings and from the chronicles of the kings of Castile in which their valiant deeds are recorded. The burghers are engaged in virtuous occupations, such as crafts, cattle raising, weaving of fabrics and, significantly, "... en otros oficios limpios y de continua ocupacion." [45] It seems from this remark that shiftless Morisco potters and haunted crypto-Jewish vendors would not find welcome in his city.

It is not our purpose to determine what kind of a town Soria was in those days. However, there is an interesting statement in the still unedited correspondence in the Biblioteca Nacional between Alvar Gómez de Castro and Pedro de Rhua which Costes had read. In one of the letters Alvar Gómez, the biographer of Cisneros, urges his friend to leave the town of *urracos y pelendones* and come to a supposedly civilized place like Alcalá de Henares.[46] It is also important to note that Pedro de Rhua alludes to a probably insignificant mismanagement that occurred during Guevara's tenure of office at the monastery some twenty-five years before the date of this letter: "Yo ha que vivo en Soria quince años y mas, y cuanto he podido conoscer la condicion de la gente desta tierra, hallo que es mas inclinada a disimular faltas ajenas, especialmente de religiosos y extranjeros, que a proseguirlas con aspereza y rigor, como con corregidores, y en casos acidentales, de personas de algun respeto, le he visto." [47] It must be mentioned in Guevara's defense that he did make provisions in his testament to straighten out this matter about which he still felt some scruples. It would have been much nobler to settle the debt in his lifetime, as María Rosa Lida remarks with justification.[48]

gran merced y consolación, a causa que el monesterio es húmedo, y la tierra fría, los aires subtiles, el pan poco, los vinos malos, las aguas crudas y las gentes no nescias, que a la verdad, si en otra parte juzgan lo que ven, allí dicen lo que piensan. Lo que mas allí sentía era, no la falta de los bastimentos, sino la absencia de los amigos, sin los cuales ni hay tierra que agrade, ni conversación que se contente."

[45] *Cartas censorias,* p. 231.
[46] *Op. cit.,* p. 193.
[47] *Cartas censorias,* p. 231.
[48] *Op. cit.,* p. 348.

After these preliminary occurrences, needless to say, the bishop left the letter unanswered. During the two months that elapsed between the arrival of the first and the dispatch of the second missive, Pedro de Rhua was apparently busy collecting another batch of misstatements, unauthorized quotations, and misinterpretations of Latin texts that abounded and were in need of correction in the *Menosprecio de la corte*. The second letter of Rhua chides Guevara with honeyed words for his failure to react to the first one, and quotes from the bishop's *Epístolas familiares*, a rhetorical device called *argumentum ad hominem*, to the effect that one should always reply to a letter and show special consideration in this respect to those of lower status. Convinced of the bishop's humility, he hopes that the lack of a reply is due to arduous occupations and is not to be attributed to the correspondent's humble profession.

These prefatory words allow the humanist to introduce a subject dear to his heart, the importance of *gramática* which included in those days literature and the interpretation of texts, too. The main reason for the low esteem in which humanities are held is that they do not provide a good living: "Confieso que la gramatica es una arte a todas las otras facultades, aunque necesaria para el fundamento dellas, pero por ciertas causas tenida en poco y habida por importuna y odiosa: lo uno porque, como entienda mas en enseñar que en ganar, es tenida por plebeya y vulgar." [49] Since the study of *gramática* involves interpreting texts, correcting faulty style, and assigning authors their proper places, those who labor in *las artes y ciencias mayores* feel indignant to be called before the tribunal of a lower court. The job of the professor of humanities who pronounces judgment over the reliability of an author resembles that of the ancient Roman censor. He determined who should be promoted to a higher position and who relegated to a post of lesser importance, and he castigated evil practices. In spite of his vocation, Rhua avers, he is not conducting himself toward the bishop as a *gramático* who reproves writers publicly but rather as a faithful servant and client and, therefore, privately calls the attention of Guevara to the errors committed by him.

These observations concerning the *gramático*'s authority in the past and the extent of the disrespect into which the term grammarian has fallen come from the magnificent chapter of Vives on the decadence of *gramática*.[50] Where the two diverge is relating these facts to the present. Vives discusses them in reference to the contemporary condition; with Pedro de Rhua they remain abstractions. The reader would have to be naive, indeed, to take seriously the supposition that Guevara did not

[49] *Cartas censorias*, p. 231.
[50] *De causis corr. artium, 1. 2, cap.* 1; *Opera omnia*, VI, pp. 44-47.

reply to Rhua's previous letter because of the "low status" of his position as a grammarian.

Before correcting many more misquotations, mistakes, and misattributions, the professor states again his motives by quoting the famous lines from the Epistle of St. Paul to the Corinthians about the quality of love. We have already seen the most important one, entirely unselfish love and respect (el amor y celo que tengo á su servicio).[51] The second one is his devotion to truth. Since he is convinced that the bishop writes not in order to satisfy his ambition but for the common good, he most certainly would not want to be misled or to mislead others. This represents fine irony, since the bishop knew just as well as the professor that he manipulated names and passages to suit his purpose. That Guevara was misled was very far from being the actual situation.

The final motive mentioned by Rhua introduces us into an area that will gain in significance as the years go by: "De mí puede creer vuestra Señoría que no escribí la carta pasada ni esta presente porque soy ó sembrador de mi fama ó envidioso de la ajena . . . ; mas porque me pesa que de cosas de vuestra Señoría hablen mal nuestros naturales, y *por ellas juzguen peor de los ingenios y doctrina de nuestra nacion los extranjeros, ansí, celando la honra de vuestra Señoría y del reino*, no me contenté haberle escripto una carta de aviso . . ." [52]

To appreciate the full extent of Pedro de Rhua's concern about the consequences of Guevara's methods outside of Spain, we have to try to examine the background of such concern, especially since we shall meet with this problem time and time again. The beginnings of it reach back to Cicero who uttered the phrase "pingui isti Cordubenses" in his *Pro Archia poeta*. It was immediately interpreted to mean that Spaniards have a penchant for flowery, pompous, and artificial style. With the death of Cicero, Romans became increasingly conscious that a decline of Golden Age oratory had set in. Yet as might have been expected, very few weighed and analyzed the complex reasons for the change. They did note that the students of rhetoric practiced figures of speech, exclamations, apostrophes, and other artificial devices in their declamatory exercises. To use the words of Duff: "Rhetorical gymnastics of this sort, while they had the merit of ensuring a high degree of readiness and finish in speech and in style as a whole, yet fostered in some speakers and authors an empty glibness from which no great literature could grow. The contemporary complaints about the decadence of oratory are sig-

[51] *Op. cit.*, p. 232.
[52] *Loc. cit.* Italics are mine.

nificant." [53] Two outstanding rhetoricians of Spanish origin, Annius Seneca and Quintilian, were blamed for the decline.

With the systematic renewal of Roman and Greek studies, the hoary *clichés* regained vigor. Guevara's style, no doubt, stands nearer to the school of Silver Age rhetorics than to classic Ciceronian expression. Pedro de Rhua, a follower of classicism in style as were most Spanish humanists, feared that the bishop's rhetoricism and his misrepresentations could become a target of foreign criticism. He proved to be completely right. The Italian humanist, Bernardino Tomitano, unleashed a strong attack in 1573 against Garcilaso de la Vega and Spanish writers in general and used Guevara as an example, quoting the long and spectacular *climax* that begins with the words: "Estando yo leyendo en Rhodas rhetorica, teniendome alli Hadriano mi señor, siendo de edad de veinte y vn años, mi carne iuuenil no menos flaca que tierna . . ." [54] Fernando de Herrera, the commentator of Garcilaso's work, defended the poet with these impassioned words:

. . . porque no me obliga a publicallo la passion, que tuvo el Tomitano, cuando encendido con vehemente, pero desfrenado impetu, quiso estender todas las fuerças de su eloquencia en vituperio de la habla y concetos, i ingenios Españoles, i no contento de aver condenado, como a el le parecio, toda nuestra nacion en lo que toca a esta parte; por que se conociesse por el exemplo ser de aquella suerte, confirmò su opinion con un lugar, que traxo de Frai Antonio de Guevara; como si fueran los Españoles tan barbaros i apartados del conocimiento de las cosas, que no supieran entender que tales eran aquellos escritos.[55]

But to return to the corrections embodied in the second letter, all of them are justified with one exception. Pedro de Rhua claims that Guevara did not quote the Jephthah story correctly, for Guevara states that Jephthah vowed to sacrifice the blood and life of his daughter to God if He gave him victory over the Ammonites. This is technically incorrect, for, according to the Biblical text, the vow was couched in general terms, "Quicumque primus occurrerit, eum offeram," meaning that whoever came out of his house first upon his return would be sacrificed to God. To his misfortune, his daughter came out first to greet him.[56] Most of

[53] *A Literary History of Rome in the Silver Age*, p. 11.
[54] *Ragionamenti della lingua Toscana*, pp. 366-67. It is worth noting how Tomitano introduces the long quotation from Guevara: "Et perche io no parli in cio piu per compiacere al Manutio & al Contarini, che alla uerita; udite queste non poche parole . . ." Then follows the elaborate climax in Italian, beginning with "essendo io lettore in Rodi, *etc.*"
[55] Garcia Laso de la Vega (con anotaciones de Fernando de Herrera), commentary on first sonnet, p. 75.
[56] In the Book of Judges, chap. 11.

the modern Biblical commentators, however, interpret this as an incident of human sacrifice resulting from a solemn oath made in the heat of battle. They only differ as to whether or not it is permissible to draw the conclusion regarding the existence or non-existence of human sacrifice in ancient Israel from this one occurrence. In this light, Guevara understood the intent of the text better than did Pedro de Rhua even if he did not quote it accurately.

Upon receipt of the second missive, Guevara decides to send a reply:

> Muy virtuoso Señor: Es verdad que hogaño rescibi otra letra de Vm., y tengole en merced aquella y esta, que suplen lo poco que yo se y lo mucho en que yerro Como, señor, sabeis, son tan varios los escriptores en esta arte de humanidad, que, fuera de las letras divinas, no hay que afirmar ni que negar en ninguna dellas No haga Vm. hincapie en historias gentiles y profanas, pues no tenemos mas certinidad que digan verdad unos que otros, *et pro utraque parte militant argumenta.* Y en lo demas yo huelgo de saber de su salud, y que este bueno A servicio de Vm.[57]

Pedro de Rhua takes the reply apart and answers it sentence by sentence as if he were writing a commentary on an old text. With thinly veiled irony he asks the rhetorical question: Is there any malice that the generosity, wisdom, and kind words of the bishop would not overcome? Then Rhua proceeds to "operate on" Guevara's creations: "No es buen cirujano el que se contenta con cerrar la herida viendo que le deja sobresanada; no ama con verdad el que tibiamente avisa o reprehende." [58] Within this one letter he compares himself three times to a surgeon who must remove bad tissue. He applies the word *verdad,* which represents for him the main issue, like so many powerful hammerblows. One cannot help but admire the architecture of sentences such as: "Es vuestra Señoria en sangre Guevara, es en oficio cronista, es en profesion teologo, es en dignidad y meritos obispo: de todos estos renombres es amar verdad, escrebir verdad, predicar verdad, vivir en la verdad y morir por ella." [59] As we see, Rhua uses Guevara's own characterization of himself and matches every clause of Guevara's with another that contains the word "verdad." In order to insure that the bishop shall not forget how important truth is, the humanist mentions it six more times within the same paragraph.

This leads us into the problem of historical truth to which part of the last *carta censoria* is devoted. Guevara has taken the position of accepting only *letras divinas* as absolute certainty and distrusting any secular

[57] *Cartas censorias,* p. 237.
[58] *Loc. cit.*
[59] *Loc. cit.*

history. The humanist calls this stand Pyrrhonism and skepticism and quotes from the letters of Seneca and from Athenagoras' *Apologia pro Christianis* excerpts that protest against the type of views exhibited in Guevara's short note.[60] Actually, the passage from Athenagoras alludes very cursorily to history and deals more with the marvel of writing as a special gift from God. By means of it contact is kept alive between the living and the dead and accomplishments of each generation can be preserved for the benefit of the next one. Should such information be received with disbelief, of what use would the memory of the past be to future yet unborn generations?

Turning to the difference between the historian and the orator, Rhua bases his reasoning on the definitions of Lucian of Samosata's *De componenda historia*. Whoever records history has to be not only a man of good character but also a lover of truth and has to proclaim it fearlessly and impartially. The orator is permitted to deviate from the path of narrow fact to the avenue of the credible and the probable; but the historian is obligated to reflect the exact, unadorned, and undoctored truth like a mirror that never deceives. He ends this section with Lucian's famous sentence that a historian has no fatherland, no king, and no law to restrict him. All that the professor explains in this section was already said much more eloquently by Vives in his *De tradendis disciplinis* (*lib.* V, ch. 1) and *De ratione dicendi* (*lib.* III, ch. 3). It is interesting to note that the professor shows reluctance to give credit to anyone or quote anyone whose writing was not at least a thousand years old. We encounter only two cases where he mentions authorities who did not flourish in the remote past, the names of Biondo and Platina.

The censorial letter leaves the topic of the orator and historian and enters into the discussion of which nations possessed reliable records of the past. The controversy about this point goes back to the *Contra Apionem* of Josephus whom Rhua cites and follows. Egyptians, Babylonians, Hebrews, and Phoenicians had entrusted the care of writing down im-

[60] It is intriguing to note that neither one of the passages is correctly quoted. Rhua refers to the last letter of the thirteenth book of Seneca's epistles. We looked in both old and new editions of *L. Annaei Senecae ad Lucilium Epistolae morales* and did not find in any of them a division of the epistles into more than two volumes. Instead, the excerpt is from vol. I, *Epistola* LXXXVIII: "Protagoras ait, de omni re in utramque partem disputari posse ex aequo, et de hac ipsa, an omnis res in utramque partem disputabilis sit. Nausiphanes ait, ex his, quae videntur esse, nihil magis esse, quam quod non esse. Parmenides ait, ex his, quae videntur, nihil esse ab uno diversum. Zenon Eleates omnia negotia de negotio deiecit: ait, Nihil esse...." (Ed. by Iohannes Schweighaeuser [Argentorati, 1809] I, pp. 363-364). So far as Athenagoras' *Apologia pro Christianis* is concerned, we could not find the quotation cited by Rhua. We used the Oxford (1706) ed. which has the original letter in Greek and a Latin translation.

portant events to their high priests and to their prophets. These records had to be kept with the utmost accuracy. The Greeks, however, did not exercise care in selecting trustworthy men for the purpose of preserving reliable ancient records. Those who did write histories were more interested in showing their eloquence and elegant style rather than in perpetuating true records of the past. Thus we find disagreement among their learned men, one refuting the other, and each accusing the other of lying. There is disagreement between Hellanicus and Acusilaus regarding genealogy; Ephorus corrects Hesiod, Timeus contradicts Ephorus; all of them accuse Herodotus of incorrections and some even question the reliability of Thucydides, although he seems to have been the most exact among them.[61] Undeniably, Rhua concludes, there is discord among the writers of secular history; but it is an untenable and grossly mistaken position to reject on that account all profane history and everything that they say.

Without trust, there could be neither contract between individuals, commerce between nations, nor continuity between past and present. This is taken, of course, from St. Augustine's *De fide rerum quae non videntur* (chapters 1 and 2). Without possessing a true memorial of accumulated experiences, exemplary deeds, laws, and customs of predecessors, mankind could not evolve beyond the level of childhood. Due to true history we encompass long years in our short span of life. To illustrate the point, Rhua retells the anecdote of Plato about an Egyptian priest who said to Solon: "You Greeks are still children, for you were born yesterday; you have acquired the ability of writing only yesterday; and you do not have the knowledge of your past." (*Timaeus*, 5; *Platonis scripta Graece omnia*, ed. Immanuel Bekker, vol. VII [London, 1826], p. 242.) History offers all these advantages, and, if once in a while one historian lies, there are others whose word is unquestioned and thus it is possible to find out the truth.

Another anecdote from Lucian about Alexander the Great and Aristo-

[61] In the statement concerning Thucydides apparently there is a typographical error. The sentence in the present form reads: "... y por este discordan tanto entre sí los griegos, y redarguyen unos á otros de falsedad, Acusilao á Hellánico, y Eforo á Hesiodo, y Timeo á Eforo, y todos á Herodoto, y algunos á Tucídides, aunque él fué el que con mas descuido escribió entre los griegos de aquel tiempo:..." It is evident that the statement does not make sense unless we read *cuidado* instead of *descuido*. As a matter of fact, just a few lines after the sentence quoted above which contains the error, Thucydides heads the list of those historians whose veracity can be trusted: "... tiene Grecia autores de creencia y autoridad, como son Tucídides, Teopompo, Xenofon, Lasampceno, Timágenes, Polibio, Alejandro, Polihistor, Metrodoro, Posidonio, Plutarco, Herodiano, Estrabon, Dionisio Halicarnaseo, Dion y otros muchos no vulgares; de quien se pueda hacer cuenta y darles crédito."

bul illustrates how historians lose credit. This same anecdote will be retold by García Matamoros when he speaks briefly about Guevara. Reminding fray Antonio again that as a Christian, a monk, a bishop, a chronicler, a *caballero,* and a learned man, he has to love truth, search for truth, favor and defend truth, and prostrate himself in its presence, the humanist refutes the bishop's claim, stated in the introduction of the *Menosprecio de corte,* of having polished, revised, and corrected the books before publication. He counsels the bishop to follow the rule of Horace, to keep a book for nine years before launching it on its way.

Toward the end of the third letter, Pedro de Rhua questions Guevara's identification of Histobriga with Nebrija and adds a personal experience to suggest where Guevara might have learned this. Rhua tells Guevara that he applied for a professorship at the university of Valladolid by *oposiciones.* His rivals got hold of the sacristans of the nearby village of Campos in order to help them prepare for the examination. They were asked during the examination what they had heard expounded that year at the university. They answered: "The Letters of Virgil and the scholia of Cicero." When further questioned as to who the commentator of Cicero was, they gave the answer that it was the *cura* of the village. In a similar fashion Guevara might have learned about the identification of Histobriga with Nebrija.

Rhua goes on to say that he could continue finding mistakes *ad infinitum,* especially in the *gran Marco Aurelio*; however, since the bishop considers that work his palladium, he does not wish to touch it. Instead he offers the bishop the hair of a she-goat, an allusion to a supposed biblical error of Guevara who stated that the poor who cannot afford a lamb should offer as a sacrifice the hair cover of the animal. Actually fray Antonio was completely correct, for he had in mind Jerome's *prologus galeatus* (helmeted), "In the temple of God each presents what he can; one gold, silver, and precious stones; another fine linen, scarlet, and hyacinth; it must suffice for us if we offer skins and goats' hair." [62]

We have few instances in the 16th century where the reaction of a critic can be studied from a detailed document such as the *Cartas censorias.* The invective against Guevara still leaves many questions unanswered: Was Rhua too naive to understand the real nature of Guevara's works? Was he pedantic, as Costes claims? Was he overreacting due to the fact that so many uncritical compilations, legends, and lies found acceptance in Spain? Was he motivated by professional jealousy? Or was it a combination of all these elements that prompted him to take up arms and sally forth against the bishop?

[62] *Apud* Curtius, *European Literature and the Latin Middle Ages,* pp. 86-87.

D. GARCÍA MATAMOROS

We have seen in the *Cartas censorias* of Pedro de Rhua evidences of his concern about the reputation and honor of Spain. In the wake of military victories, discoveries, and conquests in the New World there followed envy, hostility, and misunderstanding on the part of the other European states. Among these the city-states of Italy had a particular reason to feel humiliated by Spanish arms. Naples had had to tolerate Aragonese rule since almost the beginning of the fifteenth century. Rome itself, together with the spiritual head of Christendom, felt the weight of Spanish power. The most logical way to counteract this influence and to maintain their self-pride was to emphasize their superiority of culture and belittle Spanish cultural achievements. Croce's *La Spagna nella vita italiana durante la Rinascenza* devotes to this problem a whole chapter which he calls "Cultura italiana e barbarie spagnuola." There we obtain an exact picture of what people motivated by prejudice and hatred thought of each other.

The unthinking among the Spaniards saw in Italians a soft, degenerate, and mercantile race that needed rejuvenation by a transfusion of good, Spanish blood. Many of the Italians, on the other hand, considered Spaniards a mongrel race, a mixture of Gothic arrogance with Arabic subservience, their blood tainted by foreign invaders, and their language corrupted by *algaravia*. One passage, quoted in Croce from Gauberte's *Coronica de Aragon*, may be sufficient to illustrate this point:

Gli spagnuoli al solito si vantavano di avere, dopo il loro arrivo, molto insegnato agli italiani Che cosa c'insegnarono essi mai? Non certo le lettere, le armi, le leggi, l'arte marinara, la mercatura, la pittura, la scultura, l'agricoltura o altra civile disciplina; ma usure, furti, corseggi, schiavitu navale, giuochi, lenocini, amori meretrici, la professione del sicario, il cantare molle e lugubre, le pietanze arabiche, l'ipocrisia, i letti soffici e delicati, gli unguenti, i profumi, le cerimonie della mensa e altrettali vanita, degne di essi, che, come tutti i barbari, sono non meno libidinosi che crudeli.[63]

García Matamoros, following a long tradition of *laudes* and *apologías*, undertook to clear the Spanish name of the accusation of barbarism and to demonstrate that Spanish writers throughout history have always matched in the field of literature the victories won on the battlefields by generals. He compiled a list of illustrious names in the area of culture, from Roman authors of Peninsular origin to his own contemporaries. In so doing García Matamoros, an Erasmist, a learned humanist, and a burning patriot, had to face the problem of evaluating Guevara's achieve-

[63] P. 115-16.

ments. His comments on Guevara, incidentally, have not been analyzed heretofore by previous writers on the bishop. It would have been extremely embarrassing for García Matamoros to criticize the faults (of which he was apparently well aware) of an author whose works were acclaimed in Spain and enjoyed prominence all over Europe. He would have preferred to have omitted Guevara. However, after the publication of Rhua's letters, he felt obliged to include and defend him: "Decretum mihi erat, nihil de praestantissimo viro & antiquae nobilitatis Praesule Mindoniensi, qui solus aulicorum manibus proximis annis gestabatur, privato iudicio statuere: nisi me invitum & plane repugnantem libellus vulgatus a Petro Rhua Soriense, homine cum paucis erudito, in hanc censuram pertraxisset." [64]

His attitude toward Guevara is, by and large, the same as that of other humanists. His remark about the excessive popularity of the bishop's writings among the courtiers indicates that he himself does not believe Guevara deserved his reputation. Nevertheless, he does recognize the bishop's innate gift of eloquence which, he thinks, had made him a renowned orator of Spain and, on the other hand, chides him for not having been able to control the flow of words and images with the restraint of a true artist. This weakness results in thunderous discourses which in the time of Pericles might have moved the audience but today provokes only smiles: ". . . fulgurat interdum & tonat, sed non totam, ut olim Pericles Atheniensis, dicendo commovet civitatem: & dum nihil vult nisi culte & splendide dicere, saepe incidit in ea, quae derisum effugere non possunt." [65]

García Matamoros goes on to compare this "Spanish Herodotus" with the writers of novels of chivalry. By calling Guevara a Spanish Herodotus, the author denies him the merits of a genuine historian, even though he includes Guevara in the list of contemporary chroniclers. Novels of chivalry and Guevara's writings have in common, it is hinted, a basic unreality which results in poetic exaggeration, adulation, and grandiloquent speech. To illustrate the mistake of those who cannot differentiate between true history and poetic fable, he quotes Lucian's anecdote from *De componenda historia*, according to which Homer adorns Agamemnon with the head of Zeus, the breast of Poseidon, and the lower body of Ares, as if the qualities of three gods were needed to describe one king. The other anecdote from Lucian of Samosata, the one referred to before by Rhua, demonstrates the consequences which adulatory and exaggerated writing can produce. Upon hearing his

[64] *Pro adserenda Hispanorum eruditione* (Madrid, 1943), p. 216.
[65] *Ibid.*, pp. 216-18, paragraph 124.

historian's embellished account of his single combat with Porus, Alexander the Great took the manuscript and tossed it overboard saying that the author should, by rights, be treated the same way. The humanist ends paragraph 124 (among the peculiarities of the book is its division into numbered paragraphs) by making a critical remark about Feliciano de Silva whose adventurous novels similarly captured the imagination of all the idle courtiers. We shall again see this juxtaposition of Guevara and Feliciano de Silva.

Paragraph 126 summarizes García Matamoros' concept of good historical writing – lack of artifice in style and truth in narration. Lucas of Tuy, Rodrigo of Toledo, and Alfonso de Palencia managed to avoid untruth and contrivances, he continues, because they were more conscious of transmitting correct notions to posterity than of flattering the ego of contemporaries. The emphasis on writing for posterity is also found in the above-mentioned work of Lucian.[66] Thus a learned defender of Spanish letters felt obliged to take the middle ground between his colleagues, who looked askance at the manner in which Guevara handled the legacy of antiquity, and the general public who acclaimed Guevara as an outstanding writer.

E. MELCHOR CANO

The erudite bishop of the Canary Islands dedicates one chapter of his *De locis theologicis* to the problem of the credibility and the authority of historians. He never really mentions Antonio de Guevara by name, but some of his remarks have been interpreted as allusions to Guevara. Nicolás Antonio goes so far as to list Melchor Cano among those who, like Pedro de Rhua and García Matamoros, condemned the bishop of Mondoñedo for playing with history as if it were a fable of Aesop or a story by Lucian. These are the exact words of The *Bibliotheca Hispana Nova*: "... cujus rei etiam nomine doctissimus ille *theologicorum locorum* scriptor libri secundi sexto capite in Guevarae hoc, indignum eo ac dignitate ejus, sive judicium, sive quod magis credere est ingenii luxuriantis licentiam acri quod decuit oratione invehitur." [67] Pierre Bayle repeats this from Nicolás Antonio, "Un autre auteur se mit aussi sur les rangs, pour foudroyer les principes de Guevara." Before going on, a minor mistake has to be rectified. Melchor Cano deals with the subject not in the second but in the eleventh book of his *De locis theologicis*. Obviously either Nicolás Antonio or the printer misread the number.

[66] *The Works of Lucian of Samosata*, II (Oxford, 1905), p. 153.
[67] Tom. I, p. 125.

First, we would like to give an account of Melchor Cano's thoughts about this problem and then return to Nicolás Antonio. Melchor Cano does not underestimate the difficulty of trying to establish which author merits credence and to which it should be denied: "In primis enim constituendum est, qualis quantaque sit historiae humanae auctoritas, & quam faciat in Theologia fidem, quod non adeo expeditum est; deinde quis auctor probabilis ac fide dignus existimari debeat: quae res est omnium difficillima." [68] He proposes first to take the side and argue the case of those who can see no use in secular history; then he will marshall evidence to prove the value of such history to the theologian and determine which authors of history deserve credit.

In the section where Melchor Cano gathers statements and arguments which tend to downgrade the value of history, we meet with notions that Guevara employed to counter Rhua's persistent criticisms. Here are some of these arguments. The true law of history, as St. Jerome has frequently stated, consists of writing down things that the public treasures, even though they are false. The opinion of the "vulgus" is usually untrue. Historians cater to public belief, consequently historical works are worthless. Secular historians frequently contradict the data given by the Holy Scriptures. Clemens Alexandrinus and others have figured out that the seventy years of exile ended during the reign of Darius Hystaspes. The Scriptures state clearly that the banned returned to the Holy Land in the beginning of the rule of Cyrus. Consequently, no secular chronological calculations have validity. St. Jerome also claims that the repatriates began to rebuild the sanctuary in the second year of Darius; whereas it is unmistakably recorded in the first book of Ezra that Zerubabel laid the foundation of the Second Temple under Cyrus. "Imbecillum ergo est quodcunque argumentum ex historia humana depromptum, quamlibet historiae auctor gravis sit." [69]

Cano carries the argument further. Even histories accredited by the pontifical authorities have been proven false by very learned scholars. As an example he quotes the famous donation of Constantine upon which rested the popes' claim to the Papal State. As is known, Lorenzo Valla demonstrated the falseness of this document. In view of this, even ecclesiastical history can be of no use to a theologian. Who then should be relied upon? Perhaps Africanus or Eusebius? Pope Gelasius has repudiated them as apocryphal. Why should credence be afforded pagan

[68] *De locis theologicis*, p. 284. One cannot help wondering whether or not Melchor Cano added the chapter on history as an afterthought. Ten chapters in a book written by a monk sound more logical than eleven.

[69] *Ibid.*, p. 286.

histories when the seventh session of the Council of Florence decreed that no use shall be made in the synod of Roman or Greek history?

In discussing Assyrian history, Cano continues, experts refer to Berosus. We know that no document he wrote is extant, and whatever is said in his name is fiction concocted by Annius de Viterbo. Cicero, a reliable author, believes that Greeks have not shown reverence for the fidelity of the testimonies of the past. *Grecia mendax* was a popular slogan. Scipio, quoted by Livius, relegates Greek histories to the realm of fables. Josephus testifies to the same fact in the introduction to his *Bellum Judaicum*. It is superfluous to mention Herodotus or Xenophon whose authority was repudiated by the Greeks themselves. As far as Roman history is concerned, Flavius Vopiscus said very correctly that there are unverifiable statements in Livius, Sallustius, Tacitus, and Trogus. We can have no confidence in the histories of the pagans. Finally, Aristotle himself exempted human reliability from the list of intellectual virtues, since human nature inclines both toward truth and untruth and has a propensity for lying. Even if intentions are good, man makes mistakes. Theology has to rest on absolute truth and, therefore, it would seem that history cannot be of any worth to a theologian.

Voicing his own opinion, Melchor Cano demonstrates that a theologian can sometimes give credence to and sometimes even accept as certain what historians maintain. Repeating arguments of Vives who in his turn read them in the eleventh chapter of *De utilitate credendi* and the first two chapters of *De fide rerum quae non videntur* by St. Augustine, he says that life would degenerate to animal level if man would not take the word of his fellow man. Human society could not exist and all human bonds would dissolve unless wives trusted husbands; partners, associates; and citizens, other citizens. Children could not acquire the elements of knowledge if they doubted their masters' instructions. The correct way to defend truth against lies is not to throw all monuments of profane history into the fire or to pronounce every history in Julius Capitolinus' word "mythistoria," a combination of legend and actual happening, but to set up criteria and illustrate them with examples by which one can govern oneself.

The first criterion refers to the integrity of the historian. The narrator should have seen what he narrates or should have heard it from reliable eyewitnesses. It would be a sacrilege to doubt the veracity of the doctors of the Church, such as Ambrosius, Cyprianus, St. Jerome, and St. Augustine. These men merit the confidence of every reader. By the same yardstick a great deal of what the pagan Caesar, Suetonius, Tacitus, Plutarch, and Pliny recorded should be accepted for they partly saw with their

own eyes whatever they narrate and partly heard it from reliable testimony. Although they lacked Christian piety and virtue, they were imbued with the love of truth and abhorrence of lies to such an extent that, it is embarrassing for Melchor Cano to admit, some of them were more truthful than Christian historians. It is painful for him to concede that the *Lives of Philosophers* written by Laertius is much more reliable than the *Lives of Christian Saints*; similarly Suetonius exposed with far more trustworthiness the trials and tribulations of the Caesars than Catholic historians did the trials and tribulations of the martyrs, virgins, and confessors. They do not ignore the weaknesses and sinful acts of their philosophers and princes, whereas most Christian writers, he is ashamed to admit, color the actions of their heroes with fictitious virtues. These pernicious authors did a disservice to the cause of the Church. He praises the views expressed in the fifth book of *De tradendis disciplinis*: "Justissima est Ludovici querela de historiis quibusdam in ecclesia confictis. Prudenter ille sane ac graviter eos arguit, qui pietatis loco duxerint mendacia pro religione fingere. Id quod & maxime periculosum est, & minime necessarium." [70] Then he goes on to point out something that weighs heavily in the balance regarding the humanists' judgment of Guevara: "Mendaci quippe homini ne verum quidem credere solemus. Quamobrem qui falsis atque mendacibus scriptis mentes mortalium concitare ad Divorum cultum voluere, hi nihil mihi aliud videntur egisse, quam ut veris propter falsa adimatur fides, et quae severe ab auctoribus plane veracibus edita sunt, ea etiam revocentur in dubium." [71]

The concern of the humanist critics in regard to Guevara and any others who take exact truth lightly stemmed from the consideration that fabrication tends to undermine the whole edifice of truth, irrespective of whether the author had the best intentions or not. Why is it necessary in relating Christian history, he asks, to dignify falsifications and fables with the name "history" as if there were a dearth of genuine heroic deeds to report? This procedure resembles cowardly soldiers who hinder an army more than they help it. The fact is that the deeds of Christian heroes surpass their fame, and, instead of a shortage of heroes, there is an inadequacy of words that could do justice to their heroism. Vives had

[70] *Ibid.*, pp. 287-288. Melchor Cano mentions Vives frequently by his first name, Ludovicus. On the other hand, he contradicts the arguments of Guevara when he says: "Praeter auctores sacros nullus historicus certus esse potest, id est idoneus ad faciendam certam in Theologia fidem. Haec, quoniam cuique per se est obvia & manifesta, non est nostris argumentationibus comprobanda. Flavius porro Vopiscus vere falseque dixit, neminem historicorum non aliquid esse mentitum: unde fidenter se historiam aggredi, habiturum mendaciorum comites." (p. 289)

[71] *Loc. cit.*

already voiced such feelings in an important paragraph of his *De tradendis disciplinis*: "... fuere, que magnae pietatis loco ducerent, mendaciola pro religione confingere, quod et periculosum est, ne veris adimatur fides propter falsa et minime necessaria, quoniam pro pietate nostra tam multa sunt vera, ut falsa tamquam ignavi milites, atque inutiles, oneri sint magis quam auxilio." [72]

The second criterion concerns those historians who were neither eye-witnesses to events nor had an opportunity to hear a description of what happened from a reliable person who saw it. In this case one should prefer those narrators who are serious-minded and demonstrate prudence in selecting what is true and what is false. There are many who readily believe anything they fervently wish had happened. Our age has seen a priest who was convinced that anything that was printed could not be completely false. He thought that the authorities should not only allow lies to spread but should give such books their stamp of approval by granting them the right of publication. He brought himself to believe the adventures of Amadís and Clarián. On the other hand, it is similarly unjust to reject out of hand works that at some places intercalate spurious anecdotes.

The third criterion recommends that the theologian follow the authority of the Church. Here he lists many works that Pope Gelasius declared apocryphal, most of them of a religious content and not pertaining to our subject.

This is basically the summary of Melchor Cano's views on the usefulness of history. Nicolás Antonio and, following him, Pierre Bayle believed that the following reference to the unnamed priest meant our Guevara: "Nam & aetas nostra sacerdotem vidit, cui persuasissimum esset, nihil omnino esse falsum, quod semel typis fuisset excusum. Non enim, ut ajebat, tantum facinus Reipublicae administros commissuros, ut non solum divulgari mendacia sinerent, sed suo etiam communirent privilegio, quo illa tutius mentes mortalium pervagarentur. Quo sane argumento permotus animum induxit credere, ab Amadiso, & Clariano res eas vere gestas, quae in illorum libris commentitiis referuntur." [73] However, the description does not do him full justice. First of all, Guevara was not among those who, like Alonso Quijano el Bueno, believed the stories of Amadís. As a matter of fact, we had occasion to point out that he was the only one among his contemporaries who sensed that the *Historia Augusta* was an unreliable historical document. Secondly, we have not come across any statement by Guevara to the effect that any-

[72] *Op. cit.*, VI, p. 400.
[73] *Op. cit.*, p. 333.

thing set to print must be true. Thirdly, fray Antonio suggested that the *Amadís* and its like should be burned – quite a contrast to the above-mentioned priest who urged that the authorities put their stamp of approval on anything that was published. Therefore, we must conclude that although Cano did deal with matters that could be applied to Guevara's writings, he did not attack him directly.

In order to round out the record of the humanists' reactions to Guevara for the period ending in 1600, Antonio Augustín's remark should also be included, especially since he is quoted by Nicolás Antonio. He states: "Alter fuit Antonius Guevara, qui scire se antiquas Romanasque historias fingit, eaque comminiscitur quae nec visa nec audita mortalibus, nemo ut divinare queat in quos ille libros inciderit. Nova itaque nomina scriptorum excogitavit, somniaque venditat, obtruditque quae apud nullum reperias auctorem. Jure ergo ille ob hanc licentiam male audit." [74]

It is interesting to note that Juan de Valdés, the greatest authority on the Spanish language in Guevara's time, does not mention the bishop of Mondoñedo in his *Diálogo de la lengua*. One cannot help but wonder why the writings of one of the foremost stylistic artists of his day should be ignored. Perhaps Juan de Valdés was governed by the old adages that silence speaks louder than many words, or that if you cannot say something good about somebody, it is better to say nothing at all. However, it is easy to surmise that Valdés' ideal of classical style was in direct contradiction to Guevara's elaborate artistry.

We have seen that the Spanish humanists of the sixteenth century criticized Guevara's writings for varying reasons. Judging from the numerous translations of Guevara's works made during his lifetime as well as thereafter, these criticisms had little or no effect upon his acceptance by the public. Huizinga points out that while the public may have been impressed by a display of erudition, their main interest lay in being entertained, and they cared little about whether the material presented was fact or fiction:

A present-day reader who should take up the *Adagia* or the *Apophthegmata* with a view to enriching his own life [for they were meant for this purpose and it is what gave them value], would soon ask himself: "What matter to us, apart from strictly philological or historical considerations, those endless details concerning obscure personages of antique society, of Phrygians, of Thessalians? They are nothing to me." And – he will continue – they really mattered nothing to Erasmus's contemporaries either. The stupendous history of the sixteenth century was not enacted in classic phrases or turns; it was not based on classic interests or views of life. There were no Phrygians and Thessalians, no Agesilauses or Dionysiuses.

[74] *Op. cit.*, I, p. 126.

The humanists created out of all this a mental realm, emancipated from the limitations of time.[75]

With the exception of his exchange of letters with Pedro de Rhua, we have seen no indication that he corresponded with any of the other Spanish humanists. However, there is no doubt in our mind that Guevara thought of himself as a philosopher.

[75] *Erasmus and the Age of Reformation*, p. 42.

III. GUEVARA AND THE HUMORISTS

A. FRANCÉS DE ZÚÑIGA

In dealing with the *Crónica burlesca* of Charles' court jester, it is necessary on the one hand to avoid taking its barbs too seriously and, on the other, to utilize whatever information it affords in relation to what is known about the bishop from other sources. According to a footnote in the Biblioteca de Autores Españoles edition of the *Crónica burlesca* prepared by Adolfo de Castro, the original was published in 1529, a short time after the first version of the *Libro áureo* came off the press.[1]

The fact that Zúñiga makes remarks about Guevara indicates that the bishop was a familiar figure at the court. At the end of chapter XXV the author of the chronicle suggests that: "... que hiciesen maese de campo a fray Antonio de Guevara, gran parlerista, obispo de Guadix, porque nunca hablaria palabra, segun escribe Marco Aurelio, quejandose de el al villano del Danubio." *Gran parlerista,* a characterization he later repeats, may refer both to long harangues and to elaborate style. The second part of the quotation tends to confirm Guevara's claim that the episode of the *Villano del Danubio* in his book enjoyed immediate success or, at least, was well known.

In Chapter LII Francés de Zúñiga records the festivities ordered by the emperor at the time of the arrival of Cardinal de Salviate, the legate of Pope Clement VII, in Toledo. Among others, he notes, Fray Antonio de Guevara and Marcus Aurelius took part in the *juego de cañas,* and pursued the game with such wholehearted rivalry that only through the efforts of another *gran parlerista,* fray Bernaldo Gentil (apparently an Italian priest residing at the court of Charles V), were the contenders separated.[2]

More significant from our point of view is the account of the adventure at the cave of Atapuerca. A rumor circulated among members of the court about a mysterious cave near the place where once Don Sancho

[1] Biblioteca de Autores Españoles, XXXVI, p. XIII, n. 1.
[2] *Ibid.,* p. 38.

of Castile and Don García of Navarre fought their bitter battle. Strange voices and revelations were heard near the mouth of the cave which was supposed to be guarded by monsters. As in the time of the priestesses of Delphi, answers came out of the cave and statues with Greek inscriptions were seen that read: "... when alive, we were brothers of the Court of de Cabra, Moctezuma, Rodrigo de la Rhua, ..." A laborer reported it to the Count of Salinas and to Fray Juan de Salamanca. When the courtiers heard about it, they decided to investigate the matter personally taking along with them "algunas buenas personas e de buena vida." Among the latter Fray Antonio de Guevara, "gran decidor de todo lo que parecia," was also included. As they entered, the voices of the brothers of Count de Cabra were heard demanding that they disclose the purpose of their visit. Count de Salinas, gathering all his courage, answered, "We want to find out certain things and verify others of which we are not sure." A series of witty questions followed. Then Fray Antonio de Guevara, the bishop of Guadix, spoke up: "Querria saber, señora voz, si tengo de ser mejorado en algun obispado, a que fuese presto; ... e si han de creer todo lo que yo escribo." [3]

We shall have occasion to return later to the implications of the first statement. At this point, we only want to emphasize the instinctive doubt that some members of the court entertained about the information imparted in the *Libro áureo*. While in the case of Zúñiga and some other members of the Court, such as Alfonso de Valdés, this doubt probably reached the point of certainty, the problem of veracity did not prevent the majority of the courtiers from enjoying his writings, as we know from García Matamoros.

The prevalence of chronicles in Spain since the fifteenth century is a well-known fact. It is related to the consciousness of personal aggrandizement which assumed importance in the Renaissance period. Guevara was appointed imperial chronicler and received compensation for it, although he did not fulfill his commission. In his testament, by the way, he arranged for the return of this payment to the treasury. Costes suggests that his *Epístolas familiares* served in some ways as the chronicle of the times.[4] Zúñiga also deals with contemporary events in the form

[3] *Ibid.*, pp. 53-54. The visits to caves remind one of the journeys to the underworld in the great epics of antiquity. The traveler usually came back enlightened and encouraged by the spirits of his ancestors. The cave of Atapuerca seems to have acquired some of the qualities of ancient Delphi, too.

[4] "Les travaux de M. Morel-Fatio nous ont appris à quoi nous en tenir sur l'effort historiographique fourni par notre écrivain; des notes, des copies de documents, pour la plupart sans doute se rapportant à l'époque des *Comunidades*, voilà évidemment en quoi consistèrent les fameuses chroniques. Il faut ajouter à cela un petit nombre de morceaux d'apparat dans le genre du 'raisonnement' de Villa-

of a chronicle. Thus both writers availed themselves of an accepted form to record the happenings of the times and both used the medium in a comical manner.

Guevara has Marcus Aurelius write letters to diverse imaginary personages, some belonging to the highest stratum of society, some to people of lower standing. The bishop continues this practice in the *Epístolas familiares*. Guevara's apostrophizing of the addressees with humorous titles is a parody of a long-established custom. Zúñiga was inevitably drawn to compose a parody of the bishop's letters. Thus in Zúñiga we are confronted with a parody of a parody.

Zúñiga writes to the *gran Turco* in the following manner: "A nuestro muy desamado hermano el gran Turco Selim, gran sultan, gobernador de la casa de Meca, rey de la Siria y Asia la menor y Egipto, emperador de los imperios de Trapisonda, Grecia y Constantinopla; don Frances, por la divina clemencia, gran parlador y señor de los hombres de Persia y Arabia." [5] Similarly he addressed letters to Pope Clement VII [6] and to Ferdinand, king of Hungary whom he calls *mi sobrino*.[7] Guevara, in his turn, directs a letter to the Gran Capitán, Gonzalo Fernández de Córdoba,[8] another to Don Alonso Manrique, archbishop of Seville, and Don Antonio Manrique, duke of Nájera, "sobre que le eligieron juez en una porfia muy notable." [9] Guevara gives not only humorous but sometimes insulting titles to his addressees. To Mosén Rubín he writes, "Magnifico señor y viejo enamorado," [10] to Don Antonio de Acuña, "Muy reverendo señor y bullicioso perlado." [11] Of course, one has to keep in

brájima, avidement recuellis au siècle suivant par l'historien Sandoval..." *Antonio de Guevara. Sa vie*, pp. 21-22. Joseph R. Jones points to excerpts from Guevara's chronicle in the *Historia de la vida y hechos del Emperador Carlos V* of Prudencio de Sandoval and in Alonso de Santa Cruz's *Crónica del Emperador Carlos V*. "Fragments of Antonio de Guevara's Lost Chronicle," *Studies in Philology*, LXIII, 1966, pp. 30-50.

[5] *Op. cit.*, p. 44.
[6] *Ibid.*, p. 42.
[7] *Ibid.*, p. 43.
[8] *Epíst. fam.*, I, p. 91. The addressees of Guevara (with the exception of Mosén Rubín whose existence, so far as we know, is only documented in the *Epístolas familiares*) were important historical figures, all of them dead by the time Guevara published his letters in 1539. According to a consensus of the opinions of Seaver, Morel-Fatio, Costes, and María Rosa Lida these letters have no historical value at all and only serve the purpose of enhancing the part Guevara supposedly played in those crucial events. Menéndez Pidal, as we shall see in note 11, and Maravall tend to attribute some importance to them. A quick glance at the nature of these letters will convince the reader that they were, in large part, not to be taken as historical documents.
[9] *Ibid.*, I, p. 37.
[10] *Ibid.*, I, p. 286.
[11] *Ibid.*, I, p. 292. Menéndez Pidal is inclined to consider the letters and dis-

mind that basically Guevara's letters, spiced with good humor, were written with a moralistic purpose in mind, regardless of whether the addressees asked for the instruction or not. It seems that Guevara the moralist had, among other things, this in common with Zúñiga – he, too, felt a need to have his wit applauded.

B. LETTERS ATTRIBUTED TO DIEGO HURTADO DE MENDOZA

Among the humorous works of the middle of the sixteenth century is an exchange of letters published by Antonio Paz y Melia in his collection *Sales españolas*. These letters have been neither mentioned nor explored by critics who have written about Guevara. We have borrowed the title of this section from the work of Ángel González Palencia and Eugenio Mele, *Vida y obras de Don Diego Hurtado de Mendoza*.[12] In the third volume, under the heading "Obras atribuidas a Mendoza," they list "Carta del bachiller de Arcadia. Respuesta del capitan Salazar," which clearly implies that there is doubt as to their authorship. They add that it is not clear who Captain Salazar was. They themselves do not venture any opinion as to the authorship of this correspondence but note that Menéndez Pelayo accepts Hurtado de Mendoza's authorship of the first missive.[13] The *Carta* was allegedly written in 1548 and its full title is, "Carta del Bachiller de Arcadia escrita al Capitan Salazar, en loor y desprecio de un libro que hizo sobre la Rota de Albis, dirigido a la Duquesa de Alba." [14] The fame this letter enjoys is due, at least partly, to the fact that it preceded Cervantes in quoting the famous sentence of Feliciano de Silva: "¿Paréceos, amigo, que sabría yo hacer, si quisiese, un medio libro de Don Florisel de Niquea, y que sabría ir por aquel estilo de alforjas, que parece el juego de éste es el gato que mató el rato, etc., y que sabría yo decir la razón de la razón que tan sin razón por razón de ser vuestro tengo para alabar vuestro libro?" (I, p. 80). Paz y Melia's

courses regarding the *comuneros* authentic: "En cuanto a la política interna de España, es preciso desechar toda duda hipercrítica y afirmar que los discursos de Guevara en las revueltas de las Comunidades, reputados mera ficción, fueron realmente pronunciados, según testimonio de Alonso de Santa Cruz en su Crónica (I, p. 360, 368)." See Menéndez Pidal's article "Fray Antonio de Guevara y la idea imperial de Carlos V," in *Miscelánea histórico-literaria* (Colección Austral, No. 1110, Buenos Aires, 1952), p. 145.
 [12] In three volumes (Madrid, 1941). The section referred to "Obras atribuidas a Mendoza" is found in vol. III, pp. 203-224.
 [13] "Menéndez y Pelayo considera fundada la atribución de la primera a Mendoza." (*Ibid.*, p. 205).
 [14] *Sales españolas*, pp. 63-99.

introduction to *Sales españolas* (p. XXI) cites Clemencín's commentary which contends that Diego Hurtado de Mendoza had, before Cervantes, already criticized the *retórica nueva* and *estilo heroico* of Feliciano de Silva. But no mention is made in regard to the correctness of the quotation either by Clemencín or Paz y Melia. Rodríguez Marín shows that Feliciano de Silva's elaborate and puerile wordplay had antecedents in the *Comedia llamada Seraphina* (1521) and in the *Cancionero general* (I, p. 54, n. 10 in Clás. Cast. edition of *El Quijote*). W. S. Hendrix took the trouble to investigate whether or not the famous quotation actually comes from *Florisel de Niquea*. He concluded that it does not come from *Florisel De Niquea* but is part of an involved sentence from *La segunda Celestina*.[15]

The letter purports to criticize Pedro de Salazar's chronicle of the victory of Charles V over the Germans in the battle of Mühlberg (1547). We had occasion to remark previously about the framework of the letter, the tongue-in-cheek defense wherein the correspondent supposedly answers envious critics but in actuality puts his own disapproval in their mouths and fortifies the opprobrium by adding his own objections.[16] Whom and what does the author of the letter criticize? His protest is directed against elaborate language, against foreign innovations, against fancy style, and against material that does not conform to realism. In the field of language he objects mainly to the introduction of Italian words where Spanish has a good expression for it, such as using *hostería* instead of *mesón, estrada* instead of *camino, etc.*[17]

In the area of innovation, the writer strongly disapproves of the imitators of Petrarch, such as Boscán,[18] revealing an attitude characteristic of Cristóbal de Castillejo. He speaks out against the new rhetoric, the heroic style, and the elegance of Feliciano de Silva. Together with Feliciano de Silva he mentions Guevara: "Veis ahi al Obispo de Mondoñedo que hizo, que no debiera, aquel libro de *Menosprecio de corte y alabanza de aldea,* que no hay perro que llegue a creerle." [19] Sentences of Guevara, such as the following, give substance to the justice of this complaint: "Sepan los que no lo saben / que el mundo toma nuestro *querer*: y nosotros de bouos no selo *queremos* negar / y despues de apoderado en nuestro *querer* constriñenos a que *queramos* el nuestro no *querer*: por manera que muchas vezes *queriamos* hazer algunas obras virtuosas / por

[15] See "Sancho Panza and the comic types of the 16th century," in *Homenaje a Menéndez Pidal*, II, pp. 487-488.
[16] See pp. 61-62.
[17] *Sales españolas*, p. 77.
[18] *Ibid.*, p. 72.
[19] *Ibid.*, p. 80.

auernos ya dexado en manos del mundo no osamos hazerlas." [20] There is one more item in the letter which does not specifically allude to fray Antonio but includes him among others. The writer of the missive says: "En una cosa tuvo vuestra merced descuido, que como pusisteis aquellos garabatos en todas ellas y aquellas letras, no os acordásteis de poner le etimología dellos y dellas, puesto que un tudesco que hace aquí vidrieras dice que la V y la D, la M, la Y y la E quere decir verbum Domini manet in eternum. Lo demás interpretaldo vos, que sois coronista." [21] The *Epístolas familiares* abound in these kinds of interpretations, many of them proven incorrect by the expect Pedro de Rhua.

The "Respuesta del Capitán Salazar al Bachiller de Arcadia" continues in the same vein and, according to Paz y Melia, was written by the same person.[22] The correspondent joins the ranks of those who misunderstood Juan de Mena's intention to improve and refine the vulgar tongue by introducing Latinized expressions and accuses him of deliberate obscurity for the purpose of displaying his erudition.[23] After attacking Pedro Mejía by calling his *Silva de varia lección* "un paramiento viejo de remiendos y una ensalada de diversas yerbas dulces y amargas," he turns to Florián de Ocampo's *Corónica de España*, characterizing it as dry as stone or as the medicine of Doctor Luis de Lucena and full of unproven allegations.[24] He decries the translation of *Orlando furioso* by Jerónimo de Urrea (who instead of translating the meaning of the epic, only changes the Italian forms into Spanish, *amori* to *amores, cavaglieri* to *caballeros,* thus creating a sort of *español macarrónico*) and adds that by this method one could write more books than the bishop of Mondoñedo. Once more, the reply of Captain Salazar mentions Guevara among authors whom others of the same profession may envy: "... Porque ya sabe que ese es tu enemigo el que es de tu oficio, quiero decir, escritores como yo, *verbi gratia*, un Don Diego de Mendoza, un Don Luis de Avila, un obispo de Mondoñedo, un canonigo de Canaria, un Pedro de Trofe y otros semejantes que revientan de sabios . . ." [25]

[20] *Relox de príncipes*, III, fol. 164v.
[21] *Sales españolas*, p. 76.
[22] *Ibid.*, pp. XXI-XXII.
[23] *Ibid.*, p. 85.
[24] *Ibid.*, pp. 88-89.
[25] *Ibid.*, p. 92. Lucas de Torres remarks, in connection with this passage, that "... el Canónigo de Canarias ignoramos quién pueda ser, puestro que Cairasco de Figueroa, que desempeñó aquel cargo, es algo posterior á la fecha en que fué escrita la carta, á menos que supongamos que no se le nombraba en la carta original y que fué añadido su nombre en copias posteriores. ¿Y Pedro de Trofe? ¿Será Pero Tafur? Lo ignoramos también." (*Carta del Bachiller de Arcadia y Respuesta del Capitán Salazar*, ed. crítica con introducción y notas, p. 39, n. 142).

There is one more letter in the *Sales españolas* where Guevara's style is ridiculed and where again he and Feliciano de Silva are equated to a certain extent. This is the "Carta de D. Diego de Mendoza, en nombre de Marco Aurelio, á Feliciano de Silva." [26] The Introduction says that this is a "felicísima parodia del alambicado, campanudo y enrevesado estilo de ciertos libros de caballería . . ." [27] The major part of the letter contains more material that fits Feliciano de Silva's style than that which characterizes the style of Guevara. However, reference is made to a sufficient number of features and devices used in the mock epistles of the *Libro áureo* to justify the inclusion of the name of Marcus Aurelius in the title.

C. CERVANTES

Menéndez Pelayo has already noted two points of contact between Guevara and Cervantes – the reference to the courtesans, Laida, Flora, and Lamia, in the prologue to the *Quijote* and Don Quijote's speech about the golden age of mankind, pronounced in the manner of Guevara's reflections in the *Relox de príncipes*.[28] Fray Antonio freely equates the period of mankind's initial innocence and happiness in the Garden of Eden with the Romans' idea of their Golden Age. He does not give either a geographical or a chronological definition of what he means when he speaks about the "antiguos." Sometimes the expression "antiguos" refers to the ancient Greeks of the time of Lycurgus, sometimes to the inhabitants of the Rifeos mountains in India who at the age of fifty would throw themselves on a bonfire to the accompaniment of a splendid fiesta.[29] Consequently, one should not interpret classical antiquity in Guevara as one would in the work of an Italian humanist. Guevara's antiquity is simply Utopia, a catchall where everything of which he approves took place. It still exists in its pristine purity in some primitive settlements near the Danube as we see in the episode of the *Villano del Danubio*. This is another feature that makes Guevara very much a contemporary of Thomas More and other Renaissance writers.

María Rosa Lida's essay defines the relationship between the two authors.[30] We shall summarize her views and add some observations of our own to them. She explains with many examples that Cervantes

[26] Pp. 227-234.
[27] *Ibid.*, p. XXIII.
[28] I, chap. XXXI. See also Menéndez Pelayo, *Orígenes de la novela*, I, p. CCCLXII.
[29] *Libro áureo*, p. 234.
[30] *Op. cit.*, pp. 384-86.

exhibits an ambivalent attitude toward the bishop. In some of his works Cervantes closely follows previous patterns, falls into wellknown rhetorical grooves, and employs the devices of parallelism of thought, antithesis, epistrophe, exclamation, etc. However, Cervantes, the critic, "ridiculiza con implacable sagacidad la oratoria ampulosa, la esquematización demasiado simple, que se esfuerza por disimular tras la acumulación de léxico lo yermo del pensamiento." We would like to reproduce here a string of epithets from *El Quijote* (II, 68), one of the examples which María Rosa Lida cites, for it demonstrates strikingly the genius of Cervantes in exploiting the possibilities for gentle humor wherever he found them: "Caminad, trogloditas; callad, bárbaros; pagad, antropófagos; no os quejéis, scitas, ni abráis los ojos, Polifemos matadores, leones carniceros." Cervantes' keen perception and his consciousness of historical periods is another reason, María Rosa Lida adds, for reviving in some discourses a style characteristic of the Middle Ages, since the knightly figure hails from the same epoch.

As far as the discourse of Don Quijote on the Golden Age is concerned, María Rosa Lida thinks that its similarity to Guevara's *edad dorada* is limited to form. The two writers, she says, differ in contents, for the bishop exalts the happiness of man who used to live in peace from the work of his hands, whereas Cervantes refers to a wider classical tradition according to which man lived without working from the bounty of provident Nature.

In Antonio Alvarez de la Villa's edition of the *Aviso de privados*, a note is attached to the chapter "De la manera que ha de tener y de las cerimonias que ha de hacer el cortesano cuando al rey ha de hablar" comparing Don Quijote's lectures to Sancho before he took over the rule of the island of Barataria to Guevara's instructions to fledgling courtiers. Both warn against offensive breath caused by the eating of garlic, Cervantes' warning being a burlesque imitation of Guevara's. María Rosa Lida points out that while in Cervantes the second set of instructions to Sancho is a mere parody of the medieval formulae and gestures, the first part of the counsels of Don Quijote contains serious moral teachings harking back to Isocrates. In contrast, she adds, Guevara does not go beyond the superficial outward formulae inherited from such medieval works as the *Disciplina clericalis* of Pedro Alfonso, *Facetus*, and the *Siete partidas*.[31]

To the discourses on the characteristically medieval structure in which Guevara and Cervantes concur, we may add the debate of *armas y letras*

[31] *Aviso de privados*, p. 90. *El Quijote*, II, ch. XLIII. In the Clás. Cast. ed. (Madrid, 1957) see vol. VII, p. 109. See also María Rosa Lida, *op. cit.*, p. 351.

which significantly shows a different conclusion in the *Libro áureo* and *El Quijote*. Guevara, being a member of the Franciscan order and a strong advocate of peace, believes in the superiority of letters over arms whereas Don Quijote, whose main concern is the decline of the heroic spirit in his own days, favors arms over letters. On the other hand, the debate concerning the *caballero* and the *burgués* demonstrates basic agreement between the two authors. Cervantes in part maintains that Don Quijote represented an anachronism in his days, and it was necessary to introduce him as an ideal figure from the Middle Ages. Similarly, Guevara complains of his own times, times when the *caballeros* have disappeared and the *ricos villanos* have taken their place. In the *Relox de príncipes* he upbraids the degenerate sons of heroic fathers, and his harangue has a seventeenth century ring: "Si te oluidauas ati / acordaraste de tus antepassados: los quales murieron en trabajos / sole por dexar asus hijos & nietos armados caualleros: & que uengas agora tu / y la libertad que ellos ganaron derramando su sangre por los campos: la pierdas tu por cobdicia de dineros.[32]

It would go beyond the framework of this book to study the points of contact between Cervantes' and Guevara's works. However, we may note one or two instances. In the *Relox de príncipes* Guevara lists among the dangers that lurk around a high-minded man, the ignominy of combat with someone of lesser rank: ". . . mas infame es el que vence a un labrador: que no el que es vencido de vn cauallero." [33] We remember the adventure with the Yangüeses where Don Quijote allows himself to be beaten because he does not wish to condescend to fight with someone of inferior status.[34]

In the *argumento* of the *Aviso de privados* Guevara discourses on the usefulness of reading, the difference between perusing a good book and talking to a wise person, and the beneficial mercy of God in granting men the ability to select worthwhile books for reading and studying. Then he continues: "Si se debe mucho a los que leen y mas a los que estudian y mucho mas a los que algo componen, por cierto, muy mucho mas se debera a los que altas doctrinas componen, y esto se dice porque hay muchos libros asaz dignos de ser quemados y muy indignos de ser leidos." [35] Those who impart lofty doctrines find themselves on one end of the scale and are worthy of admiration and appreciation. In contrast, those who occupy themselves with *cosas de burlas* and *cosas livianas*

[32] *Relox de príncipes,* III, fol. 171v.
[33] *Ibid.,* III, fol. 181v.
[34] *El Quijote,* II, pp. 13-14.
[35] P. 44.

deserve exile from the country and their books should be burned. The list of works Guevara condemns represents just another moralistic attack on *Amadís de Gaula*, *Cárcel de amor*, *La Celestina*, *Tristán de Leonís*, and *Primaleón*, so frequent in this period.[36] In contrast, the *escrutinio* in *Quijote* is full of gentle humor and serves an esthetic rather than a moralistic purpose.

In closing this section, it might not be amiss to emphasize again that in the sixteenth century Guevara was possibly the best known Spanish writer in Europe. Statistics of editions and translations bear out this fact. Later we shall discuss the whys and wherefores of such success in some detail. While we are concentrating on those who criticized or parodied Guevara, we do not want to lose sight of the fact that such disapproval was restricted to a small minority. Pedro de Rhua's *Cartas censorias* did not diminish Guevara's popularity, and the proud humanist was soon forgotten, while many of the bishop's refurbished commonplaces enjoyed international acceptance.

[36] Bataillon refers to a list of uninterrupted hostile statements concerning the novels of chivalry to be found in Menéndez Pelayo's *Orígenes de la novela* (I, p. 260, 266ff., and 278-79), and to one in Castro's *El Pensamiento de Cervantes* (p. 26, n. 2). They include Juan de Valdés, Vives, Melchor Cano, Alejo Vanegas, Pedro Mexía, Fray Luis de Granada, *etc*. The French writer adds a few more names to this impressive array of authorities. *Op. cit.*, p. 663, n. 1.

IV. GUEVARA AN INTERNATIONAL MODEL
OF STYLE

A glance at the bibliography of Guevara compiled by Lino G. Canedo on the occasion of the fourth centennial of the bishop's death reveals the diffusion of his works all over Europe. Canedo lists an impressive total of 626 editions of Guevara's works and selections from his works.[1] Among the languages into which Guevara's writings were translated, Canedo's list includes versions in Swedish, Polish, Armenian, and Hungarian. Before Cervantes, no other Spanish author had enjoyed such immense popularity throughout Europe.

Several scholars have studied the impact of Guevara on European literature in the sixteenth and seventeenth centuries. Among others Carlos Clavería has discussed the acceptance of fray Antonio's books in Sweden, and Louis Clément has explored the effect of the works of Guevara in France.[2] However, for the present we shall concentrate our attention on the much discussed influence of the author of the *Libro áureo* in England. As is well known, an important polemic, involving some of the best known literary critics of Europe, centered around the question of whether Guevara was or was not the originator of the sixteenth century English literary current known as euphuism.[3] José María de Cossío offers a sketchy outline of this international controversy in the Introduction to his edition of the *Epístolas familiares*.[4] On the whole, he bases his conclusions on Clarence Griffin Child's *John Lyly and Euphuism* written in

[1] "Las obras de Fray Antonio de Guevara," *Archivo Ibero-Americano*, 2a época, 6 (1946), pp. 441-601.
[2] See Clavería's "Guevara en Suecia," *Revista de Filología Española*, XXVI (1942), pp. 221-248 and Clément's "Antoine de Guevara. Ses lecteurs et ses imitateurs français au XVIe siècle," *Revue d'histoire littéraire de la France*, VII (1900), pp. 590-602 and VIII (1901), pp. 214-233.
[3] Through the study of euphuism one may acquire a deeper understanding not only of the importance of Guevara as a model for writers of the sixteenth century but also new insights into the style of the bishop.
[4] I, pp. XVII-XXIII.

1894. Other valuable analyses have been published since that time and the last word has, perhaps, not yet been said on this subject.

The expression "euphuism" derives from the title of a novel published by John Lyly in 1578, *Euphues. The Anatomy of Wyt*.[5] The work was an immediate success. New editions appeared in rapid succession. The plot, slow-moving as it is, represented a welcome change from the usual adventures of wandering knights. Under the anachronistic disguise of Naples and Athens the public easily detected references to London and Oxford, contemporary society, and university life. (In addition, its stylistic architecture brought to fruition certain principles of writing which have been called "Euphuistic" ever since that time.)

The term "euphuism" refers both to a certain manner of writing and to illustrative matter or material. Lyly achieves his desired results by the following means:

1. Antithesis. As we have seen in Guevara's case, this method can be made very elaborate by balancing parts of speech – substantive to substantive, verb to verb, adjective to adjective. The same artistic balance is often extended to sentences and thought sequences. In addition, we sometimes meet a whole series of rhetorical questions and answers or a series of arguments that take place inside the consciousness of a person, introduced by "Ay, but." This resembles in a sense (in spite of its rhetorical artificiality), the modern technique of stream of consciousness.

2. Repetition. R. Warwick Bond classifies under this title the various forms of sound-likeness, such as alliteration (not frequent in Guevara), consonance and assonance, puns and play on words.[6]

3. Classical references. Talking about friendship, Euphues alludes to Damon and Pythias, Orestes and Pylades, Titus and Gysippus, Theseus and Pyrothus, Scipio and Laelius. When discoursing upon the irrational nature of love, Lucilla cites the examples of Mirha who fell in love with her father, Biblis with her brother, Phaedra with her son-in-law.[7]

4. Examples from natural history. Child is quick to point out that these seemingly recondite illustrations were commonplaces of the time and his allusions to "unnatural natural history" must not be considered original contributions.[8] It has been commonly accepted by most investigators that the only purpose of borrowing examples from the physical universe was to point up a moral or illustrate an idea with an example.

[5] For our study we are utilizing R. Warwick Bond's two-volume edition (Oxford, 1902) which has an introductory essay "Euphues and Euphuism," pp. 119-175.

[6] *Ibid.*, I, pp. 122-125.

[7] *Ibid.*, I, p. 231.

[8] Clarence Griffin Child, *John Lyly and Euphuism* (Erlangen & Leipzig, 1894), pp. 50-51.

5. Constant recourse to proverbs, apophthegms, maxims, and pithy sayings. They are drawn, Bond comments, from ancient authors, from current collections such as the *Adagia* of Erasmus or John Heywood's *Proverbs and Epigrams,* or culled from the popular sayings of the day.[9]

This brief characterization may suffice to correct a popular mistaken belief that throws euphuism together with Marinism, *préciosité,* and Gongorism, and considers all of them as some kind of aberration. All those movements strove for a more precise, artistic technique and a refinement of style. But we must rid ourselves of the idea that they represented only empty artificiality, personal extravagance, or vain display of erudition. While following the tortuous path of the controversy regarding euphuism, we shall become aware of how much Lyly, Guevara, and their followers have contributed to clearness of language, precision, and force of expression. Says Bond, "Lyly grasped the fact that in prose no less than in poetry, the reader demanded to be led onward by a succession of half imperceptible shocks of pleasure in the beauty and vigour of diction, or in the ingenuity of phrasing, in sentence after sentence – pleasure inseparable from that caused by a perception of the nice adaptation of words to thought, pleasure quite other than that derivable from the acquisition of fresh knowledge." [10] It is a judgment which could apply at least in part to Guevara.

A. THE LANDMANN THEORY

In 1881, when source studies were in their heyday, a German dissertation was published which attempted to trace the origin of euphuism. The writer, Friedrich Landmann, examined the development of English prose in the sixteenth century.[11] When he reached Lyly's works, he noticed quite accurately that they surpassed the usual contemporary efforts to produce an elaborate style. To use his own words: "Das, was den Euphuismus charakterisiert, besteht in einer syntaktischen Eigentümlichkeit, welche ihn deutlich in seinen Hauptelementen von anderen verwandten herrschenden Geschmacklosigkeiten unterscheidet." [12] Landmann, as we see, takes a completely negative attitude toward euphuism and everything connected with it. In other words, when he looks for the author who was responsible for transplanting artificial style to England

[9] *Op. cit.,* I, p. 134.
[10] *Ibid.,* pp. 145-146.
[11] *Der Euphuismus, sein Wesen, seine Quelle, seine Geschichte. Beitrag zur Geschichte der englischen Literatur des sechszehnten Jahrhunderts* (Giessen, 1881).
[12] *Ibid.,* p. 60.

and triumphantly finds him in Guevara, he does no honor to Spanish literature; he merely follows in the tradition of Tomitano (whom we mentioned above), Tiraboschi, Muratori, and so many others who considered Spanish writers as having a penchant for artificiality, pomposity, and affectation.[13] Landmann exempts Italian literature from a similar charge, in contradiction to John Morley who, representing generally accepted opinion, maintained that the source of artificial prose lay in the excesses of the late Renaissance.[14]

Landmann neatly separates euphuism from the rest of contemporary prose. For him euphuism is identical with what he calls "Guevarism." So far as Italian influence is concerned, he believes, it is limited to Boccaccio and his followers and to Guicciardini's Italian history, all of which were written in pure style and could not possibly have corrupted English prose. Painter's *Palace of Pleasure*, a collection of short stories one of which served as a source for Shakespeare's *Romeo and Juliet*, is free from euphuistic elements, he says. On the other hand, George Pettie's *Petite Pallace of Pleasure* imitates Guevara's style completely and – adds Landmann – would be considered a work of Lyly's were it not for the fact that its authorship is beyond doubt.[15]

Before turning to Lyly's *Euphues*, Landmann mentions Sir Thomas Elyot (another writer who supposedly came under Guevara's influence and supposedly tried to improve the English tongue by bringing it closer to the Greek language) known primarily as the author of *The Boke of the Governour*. However, it was not *The Boke of the Governour*, but another of Elyot's works, *The image of governance compiled of the actes and sentences notable of the noble Emperour Alexander Severus late translated out of Greke into Englyshe* which was (according to Landmann) an imitation of the *Libro áureo*. Just as Guevara presents the life story of Marcus Aurelius as an ideal to be followed, Elyot sets up Alexander Severus as a paragon to be imitated. Elyot, like Guevara, alleges that he had found the manuscript in Naples. The document was written originally in the Greek tongue by Eucolpius, the secretary of the wise and austere Emperor, and contains the acts and maxims of the ruler. A nobleman from Naples supposedly loaned him the valuable manuscript. These similarities convinced Landmann that Elyot, in reproducing the rhetorical figures of Isocrates with all their accompanying elements, was

[13] For Tomitano see p. 68-69. For a detailed bibliography concerning the Tiraboschi, Bettinelli, and Llampillas debate, see Pedro Sáinz y Rodríguez' *Las Polémicas sobre la cultura española* (Madrid, 1919), pp. 30-31.

[14] "On Euphuism," *Quarterly Review*, CIX (1861), pp. 350-383.

[15] *Op. cit.*, p. 74.

simply fired by the desire to elevate the English language to the level of the outstanding writers of antiquity: "Wir haben also schon im Anfang des sechszehnten Jahrhunderts das ausgesprochene Bestreben, die ausgebildete Rhetorik der Alten in die englische Sprache aufzunehmen und hierdurch die 'vulgar tongue,' wie Elyot seine Muttersprache nennt, zu erheben." [16]

Nevertheless, he contends, a more immediate source of euphuism was John Bourchier, Lord Berners, who translated the *Libro áureo*, as *The Golden Boke of Marcus Aurelius Emperour and Eloquent Oratour*. Bourchier in translating did not use the original Spanish text but the French version of René Bertaut de la Grise (1521). This transplantation of the *Libro áureo* found a warm reception, especially among the courtiers of Queen Elizabeth, primarily because of its style. Prior to the publication of *Euphues* (1578) Guevara's works kept six translators busy, and Bourchier's translation alone was published thirteen times within a short period.

Court enthusiasm for rhetorical style in English prose was heightened by Thomas North's translation of the *Relox de príncipes* into English. This rendition succeeded in transplanting "Guevarism" into English in its totality – "Diese zweite Nachahmung des Guevarismus wirkte viel nachhaltiger, als die erste, weil North den Stil Guevaras genau ins Englische übertrug." [17] Once he found the culprit, Landmann went on to marshal proof in order to convict him. These words may seem strong, but it is necessary to stress the attitude of Landmann. [18] Landmann's views are somewhat better organized in a paper which he read at the meeting of the New Shakspere Society in 1882 and therefore should be included along with his dissertation. This paper was published in the Transactions of the New Shakspere Society under the title "Shakspere and Euphuism. *Euphues* an Adaptation from Guevara." [19] Let us now summarize these more decisive arguments.

The most frequent peculiarity of the bishop's style, as we have seen, is the balance of sentences by parallelism or antithesis with parison. The correspondence of clauses and of the words within the clause becomes even more pointed with consonance or rhyme. Landmann affirms that,

[16] *Ibid.*, pp. 64-65.
[17] *Ibid.*, p. 69.
[18] See his "John Lyly, Guevara y el 'Euphuismo' en Inglaterra," in *Ensayos y discursos de crítica literaria hispano-europea*, II, pp. 427-429. Farinelli blames Italian writers of the late Renaissance for the corruption of good taste. He stands alone in recognizing the uncomplimentary implications of Landmann's designation of Guevara as the source of euphuism.
[19] Series I, part 2 (1880-85), pp. 241-276.

"Dieser pointierte Antithesenstil wurde im Englischen vor dem Euphues am genauesten von North nachgeahmt" and offers a comparison of a quotation from the *Relox de príncipes* and its translation in the *Diall of Princes*.[20]

The second characteristic of Guevara, the analogies from nature and the animal kingdom, is found in *Euphues* to a heightened degree, Landmann points out. However, we may note that Lyly uses Pliny's fabulous natural philosophy, whereas Guevara limits himself to the observable qualities of the animal and mineral world. Interestingly enough in neither of the two references taken from Guevara does Landmann notice that the comparisons lead up to a humorous climax and that analogies from the animal world are only a means to an end: "Mucho digo, pero creeme que mas siento. Ninguno se quexe de los Dioses porque le dieron muger fea entre sus hados. La plata blanca no se labra sino en pez muy negra. El arbol muy tierno no se conserva sino con la corteza muy aspera. Quiero dezir: que el hombre teniendo la muger fea / tiene la Fama segura." [21] The second passage is from the *Relox de príncipes,* as was the first, but here Landmann quotes from North's translation of it: "Accordying to the dyversity of beasts, so nature hath in divers parts of the body placed their strength: as the Eagle in her byl, ye Unicorne in the horne, the serpent in the taile, the bul in the head, the beare in his pawes, the horse in the breast, the dogge in the teath, the bore in the tuske, the doves in the winges, and the women in their tongues." [22]

The third principal feature of euphuism, constant references to ancient history and Greek and Roman mythology, may be excused in Guevara's book, since his hero was a Roman Emperor. However, in Lyly's works the classical references sound more out of place.

In addition to attempting to demonstrate the stylistic identity of Guevara, North, and Lyly, Landmann offers specific coincidences which help support his arguments. The subject matter of *Euphues* corresponds to that of the *Diall of Princes* in many respects. Both contain dissertations on the same topics. *Euphues* has letters affixed at the end, and so does the *Libro áureo*. These letters generally deal with the same matters. In both the same figures occur, and some of these persons bear identical names. The plots are unimportant in both; they only serve as frameworks for long moral treatises, soliloquies, and dialogues on love, woman, God, friendship, education, court, and countryside.

The heroine of *Euphues* is called Lucilla. She is a capricious and im-

[20] *Der Euphuismus,* p. 71.
[21] *Ibid.,* p. 72. The passage is from the *Relox de príncipes,* III, fol. 221r.
[22] *Shakspere and Euphuism,* p. 254.

mature person. So also is the other Lucilla, the daughter of Marcus Aurelius. The fathers of both deliver wordy warnings on the proper behavior of young ladies (although Guevara's surrogate is addressing himself both to Faustina and Lucilla).[23] The chapters (I, 4 and 9-12) dedicated to the Christian religion in the *Diall of Princes* prompted Lyly, according to Landmann, to introduce the dialogue between Euphues and Atheos where Euphues proves conclusively the existence of God.[24] Marcus Aurelius writes a letter to a disorderly nephew, Epesipo, who is rumored to have left his studies and to be leading a life of pleasure; Euphues similarly sends a missive to Alcius, a young man in Naples, who became a discredit to the university.[25]

Chapters 32-40 in the second book of the *Diall of Princes* deal with education; so does Lyly devote a bookish treatise ("Euphues and his Ephoebus," I, pp. 260-288) to the same problem. Two letters to Domicio (III, ch. 34) and Torquato (III, ch. 41) comfort them in exile which remind one of the epistle of Euphues to Botonio to take his exile patiently (p. 313). At the end of the *Diall of Princes* there is a letter addressed to the *enamoradas* of Rome, containing an invective against the frivolity of women. Marcus Aurelius is careful to exempt the respectable ladies of the capital from his rebuke; Lyly also includes a misogynist section called "A cooling Carde for Philautus and all fond louers" (pp. 246-257) at the end of which he attaches an apology "To the graue Matrones and honest Maydens of Italy" (pp. 257-259). Marcus Aurelius writes again separately to three *enamoradas*, Macrina, Bohemia, and Livia, and receives answers from them. Lyly also has Liuia write a letter to her friend Euphues from the Emperor's court and Euphues answers this letter (pp. 319-323). Since Lyly had not previously mentioned an emperor, Landmann believes that he is copying the Emperor of Guevara. This careless introduction of an emperor and other details which are appropriate in Guevara's work but represent anachronisms in that of Lyly, fortify Landmann's conviction that Lyly adapted the *Diall of Princes* to his own time, while he admits at the same time that it was not the exclusive source for *Euphues*.

From another work of Guevara, *Aviso de privados*, North formed the fourth book of the *Diall of Princes* (the *Relox de príncipes* consists

[23] *The Diall of Princes*, III, chap. LXII. For Ferardo's plea to Lucilla see *Euphues*, I, pp. 243-44. Some of the ideas expressed by Guevara and Lyly seem to echo the outcry of Pleberio against the dangers of love in the last act of *La Celestina*.
[24] "Shakspere and Euphuism," p. 256. Bond, on the other hand, believes that this section owes nothing at all to Guevara. *Op. cit.*, I, p. 155.
[25] *Diall of Princes*, I, chap. XLII; *Euphues*, I, p. 315.

of only three books). Apparently this treatise, together with the *Menosprecio de corte* (translated into English by Sir Francis Bryan in 1548 with the title *A Dispraise of the life of a Courtier and a commendation of the life of the labouryng man*) caused Lyly to introduce the courtier Fidus, who tells of his love and explains why he left the life at the court and chose the countryside. To sum up, the German scholar says: "Es liessen sich ausser den angeführten Stellen noch eine ganze Anzahl anderer zusammenstellen, doch glaube ich, die vorliegenden zeigen uns zur Genüge, dass Lyly zur Abfassung des Euphues durch die Übersetzung von North nicht allein angeregt wurde und dieselbe in der ganzen Anlage seines Romans nachahmt; sondern dass er auch den Inhalt des Marc Aurel benutzte, indem er entweder dieselben Ideen verwandte, welche Guevara schon ausgesprochen hatte, oder sie in ähnlicher Form verarbeitete." [26]

Landman concludes his paper, "Shakspere and Euphuism. *Euphues* an Adaptation from Guevara," by calling attention to the fact that euphuism was displaced by another eccentric fad of affectation, Sidney's shepherd romance. This tedious and sentimental style, Landmann maintains, also came partly as an adaptation of Montemayor's *Diana* and partly from Sannazaro's *Arcadia*. This was followed by an imitation of Gongorism, also borrowed from Spain, of course, according to Landmann.[27] These, then, are the salient features of the Landmann theory. Its originality necessarily commanded the scrutiny of the experts in the field, and around it there developed an international polemic.

B. REACTIONS TO LANDMANN'S THEORY

As one might expect, the reactions to the Landmann theory varied. Mrs. Humphrey Ward who wrote the article "Lyly and Euphuism" for the then new ninth edition of the Encyclopedia Britannica seems to have accepted without modification Landmann's explanation for the adoption of euphuistic style by English writers. She does not question the validity of any part of it; indeed, she is happy to publicize the valuable discovery in the circles of the reading public. Sir Sidney Lee, and famed Shakes-

[26] *Der Euphuismus*, p. 81.
[27] "Shakspere and Euphuism," pp. 260-264. Landmann promises to trace the effects of Gongoristic style in English literature. He calls attention to a satire which appeared under three different names: *Don Zara del Fogo the Spaniarde* (1656), *Wit and Fancy in a Mace* (1657), and *Romancio-Mastrix* or a *Romance on Romances* (1660). He names the author of the first version, obviously a pseudonym, B. Musophilus. The third version was supposed to be written by a Samuel Holland.

pearian scholar, wrote a letter to *The Athenaeum* in 1883 in which he corrects what he calls "minor inaccuracies" in her account. In spite of the correspondent's modesty, this letter contains several major points.

Sir Sidney Lee also accepts Landmann's basic proposition – euphuism is a transplantation of Guevara's style into England. Lyly learned the technique from the translations of the *Libro áureo* by Lord Berners (1534) and the *Relox de príncipes* by Sir Thomas North (1557, according to Lee). He feels that neither Landmann nor Mrs. Ward accords due recognition to Lord Berners' translation. Sir Sidney Lee maintains that the two translations are identical in style and almost identical in subject matter, and differ only in one respect – Lord Berners' translation is based on the first version of Guevara's book, the *Libro áureo,* whereas North rendered into English the enlarged version, the *Relox de príncipes.* In view of the dates of translation, Lord Berners deserves to be regarded as the originator of euphuism more than does North. To prove his contention, he collates Lord Berners' and Sir Thomas North's translations of a passage from Guevara that deals with the destructive and the healing power of time and finds that they both contain the salient features of euphuistic style.[28]

Lord Berners' adaptation was so popular that nine editions of it were published between the years 1534 and 1560, and five more between 1560 and 1588. Consequently, it is inaccurate to limit the development of euphuistic style in England to the years 1560-1590; an earlier date should be assigned to its introduction into England. And to fortify his point, Sir Sidney Lee mentions something that he came across while editing the same Lord Berners' translation of Froissart's *Huon de Bordeaux.*[29] He found that: "The translator's prologue to Lord Berners' *Froissart,* written in 1524, and that to be found in other of his works, show him to have come under Guevara's or a similar influence before he translated the *Golden Boke.* In the following abbreviated extracts from the prologue to *Froissart* the parallelism of the sentences, the repetition of the same thought differently expressed, the rhetorical question, the accumulation of synonyms, the classical references are irrefutable witnesses to the presence of well-developed Euphuism." [30] The passage of Berners extols the advantages of history. Sir Sidney Lee himself failed to pursue the

[28] "Euphuism," issue of July 14, 1883, pp. 49-50.

[29] *The Boke of Duke Huon of Burdeux,* done into English by Sir John Bourchier, Lord Berners, and printed by Wynkyn de Worde about 1534 A.D. Early English Text Society, extra series (London, 1881-87).

[30] *Op. cit.,* p. 49. Sir Sidney Lee repeats the thoughts expressed in his letter to *The Athenaeum* in Appendix I, pp. 785-788, of his edition of the above-mentioned translation of *Huon de Bordeaux* by Lord Berners.

implications of his statement but other scholars did, the most important among them being John Dover Wilson.[31]

Wilson is much more cautious in his approach than is Landmann. He agrees with Landmann on one basic point – the style of *Euphues* was Lyly's invention. As to its origin, he believes that only a tentative solution is possible. He feels that critics have fallen victim to the allurements of a theory which would attribute to Spaniards all the diseases afflicting the prose of the Elizabethan period. In addition to Lyly, Sidney was supposed to have imitated the style of Montemayor in writing his *Arcadia* and Nash in his *The unfortunate traveller or The life of Jack Wilton* transplanted the picaresque novel as initiated by *Lazarillo de Tormes*.

One of the arguments that militate against the almost mathematical equation of Landmann is the fact that the translators used French intermediaries instead of working from the Spanish original. The other and more important obstacle is the statement of Sidney Lee to the effect that Lord Berners was writing in full-blown euphuistic style in 1524. Before drawing any definite conclusions from the date, Wilson points out, one must keep in mind that Guevara, according to the prologue to the *Libro áureo*, was supposed to have begun his arduous work of translating the Greek and Latin manuscripts in 1518, almost a decade before both the surreptitious and authorized versions had been published. As a result, Wilson says, someone might have come under Guevara's influence before 1524, the crucial date when Lord Berners already manifested euphuistic style in the prologue to the translation of *Huon de Bordeaux*. This would not be impossible at all, except for the fact that Berners, according to all appearances, could not read Spanish and had to use René Bertaut's French translation.[32] In view of this, continues Wilson, one would have to accept four improbabilities in order to agree with Landmann's theory: 1. That an unauthorized edition of the *Libro áureo* had existed earlier than 1524; 2. that this had been translated into French before 1524 by Bertaut or by someone else whose existence is unknown; 3. that Lord Berners somehow got hold of this hypothetical French translation; and 4. that the French translation reproduced the style of the original so faithfully that Berners was able to learn from it the basic elements of "Guevarism" and apply them in his prologue to *Huon de Bordeaux*.

Taking into account these difficulties, he considers Landmann's theory

[31] See his *John Lyly* (Cambridge, 1905).
[32] See John Garrett Underhill, *Spanish Literature in the England of the Tudors* (New York, 1899), p. 69. Underhill maintains that Lord Berners translated the *Libro áureo* from the French version and not from the original Spanish.

untenable and suggests an approach to the problem from the English side. This is more logical to begin with – he feels – for it is obvious that no foreign literary influence can find acceptance in a country unless there is a favorable climate already in existence. He finds rudimentary euphuism – balanced clauses with alliteration – in Latimer's prose.[33] Latimer also employs the question and answer method, so characteristic of Lyly's writings where a rhetorical question is followed by "ay, but. . . ." Antithesis and parallelism appear in the prose of Sir John Cheke and his pupil Roger Ascham. Wilson quotes Cheke's criticism of Sallust's style as being "more art than nature and more labour than art" – an excellent example of what was later called euphuism. *The Schoolmaster* of Ascham shows transverse alliteration, classical allusions, and occasionally examples from natural history.

Up to this point, Wilson was actually proving the existence of euphuistic tendencies before Lyly, for the characteristic features of that style appear only occasionally and some – specifically references to mythical beasts and flowers – never. However, in George Pettie's *Petite Pallace of Pleasure,* published in 1576 two years before *Euphues,* we can find every element of euphuism. Wilson emphasizes that Pettie was a member of the same Oxford circle that produced Lyly. "No one, reading the *Petite Pallace,*" says Wilson, "can doubt that Pettie was the real creator of euphuism in its fullest development, and that Lyly was only an imitator." [34] In conclusion we might say that Wilson convinced himself that euphuism cannot be ascribed entirely to the influence of Guevara, as Landmann claimed. Fray Antonio was among the first ones who developed the style, but Lord Berners was feeling his way in that direction when he translated Froissart's *Huon de Bordeaux,* years before he had read Guevara. In addition, one should not forget that Lord Berners did not translate directly from the Spanish, Wilson points out, and, therefore, whatever influence the bishop of Mondoñedo had on his prose was weakened as it worked its way through the French. Even admitting the Spanish influence at the court and at Oxford, Landmann's theory can only be accepted in a very modified form. On the other hand it cannot be denied that Lyly owed a great debt to the Spanish author. The true answer, according to Wilson, lies in a combination of native and foreign influences. Guevara merely hastened a process that was already at work.[35]

[33] Wilson asserts that alliteration is not present in Guevara's work – it is a native product (*Op. cit.,* p. 37). It seems to us that this is too radical an assertion. Admittedly it is not employed frequently by the bishop but it is not absent.
[34] *Ibid.,* p. 40.
[35] *Ibid.,* pp. 42-43.

C. THE ITALIAN THEORY

Before Landmann's theory came to light, literary critics tended to attribute the artificiality of the euphuistic prose to Italian antecedents. It is important to explore this possibility since it involves Guevara quite significantly. Did not the bishop find the alleged manuscript he translated in the library of the Medicis in Florence? This claim has more than a symbolic significance. Among his near-contemporaries Guevara does not mention any French or German writers, but he does quote Boccaccio's *De genealogia deorum* for his treatise on pagan gods as well as Flavio Blondo's (Biondo) *Roma triumphante*.[36]

The first critic to direct attention to Italian influences was John Morley in a review of a new edition of Lyly's plays.[37] This edition was unexpected for both Lyly's dramatic works and his *Euphues* were completely forgotten after a spurt of success that lasted about fifty years. After that, only a stray literary historian would take the trouble to read his writings; the general public was satisfied with the label that Lyly vitiated taste and corrupted language by introducing an affected and artificial mode of conversation.

Morley's purpose was to exonerate Lyly from such accusation and to show that the Elizabethan author should not be held responsible for perverting literary taste. Instead of having established a new cult, the critic claims that he only followed the taste of the day, and *Euphues* became popular not because it set a fashion but because it followed the vogue. Morley considers the habits of the court and Queen Elizabeth's skill in coining choice phrases as the main factors that encouraged euphuism. As far as literary influence is concerned, it is to be sought in the conceits of Petrarch and the philosophy of Neo-Platonism. The printing houses of Venice, Florence, and Rome poured out dozens of commentaries on the works of Petrarch. His words were studied for the purpose of finding allegories and fanciful interpretations – thus making Petrarch unwittingly a source of highflown style. Neo-Platonism also came from the Italian city-states to England. In the cultural centers of the city-states Neo-Platonism was embroidered by the principles of occult philosophy and confirmed by the wondrous accounts found in the *Natural History* of Pliny. In an age of miraculous discoveries why should

[36] *De genealogia deorum* is quoted at least four times in the *Relox de príncipes*, I, fol. 13v; II, fol. 73v; II, fol. 103v; and II, fol. 123v. Flavio Biondo's *Roma triumphante* is cited on fol. 106r of the second book of the *Relox*.

[37] See n. 14, p. 153. The edition being reviewed was *The Dramatic Works of John Lilly (the Euphuist): with Notes, and some Account of his Life and Writings.* By F. W. Fairholt, F. S. A. in 2 vols. 1858.

one deny the alleged virtues of stars, certain stones, and animals forming part of the all-embracing marvel of creation? For Morley, these currents of thought and the fact that Englishmen traveled extensively in the city-states provided enough proof that the blame for euphuism is to be sought there rather than in Spain. As we see, his explanation of the importance of Neo-Platonism in the development of euphuism is rather sketchy and one-sided.

Alfred Mézières was also among the early critics who sought in Italy the fountainhead of euphuism.[38] He voices his conviction in stronger terms than did Morley. As a playwright, Lyly created a school. In his style, Lyly was more Italian than English, and the secret of his success was based on the fact that in the sixteenth century England eagerly accepted any Italian import. He also points to Petrarchism and Neo-Platonism as important currents of thought but adds that Lyly mistakenly turned to Bembo as a model and not to Petrarch. Cardinal Bembo, as is generally recognized, attached too much importance to form and polish at the expense of forceful thought. This bourgeois from London, Mézières explains, with serious and religious bent, this family man worried about the education of his children, was awestruck by the latest productions of Italian literature. He did not recognize that instead of being genuine masterpieces, these were the unmistakable signs of the decadence following the flowering of the Renaissance. However, Mézières emphasizes that Lyly was not alone in this misunderstanding. He only gave his name to a corruption of taste that was already an accomplished fact.

Mézières agrees with Morley that the pretentious and affected style corresponded exactly to the taste of that period. People frequently exaggerate, he thinks, the impact of a writer on his generation; sometimes it is just the other way, the writer merely mirrors the taste of the time. A substantiation of this statement may be seen in the preface to *Euphues* where Lyly himself complains that "It is a world to see how English men desire to heare finer speach than the language will allow, to eate finer bread than is made of Wheat, to weare finer cloth then is wrought of Woll."

Mézières proposes an immediate reason for the preference for mythological allusions and Neo-Platonic thought. Lyly wrote for Queen Elizabeth and her court. The Queen was portrayed not only as a powerful and victorious monarch but also as a model of beauty and chastity. When love was mentioned in connection with the Queen, it had to be the pure and poetic adoration that does not go beyond the limits of hope and

[38] *Prédécesseurs et contemporains de Shakspeare* (Paris, 1863), pp. 59-70.

aspiration, the kind of love that Provençal troubadours avowed to their ladies beyond reach. This atmosphere offered a fertile breeding ground for affected style, for references to Venus, Diana, and other goddesses, and for delicate phrasing.

Arturo Farinelli also emphasizes Italian influences in his review of Child's *John Lyly and Euphuism*.[39] Farinelli protests against the idea that Spain contaminated England with sonorous and empty rhetoric, daring and false metaphors, and other characteristics of an artificial style. He seeks the sources of all literary movements of that period, salutary or unwholesome, in the Italian Renaissance. He cannot accept the proposition that one writer, and a stranger at that, should have been able to corrupt traditional English taste with almost magical influence. He, like Morley, looks to the lyric poetry of Italy for the source of the elaborate and mellifluous style of Lyly. Lyly only gave his name, Farinelli continues, to a literary extravagance already full-blown in George Pettie. Pettie, on the other hand, could have taken the story of Sinorix either from Plutarch (where Guevara read it) or from *Il Cortegiano* of Castiglione. This would exclude the role of Guevara entirely from the dissemination of euphuism in England.

We find the most complete treatment of the theory of Italian origins in Violet M. Jeffery's doctoral thesis, *John Lyly and the Italian Renaissance*.[40] The thin plot of *Euphues*, it is pointed out, centers around four social gatherings where convivial dinners were held and questions debated. The conversation revolved around topics connected with love; for example, whether the qualities of the mind or the appearance of the man appeal most to women (I, p. 201), or whether man or woman is more constant in love (I, p. 203).[41] There is very little external action in the novel; discourses and deliberations play a primary role. Miss Jeffery asks herself: Where do we find examples of this type of setting? The most obvious counterparts of such a combination of social etiquette and serious discussion come from Italy. The best known treatise in a rudimentary novelistic framework is Castiglione's *Il Cortegiano*. The background is the court of Urbino where a group of courtiers and ladies gather every evening after dinner and discuss the requirements of an ideal courtier, his education, and his attainments. The book ends with

[39] See n.. 18, p. 66.

[40] The dissertation was written for the University of London and was later published as No. 53 in the Bibliothèque de la Revue de Littérature Comparée series (Paris, 1928).

[41] The four social events were the supper party at the home of Don Ferardo, the after-dinner conversation with Fidus, the stay of the protagonists in Naples (which stands for London), and Lady Flavia's dinner gathering.

Cardinal Bembo's oration in praise of the Neo-Platonic doctrine of love. *Il Cortegiano* was translated into English by Sir Thomas Hoby in 1561.[42]

Another prototype, almost as famous as *Il Cortegiano,* was Pietro Bembo's *Gli Asolani* (1505). Here we see essentially a treatise on love, again with an insignificant plot and a weak attempt at characterization. The setting and the subject of the discussion, love as understood by Neo-Platonic philosophy, claim the attention of the readers. The setting in this case is the court of Caterina Cornaro, ex-queen of Cyprus in the castle of Asolo. There three young men and three young women debate the advantages and disadvantages of love. The young men argue volubly to settle the disputes about love like knights armed with words instead of weapons.

The third example given by the author of the dissertation is the "questioni d'amore" episode in Boccaccio's *Filocolo.* Here the analogy with *Euphues* is even more striking. Filocolo and his companions arrive in Partenope (Naples) after a sea voyage. Wandering in the lovely surroundings of Naples, they happen upon a joyous company of young men and women in a garden. They are invited to join a garden party where problems of love are being discussed. So does Euphues arrive in Naples, after having left his native Athens, and he, too, is invited to participate in a supper party. In addition to the setting, the very topics discussed in *Euphues* were taken from the storehouse of commonplaces of Renaissance Italy: Is beauty or wit more desirable in a woman? Whom would one choose for a wife, "the fair fool, the witty wanton, or the crooked saint?" [43]

These examples point to the fact that it was important for an Italian courtier to be able to converse wittily and elegantly. The central problem of *Euphues,* the preeminence of wit or wisdom, also concerns the art of conversing. These conversations also take place in a conventional setting, in a shady garden or a cool hall. While Miss Jeffery admits Bond's contention that "parallelism is not derivation," she feels that the coincidences between the Italian prototypes and *Euphues* are too numerous not to consider the possibility of direct imitation.[44]

As was mentioned before, the topics debated deal with the essence,

[42] See Francis Otto Matthiessen, *Translation, an Elizabethan Art* (Cambridge, Mass., 1931), pp. 3-53.

[43] *Filocolo* was available in English translation by the year 1566. See Edward Hutton, ed., *Thirteene Most Pleasaunt and Delectable Questions,* written in Italian by Iohn Bocace, Englished 1566 by H. G. (Henry Grantham or Humphrey Gifford), Introduction, p. XVII. Introduction was written by the editor. (London, 1927).

[44] *Op. cit.,* p. 28.

nature, and definition of love. While Cardinal Bembo transports his audience to Platonic heights with his apotheosis of spiritual beauty and divine love, Euphues and Philautus also debate the traditional question whether the lover should be contented with contemplating the beauty of his lady and conversing with her, or whether it is a requisite of true love to desire closer intimacy. Philautus, representing Lyly, votes for a combination of spiritual and physical union ("the end of love is wedding, not wooing"). Euphues clings to the traditional Neo-Platonic view that man should not seek sensual pleasures but be satisfied with the beauty, nearness, and conversation of his lady. In making Philautus his spokesman, Miss Jeffery observes, Lyly points up an essential difference between the Italian and the English points of view. Italians – she believes – can contemplate love from an intellectual height and sincerely believe in a lofty theory, regardless of whether or not the practice conforms to the theory. For the Englishman, such a dichotomy between theory and practice does not exist.[45]

Lyly's ambivalent attitude toward women could also have been patterned after Italian antecedents. "A cooling Carde for Philautus and all fond louers" repeats the traditional anti-feminine arguments known since the appearance of the *Corbaccio* of Boccaccio. The misogynist letter of Euphues is followed by what amounts to an apology "To the graue Matrones and honest Maydens of Italy." Once more it was Boccaccio's *De claris mulieribus* which the author might have had in mind in admitting the possibility of virtue in women like Penelope, Lucretia, and many others. What causes one to think of Boccaccio is the combination in one author of the two attitudes toward women, admiration and reproof.[46]

Miss Jeffery also points out how incomplete are the descriptions of the appearance of the women in *Euphues*. In other words, beauty is treated in an abstract form, in accordance with the Neo-Platonic discussions characteristic of the Italian models. Of course, one may add that the whole novel possesses an abstract quality; there is very little action in it and discourses predominate.

The author of the dissertation maintains that not only Lyly's subject matter, but also his style were learned from Italian antecedents. She develops a two-pronged argument. First of all, she compares Watson's *Hekatompathia*, a collection of sonnets published in 1582, with two Italian prototypes, the sonnets of Petrarch and those of Serafino Aquilano. She finds that many of the artificialities later attributed to

[45] *Ibid.*, p. 34.
[46] *Ibid.*, p. 41.

euphuism, such as antithesis, parallelism, comparisons, alliteration, rhyme, puns, and oratorical questions, are partly present in Petrarch's works, and mostly found in the sonnets of the Italian Petrarchists and their foreign imitators. This derivation would require the acceptance of the idea that prose writers employed the phraseology, concepts, and some of the techniques of poetry. On the other hand, she also points to Boccaccio's *Fiammetta* and *Filocolo* in which long monologues consisting mainly of questions, or questions and answers, frequently occur. Again, the references to classical mythology (especially to Ovid) for the sake of arguments and illustrations, do not originate from the direct study of the Roman poet but are presented in the manner found in Boccaccio. "In fact," Miss Jeffery concludes, "it would not be overestimating to state that *Euphues,* to anyone well-acquainted with Italian literature, reads like a translation or compilation from Boccaccio executed by a Petrarchist." [47]

It should also be pointed out that Lyly was in the service of a typical "Italianate" courtier, Lord Oxford. This circumstance might have contributed to his surprising knowledge of Italian court life. The anti-Italian sentiment which Feuillerat considers a deterrent to any serious Italian influence on English writers did not prevent Lyly from giving an Italian setting to his novel. It is even possible that he deliberately chose an Italian background, for it might have served a double purpose – it catered to those who harbored anti-Italian sentiments and avoided open criticism of contemporary English society. Be that as it may, to deny any Italian influence in *Euphues* is to close one's eyes completely to clear evidence.

D. THE THEORY OF CLASSICAL MODELS

The last twenty-three pages of Norden's *Die antike Kunstprosa* is completely devoted to the problems which now concern us: the nature of euphuism, Guevara's place in the origin of euphuistic style, and the reconciliation of the Landmann theory with his own findings.[48] He calls euphuism "Der Stil der formalen Antithese" and maintains that it cannot be classified with other schools of artistic style. While Gongorism and Marinism move, according to Norden, on the plane of thought, "Guevarism" and euphuism are limited strictly to form. Antithesis is the outstanding feature of both "Guevarism" and euphuism, and Norden attempts to clarify this technique completely: "Bei ihrer [referring to anti-

[47] *Ibid.,* pp. 120-131.
[48] *Op. cit.,* pp. 786-809.

thesis] Behandlung muss ich ausführlicher sein, da ich nur so glaube, die vielbehandelte Frage mit absoluter Sicherheit beantworten zu können." [49]

Norden entertains no doubt about the correctness of Landmann's suggestion that Lyly learned the antithetical style from Guevara. As a matter of fact, the author of *Die antike Kunstprosa* states rather emphatically that Landmann's theory found general acceptance among scholars.[50] The question that interests Norden most is where Guevara learned his extreme antithesis. He solves the problem himself by attributing the spread of antithetical style to the popularity of Isocrates (and to a lesser extent of Cicero) among the humanists of the sixteenth and seventeenth centuries. Norden does not seem to make any differentiation between the styles of Isocrates and Cicero. Some of the humanists, he maintains, carried over the traditional rules of refined style from Latin into the vernacular. He entertains no doubt that Guevara was a humanist who wrote in Spanish rather than in Latin and employed the techniques of antiquity in his writings.

One of the most resolute opponents of the Landmann theory was Albert Feuillerat. He first entered the debate when he reviewed John Dover Wilson's *John Lyly* in 1906.[51] In this review, Feuillerat expressed regret that Wilson abandoned the battlefield when victory was already within sight. Wilson demonstrates correctly, the reviewer believes, that Lord Berners employed euphuistic style in 1524, that is five years before the publication of the *Libro áureo*. This means that euphuism existed in embryonic form in the English language and that it probably would have developed independent of any foreign influence. Had Wilson carried his research a little further, says Feuillerat, he would have found that many of the characteristic features of euphuism (antithesis, parallelism, alliteration, and rhyme) are present in More and Fisher (1510). Although he is on the right track, Wilson also stops short of proving that these same features hark back to antiquity, more precisely to the school of Gorgias. They are evident in Isocrates, Herodotus, Cicero, Seneca, and others. If one realizes that Isocrates, Cicero, and Seneca (the three who show

[49] *Ibid.*, p. 786. As we note, there is a basic agreement between the theories discussed so far. They maintain that Lyly learned his techniques through an intermediary. According to Landmann's view, Guevara was this agent. Violet Jeffery thinks that Boccaccio and Petrarca transmitted the devices to their imitators. However, all agree that these techniques were already employed in antiquity.

[50] *Ibid.*, p. 788. Norden states it in the following manner: "Woher stammt dieser Stil der englischen Prosa? Nachdem darüber viel Falsches gesagt war, wies Landmann mit völliger Evidenz und unter allgemeiner Zustimmung die Quelle nach: es ist der berühmte Roman des Spaniers Don Antonio de Guevara, El libro de Marco Aurelio, erschienen 1529."

[51] *Modern Language Review*, I (1906), pp. 330-334.

most frequently the distinctive marks of artistic prose) were the most widely read authors during the Renaissance, both in England and in Europe in general, many of the mysteries would disappear. What is more natural on the part of English writers than to turn to the techniques of their favorite classical authors when they wanted to improve their writing in the vernacular, he asks: "Et si les euphuistes anglais offrent certaines ressemblances avec Guevara, n'est-ce pas pour la simple raison que l'Espagnol et les Anglais étudiaient les mêmes modèles et qu'ils copiaient la même écriture?" [52]

This review was only a forerunner of the massive study of Feuillerat entitled *John Lyly. Contribution à l'histoire de la Renaissance en Angleterre* (Cambridge, 1910). He does not deny that Guevara had exercised certain influence on English prose. After all, Sir Francis Bryan had translated the *Menosprecio de corte* (*A Dispraise of the life of a Courtier*) in 1548, Edward Hellowes, the *Epístolas familiares* (1574) and the *Décadas* (1577), and so on. However, he cannot concur in Landmann's suggestion that Guevara should have been the only or even the most important source of euphuism.

First of all, he argues, Landmann's theory in order to be valid would require that North's style, apart from alliteration, should be identical with that of Guevara. Landmann, recognizing this requisite, does equate the two when he maintains that the rhetorical figures of the *Diall of Princes* already represented euphuism and that all Lyly had to do was to carry it a little further.[53] Feuillerat contends that North could not possibly have transplanted into English the characteristic features of euphuism. Even though North apparently knew Spanish, he still availed himself of the translation of Bertaut de la Grise who employed "une langue lourde, gauche, embarrassée, parfois obscure, toujours sans harmonie et qui ne reproduit nullement toutes les caractéristiques du texte espagnol." [54]

By the time the Spanish original underwent the two transformations, namely being reproduced first in French and then in English, Guevara's style was stripped of all important elements, especially the structural ones. Assonance, consonance, and rhyme were preserved only if the French and English happened to have the same ending as the original Spanish words; the balance of sentences was disturbed by the introduction of new elements. In his effort to point out the similarities between "Guevarism" and euphuism, Landmann passed over in silence one of the

[52] *Ibid.*, pp. 331-332.
[53] *Der Euphuismus*, p. 70.
[54] *John Lyly*, pp. 446-447.

major techniques of the bishop's style, the ricocheting of the same word from one clause to another. Feuillerat quotes the beginning of the *Prólogo sobre la obra* of the *Relox de príncipes* as a typical example: "La mayor *vanidad* que hallo entre los hijos de *vanidad* es: que no contentos de ser *vanos* enla vida: procuran que aya memoria de sus *vanidades* despues dela muerte. . . ." [55]

Feuillerat makes a general distinction between the style of Guevara and North on the one hand, and that of Lyly on the other. The somewhat heavy dignity of slow-moving sentences with a recurring ample Ciceronian rhythm is the dominant trait of Guevara's and North's style. Lyly's procedure, however, is entirely different: "Dans ce style qui porte tout le poids de la sagesse emphatique de l'archevêque de Mondoñedo . . . , qui pourrait reconnaître les traits accusés, raides et nets, le tic-tac métronomique et méchanique de la phrase de Lyly?" [56] The alert vivacity of Lyly, his pointed and epigrammatic expressions remind Feuillerat of the French way of writing. Should, then, one modify Landmann's theory and simply affirm that euphuism was born in imitation of Lord Berners? In that case, one would have to prove that antithesis, parallelism, assonance, and balanced clauses made their first appearance in English literature with the translation of Lord Berners in 1534. Feuillerat affirms the presence of practically all euphuistic techniques in the different works of John Fisher, Thomas More, and Thomas Elyot, written between 1509 and 1535. And, as we know, Sidney Lee and John Dover Wilson have demonstrated that Lord Berners availed himself of the same devices in the Prologue to his translation of Froissart's *Huon de Bordeaux*. Therefore (according to Feuillerat), the most one can say is that Guevara's success in England was due to his style which contained elements that were admired in the English prose of the sixteenth century.

In what direction shall one look for a solution to this thorny problem of the origin of euphuism? Among the most important influences of the Renaissance was the impact of classical literature, says Feuillerat. The educated men of the age admired not only the wisdom of the ancients but also the eloquence of the Greek and Roman writers. Many of the readers instead of being attracted by the harmonious beauty and simplicity of classical writings were captivated by the devices made fashionable since the days of Gorgias and Isocrates, namely the *parison*, *homoioteleuton*, etc. Feuillerat quotes a letter of Ascham to Sturm in which he complains that at Oxford students study Lucian, Plutarch, Herodian, Seneca, Aulus Gellius, and Apuleius instead of the first-rate

[55] *Ibid.*, p. 448.
[56] *Ibid.*, p. 450.

authors.[57] Among the classical authors Isocrates enjoyed particular popularity. He is mentioned in a royal decree of 1549 together with Homer and Euripides as being among the authors a teacher of Greek was obliged to lecture on.[58] Thomas Elyot translated Isocrates' *Discourse to Nikocles* into English because he felt that no book, with the exception of the Holy Scriptures, could equal it in regard to counsel and style.[59]

However, adds Feuillerat, the figures of Gorgias were disseminated in English prose not only by means of translations of Isocrates' writings but also by rhetorical tracts, much in demand during the sixteenth century, which prescribed the use of the figures of Gorgias. Feuillerat accords to Isocrates and the English masters of rhetoric and not to Guevara the honor (not the shame) of introducing into England the techniques that led to the development of euphuism: "Le processus de la formation du style euphuistique apparaît donc maintenant avec clarté. L'euphuisme, comme la plupart des mouvements de style européens qui se produisirent au temps de la Renaissance, est dû a l'imitation des littératures antiques; plus particulièrement, il constitue un rejeton anglais de l'école de Gorgias. Isocrate, parce qu'il avait employé les figures de Gorgias avec le plus de succès et aussi parce qu'il eut une très grande vogue, semble avoir été l'écrivain qui fit adopter ces figures par les stylistes anglais." [60]

Similarly, Feuillerat attributes to the rhetoricians the vogue of comparisons borrowed from ancient history and ancient mythology. Finally, since he considers euphuism to be a combination of prose and poetry, he ascribes alliteration to the influence of national poetry. The interaction of all these factors produced euphuism within three-quarters of a century, he believes.

In the next section we shall examine Feuillerat's differentiation between Guevara's alleged "Ciceronian" style and the abrupt tick-tock effect that Lyly's writings produce. At this time, however, we want to point out that Feuillerat's analysis of Lyly's work achieves, to a certain extent, the opposite result from that which he desired – it tends to confirm the similarities between Guevara and Lyly. We are not thinking of the obvious similarities which they shared with other Renaissance writers

[57] *Ibid.*, p. 461, n. 1.
[58] *Ibid.*, p. 462, n. 4.
[59] Feuillerat quotes Elyot's statement from the *Doctrinal of Princes*: "This little booke (whiche in mine opinion) is to be compared in counsaile and short sentence with any booke, holy scripture excepted, I haue translated out of greeke, not presumyng to contende with them, which haue done the same in latine; but to the intent onely that I wolde assaie, if our Englisshe tunge mought receiue the quicke and propre sentences pronounced by the greekes. *John Lyly*, p. 462, n. 6.
[60] *Ibid.*, pp. 469-70.

– the references to the history of Greece and Rome, to Homeric heroes, great kings and famous generals, or to philosophers and illustrious women. We have in mind statements like the following: "L'érudition de Lyly est d'ailleurs des plus superficielles. Car, il ne faut pas s'en laisser imposer par le nombre d'allusions que l'on peut relever dans l'oeuvre.... Car là oú il serait possible de voir un emprunt [from ancient authors], il s'agit, la plupart du temps, d'une anecdote très connue que Lyly a pu tout aussi bien cueillir dans les nombreux recueils de citacions et de faits mémorables où les gens de l'époque s'approvisionnaient, à peu de frais, de pensée antique." [61] Feuillerat adds a whole list of mistakes which prove the very unstable character of Lyly's familiarity with the classics. Lyly does not show any respect for the ancient authors – whenever a text does not seem interesting enough to him, Lyly does not hesitate to add an intriguing detail or to interpolate whole anecdotes out of his own imagination. His inventiveness is so convincing that it almost disarms the critic. As we have noted, Pedro de Rhua complained about a similar lack of accuracy in Guevara's writings.

E. THE THEORY OF MEDIEVAL LATIN PROSE AS A MODEL

The leading advocate of this theory is Morris W. Croll, a professor of English at Princeton University who published Lyly's *Euphues* with an introduction and notes in 1916. Before stating his position, he offers a description of euphuism. His account also includes Guevara's style, for Croll agrees with Landmann and Norden that, generally speaking, the styles of Guevara and Lyly show the same fundamental ingredients and should be discussed together. He also accepts Landmann's view that the most significant elements of both "Guevarism" and euphuism have to do with vocal ornaments of speech: "The essential feature of the style euphuism – to repeat – is a vocal, or oral, pattern, and all its other characteristics, such as the use of antithesis, and the constant use of simile, are only means by which the Euphuist effects his various devices of sound-design." [62] Croll considers the emphasis on antithesis as the characteristic mark of euphuism unfortunate, "a prolific mother of errors." He claims that Lyly's use of this device is purely "a figure of arrangement of words for an effect of sound" and has nothing in common

[61] *Ibid.*, pp. 423-24.
[62] Morris William Croll and Harry Clemons eds., *Euphues: The Anatomy of Wit. Euphues and His England* by John Lyly (London, 1916), p. XVI. This introduction was included in *Style, Rhetoric, and Rhythm. Essays by Morris W. Croll*, ed. R. J. Schoeck and J. Max Patrick (Princeton, 1966), as Essay Six, pp. 241-295.

with Bacon's use of contrast which reveals a new relationship as for example "revenge is a kind of wild justice." These remarks of Croll are directed against Norden who calls euphuism "der Stil der formalen Antithese" (II, p. 786) and Feuillerat who follows Norden on this road and maintains that, "Son *Anatomy of Wit,* dans son but and dans sa construction, n'est en somme qu'une antithèse prolongée. Et dans les détails de l'expression c'est encore cette figure de style qui domine." [63]

Then Croll turns to the problem of the source of the *estilo culto* meaning by this phrase both Guevara's *alto estilo* and euphuistic rhetoric. The accepted opinions of critics before Croll inclined toward the belief that euphuism was a product of humanistic learning in the imitation of the classical authors. Landmann believed as a matter of course, without offering proof, that the *alto estilo* of Guevara reproduced the balanced structure of ancient orators, and the same observation also applied to Lyly. Bond follows him in this opinion: "It has been repeatedly pointed out that the effort after elaboration of which *Euphues* represents the culminating point, is an outcome of the Renaissance; that all this attention to fineness, eloquence, and pomp of phrase is a general result of the revived study of the classics, and of the balanced oratorical prose, of Cicero and Seneca, in particular – a reflection, in fact, of that preoccupation of style which marked the fifteenth-century humanists in Italy." [64] Norden first investigated the general level of humanistic learning in Spain and convinced himself that Guevara was a humanist.

[63] *Op. cit.,* p. 412.

[64] *Op. cit.,* I, p. 135. The opinions expressed by Bond and Norden about classical oratory would fit the practices and theory of Fray Luis de Granada (1504-1588) but not those of Guevara. While figures of speech do occur in Cicero, too, their superabundance inclines one to call fray Antonio a disciple of St. Ildefonsus rather than of Cicero. In contrast, Granada's *Rhetoricae ecclesiasticae* (1576) is based mainly on Cicero and Quintilian. Several of the *schemata* we encountered in Guevara, however, are present in Granada, too. We shall cite a few examples. *Anaphora:* "¿Para qué vino Cristo al mundo, sino para ayudarte a ser salvo? ¿Para qué murió en la Cruz, sino para matar el pecado? ¿Para qué resucitó después de muerto, sino para hacerte resucitar en esta nueva manera de vida?" (*Guía de pecadores,* p. 116.) *Polyptoton:* "Allí estarán sus ánimas carcomiéndose y despedazándose con aquel gusano *remordedor* de la consciencia, que nunca cesará de *morder.*" (*Ibid.,* p. 51) *Duplicatio:* "Cayó, cayó aquella gran ciudad de Babilonia..." (*Ibid.,* p. 50) *Homoioteleuton:* "... cuando te veas en este trance ¿qué sentirás? ¿dónde irás? ¿qué harás? ¿a quién llamarás? Volver atrás es imposible; pasar adelante es intolerable; estarse así no se concede; pues ¿qué harás?" (*Ibid.,* p. 39).

Nevertheless, Granada's sense of proportion kept his style from being dominated by either Ciceronianism or Guevara-like medieval oratory. Instead, he consciously introduced into his sermons vernacular expressions, revived long-forgotten proverbs, sayings, and word forms, and interspersed his messages with matters of popular interest in order to retain the attention of his audience.

Satisfied with the results, he announced, "Dass er [Guevara] daher, wie den Inhalt, so auch den Stil nach antiken Mustern gestaltet hatte, ergab sich mir als selbstverständliche Folgerung." [65] Among the Spaniards it was Guevara and among the English writers Roger Ascham and Lyly who transplanted the style of Isocrates and Cicero, but more especially that of the former, into their respective vernaculars and derived the use *schemata* from them. Feuillerat accepted this conclusion and emphasized the part Isocrates played in this development even more strongly.

In spite of this array of authorities, Croll rejects the theory of classical imitation. He affirms that the spirit of the *estilo culto,* with all the rhetorical *schemata,* is the reverse of the genuine classical spirit. In Isocrates and Cicero, he says, the rhetorical figures occupy a minor position in comparison with the other characteristics of their style, with the result that the total impression is entirely different from that of the practitioners of the *estilo culto.* Cicero's style is cumulative and comprehensive, varying its rhythm as it moves forward; Lyly prefers short and pointed clauses. Isocrates employs *schemata* only carefully in contrast with their constancy and uniformity in the *estilo culto.* Croll cannot accept the supposition that the humanists of the sixteenth century misinterpreted the intent of the figures of Gorgias because in other respects their concept of classical literature is quite correct.

The result is that other factors will have to be included in order to explain the transformation of the original intent and use of the *schemata.* This factor, Croll believes, is to be found in the legacy of medieval Latin prose that the Renaissance inherited from the Middle Ages and the uninterrupted influence that medieval tradition exercised upon so many writers of the sixteenth century. In other words, Croll does not deny that the original source of *estilo culto* lies in the rhetorical schools of Greece and Rome. He only claims that the techniques of the orators of Antiquity underwent a drastic change by the time they reached Guevara, Pettie, and Lyly.

How did such a modification come about? Croll attributes it to the medieval instruction in rhetoric. As the monasteries gradually took charge of education, the training in oratorical style narrowed and was reduced almost completely to the study of the figures of speech, while the more solid and serious branches of rhetoric dealing with invention and disposition were neglected. This development was almost inevitable since the Church addressed itself to an unsophisticated audience easily moved by the emotional appeal of this kind of oratory. The effect of the sermons was heightened by the repetition of a single *schema,* somewhat in the

[65] *Op. cit.,* II, p. 790-793.

manner of an incantation, and elicited astonishment by the spectacular combination of figures of speech like transverse alliteration and transverse *homoioteleuton* such as occur in the *Imitatio Christi* or the sermons of Bede. Croll gives the following example from Bede's sermon on the Annunciation: "Nec se tamen de *sin*gularitate meriti ɛxcellentioris *sin*gular i t e r extoll i t, sed potius su*ae* condiꜰoɴıs ac divin*ae* digna-ꜰoɴıs in omnibus memor, *famula*ꜰum se ᴄʜʀisti consortio humil i t e r adjung i t, *famulatum* ᴄʜʀisto devota quod jube t u r impend i t." Since books, or rather manuscripts, were read aloud, the same type of rhetoric found its way into the devotional treatises, Lives of Saints, and even chronicles. In a word, the ultimate source of the figures of Isocrates and the medieval oratory is the same, the *schemata* of Gorgias, but the spirit and, to a certain extent, even the form of everything medieval is as different from the Greek of Isocrates as is Gothic architecture from Romanesque or from the classic.[66]

Croll cites as an internal proof of his theory one of the peculiarities of medieval Latin prose that is not present either in the classics, in the writings of the church fathers, in Apuleius, or in the Greek romances but is a characteristic feature of Guevara, North, and Lyly. He refers to the agreement of the final sound and the intentional contrast of the penultimate vowel which carries the accent and which would have to be alike in order to form rhyme.[67]

An important part of the external evidence adduced by Croll's theory is the tendency of many sixteenth century humanists to differentiate between the classical use of the *schemata* and the medieval imitation of them. (Guevara was not among these and incurred the displeasure of his contemporaries by cleaving to the old ways.) In the minds of many humanists these figures are associated with the style of sermons. Salutati praises the sermon of the bishop of Florence because he does not employ *more fratrum* the puerile and effeminate artificial rhythm and conso-nance.[68] Thomas Wilson in 1560 also identifies some of the most familiar

[66] Introduction to his edition of *Euphues*, pp. XXX-XXXII.

[67] The following is one example from Guevara: "... qual fuere la compañía con que cada uno *anda*, en tal reputación ternán su *persona.*" *Menosprecio de corte*, p. 113. Lyly frequently contrasts *nature* and *nurture*, meaning thereby inherited and acquired characteristics. Child calls this figure *annominatio*; Land-mann terms it syllable antithesis.

[68] "Episcopo Florentino. Vidi gavisusque sum elegantissimam illam orationem vestram quam mihi dignatus fuistis vestra benignitate transmittere. ... Et quum omnia placeant, super omnia *michi* gratum *est*, quod *more fratrum ille sermo rythmica lubricatione* [should it be *lucubricatione*?] *non ludit, non est ibi syllaba-rum aequalitas, quae sine dinumeratione fieri non solet, non sunt ibi clausulae quae similiter desinant aut cadant,* quod a Cicerone nostro non aliter reprehenditur

figures with the style of preachers.[69] One of the witnesses Croll quotes is Vives who, as we indicated above, makes the distinction between the *oratio aulica* (by which according to both Norden and Croll he means Guevara's style) as being *deliciosa, lasciva, ludibunda* and the *gravis et sancta oratio*.[70] This condemnation resembles Salutati's criticism but it involves another area, namely the formalities and ceremonies of court and state which, especially in England and Spain, have also preserved medieval traditions. In this respect, according to Croll, these countries differ from Italy and France where already in the fourteenth and fifteenth centuries humanism had made deep inroads into the older culture, whereas Spain and England were much slower in assimilating the new classicism. Consequently, he continues: "If Bishop Antonio de Guevara writes a similar style [meaning similar to Roger Ascham's style in addressing King Henry or George Gascoigne praising Queen Elizabeth in an allegory] calling it *oratio aulica*, why should we wonder, when we know that his subject-matter, his thought, and his sources of information are as medieval as his style?" [71]

The essence of Croll's argument, then, is that euphuism and "Guevarism" were not the result of an effort of the humanists to imitate the styles of the writers of Antiquity but rather the residues of the medieval Latin rhetoric practiced especially by preachers. The figures of speech of medieval Latin lived for a short span of glory only to disappear forever before the advance of new forms more in line with Renaissance culture.

William Ringler's article, "The Immediate Source of Euphuism" (*PMLA*, LIII, 1938, pp. 678-686), confirms the conclusions of Croll by calling attention to the Latin lectures of John Rainolds at Oxford delivered between 1572 and 1578. Since Rainolds was the most popular academic lecturer of the period when Lyly was a young university man and since the orations of Rainolds show all the important characteristics,

quam puerile quiddam, quod minime deceat in rebus seriis vel ab hominibus, qui graves sint, adhiberi. *Benedictus deus, quod sermonem unum vidimus hoc fermento non contaminatum et qui legi possit sine concentu et effeminata consonantiae cantilena.*" Apud Norden, *op. cit.*, II, p. 765.

[69] "I heard a preacher deliting much in this kind of composition, who used so often to end his sentences with words like unto that which went before, that in my judgment there was not a dozen sentences in his whole sermon, but they ended all in Rime for the most parte." *The Arte of Rhetorique*, 1560, ed. G. H. Mair (Oxford, 1909), p. 168. Although Wilson mentions rhyme, the examples he gives make it clear that he includes not only *homoioteleuton* but other traits associated with euphuistic style.

[70] Croll, *op. cit.*, pp. XXXIX-XL and Norden, *op. cit.*, II, p. 794. They quote from *De ratione dicendi*. See *Opera omnia*, II, p. 153.

[71] *Op. cit.*, p. LIII.

both structural and ornamental, of what in a short time was to be called euphuism, perhaps it is not too far-fetched to see in Rainolds at least one of the immediate models of Lyly.

María Rosa Lida agrees with Croll regarding the medieval Latin contribution to the figures of Gorgias, but she does not stop at this point; after tracing the Latin sources of the *alto estilo,* she indicates the exact stages where the medieval Latin style enters the stream of Spanish vernacular literature during the Middle Ages and follows this development to Guevara's productions. As we shall see, this not inconsiderable modification of Croll's theory places more emphasis on medieval national prose than on Latin specimens of the same epoch.

María Rosa Lida considers Saint Ildefonsus, bishop of Toledo in the second half of the seventh century, the first important architect of the stylistic structure that culminated in Guevara's style.[72] To be sure, others, such as St. Isidore, had previously employed this mode of expression to a certain extent, but the tract of St. Ildefonsus – *De virginitate Beatae Mariae* – stands out because of its declamatory and repetitious prose. The treatise ostensibly represents the defense of the virginity of Mary against the disbelief of three infidels, Jovinian, Helvidius, and Judaeus (a name which probably stands for Jews in general). According to María Rosa Lida, this treatise is no more than a literary exercise and was not written in the heat of a controversy.[73]

María Rosa Lida points out that in addition to the artificial style there

[72] *Op. cit.,* pp. 379-384.

[73] Menéndez Pelayo maintains that Jovinian and Helvidius were not contemporaries of St. Ildefonsus but rather well-known heretics of the fourth century and that St. Jerome wrote several polemical tracts against them. Nevertheless, Menéndez Pelayo continues, the vehemence of the arguments convinces him that there must have been followers of the old heresy in the seventh century, and the tract reflects the zeal of a real controversy. As far as Judaeus is concerned, the renowned polygraph thinks that there always were Jews or converts from Judaism in Spain who demonstrated disbelief and error in regard to Mary's virginity. See his *Historia de los heterodoxos españoles,* I (Santander, 1946), p. 364. Jewish theology has never accepted the doctrine of immaculate birth. Isaac ben Abraham Troki's (1533-1594) *Hizzuk Emunah,* a source book of answers to Christian theological arguments, devotes a full chapter to the sentence in Isaiah which, according to Christian theologians, foretold the immaculate birth of Jesus: "Ecco virgo concipiet, et pariet filium, et vocabitur nomen eius Emmanuel" (7:14). Christian theologians see in the absence of the mention of the father a reference to conception by the Holy Spirit. The official Jewish view, espoused by Troki, was and still is that the word *almah* does not refer to a virgin but means girl in general. Furthermore, this sign could not possibly refer to an event that was to take place 700 years later – it was only a warning of the prophet Isaiah to King Ahaz that before a girl conceives, gives birth to a child, and names him, the Aram-Israel league will have destroyed Jerusalem and with it the Kingdom of Judah. (*Hizzuk Emunah,* ed. M. Wechsler, New York, 1933, part I, chap. 21, pp. 79-86)

is circumstantial evidence which indicates that the tract is a "puro alarde virtuosista." The copyist includes in the full title of *De virginitate* the phrase *more synonymorum conscriptus* alluding to the use of synonyms and other figures of speech. Besides, the other works of St. Ildefonsus do not employ the *schemata*. To give an example of the prose of the *De virginitate,* here is the way St. Ildefonsus addresses Jovinian in the first chapter of his book: "Auditu percipe tu, Ioviniane, corde sapito fatue, praecordiis cognosce stulte, sensu disce caduce. Nolo pudorem nostrae virginis corruptum partu causeris, nolo integritatem generatione discerpas, nolo virginitatem exitu nascentis scindas, nolo virginem genetricis officio prives, nolo genetrici virginalis gloriae plenitudinem tollas." [74]

The line of development initiated with St. Ildefonsus in Latin prose and its repercussions in the vernacular will lead, as María Rosa Lida demonstrates, to the style of Guevara. However, there are also other factors which contributed to this end result. The first ornamental prose in Spanish is a translation from Latin of a lyrical passage in Ximénez de Rada's *Historia Gothica* bewailing the ruin of Spain, which was faithfully reproduced in the *Crónica general* of Alfonso X. This passage coincides in many respects with the style of St. Ildefonsus in that it also employs the devices of repetition, antithesis, and *homoioteleuton.* From the *Crónica general* these figures of speech crept into the second and third part of Juan Manuel's *Conde Lucanor.* This trend of paratactic prose received new impetus from the translation of the *De virginitate* into Spanish by Alfonso Martínez de Toledo, the Archpriest of Talavera. The Archpriest carried over some traits of this style to his *Corbacho.*[75]

The next stage in the development of medieval Spanish prose occurred, continues María Rosa Lida, when Spanish authors, stimulated by Boccaccio's example, tried their hand at the transplantation of the long and interwoven sentences of classical Latin into the vernacular. The results of this experiment manifested themselves in the prose of Juan de Mena, the *Crónica de don Alvaro de Luna,* and, we may add, the writings of Enrique de Villena. We should not think, however, María Rosa Lida remarks, that these two lines of development of Spanish vernacular were

[74] *Apud* Vicente Blanco García and José Orlandis Rovira, *Textos latinos* (Pamplona, 1954), p. 40. Blanco García has a Spanish translation of the tract with a brief study on the style of St. Ildefonsus (*San Ildefonso. De virginitate Beatae Mariae,* Madrid, 1937). This study convincingly confirms María Rosa Lida's views concerning the presence in this medieval tract of many of the rhetorical figures used later by Guevara.

[75] See José Madoz, *San Ildefonso de Toledo a través de la pluma del Arcipreste de Talavera* (Madrid, 1943), pp. 45-46. Madoz points out that the Archpriest enlivens even his translation with vivid details which characterize the exuberant movement of the *Corbacho.*

never combined in a single writer. She finds in the prose of Juan de Lucena (*Libro de vita beata*) and in *La Celestina* instances where the authors at times follow the classical (and Italian) model and at times revert back to the purely medieval pattern. Insofar as Guevara is concerned, María Rosa Lida considers his prose to be the Spanish variation of ornamental prose that began with St. Ildefonsus and was already transplanted into Spanish in the Middle Ages. Because the relation between Guevara and Lyly was outside the framework of her study, all she mentions in this respect is that fray Antonio may well have been instrumental in the creation of euphuistic style. However, she feels that such a statement without modifications would oversimplify a complicated problem.[76]

F. OTHER REACTIONS AND THOUGHTS CONCERNING THE LANDMANN THEORY

The argument that Croll used against the theories of Norden and Feuillerat was turned against him by some of the later critics. Croll, was we saw, had attempted to prove that, although Guevara and Lyly employed the figures of Isocrates (and, to a certain extent, the devices of Cicero), their style cannot be explained as an imitation of the classics because the total effect their prose produces is different from that evoked by reading classical authors. Some of the critics of Croll, such as Jonas A. Barish and G. Wilson Knight, maintain that his own characterization of euphuism is a lopsided and partial one because he concentrates his attention on one aspect of the euphuistic manner of writing, the sound effects. Croll says:

> But the simplest and safest form of the definition is that Euphuism is a style characterized by the figures known in ancient and medieval rhetoric as schemes [*schemata*], and more specifically by the word-schemes [*schemata verborum*], in contrast with those known as *tropes*; that is to say, in effect, by the figures of sound, or vocal ornament. . . . The essential feature of the style – to repeat – is a vocal, or oral, pattern, and all its other characteristics, such as the use of antithesis, and the constant use of simile, are only means by which the Euphuist effects his various devices of sound-design.[77]

The criticism of presenting a one-sided view of "Guevarism" and euphuism, we may add, applies not only to Croll but also to Landmann who supposedly did not appreciate the deeper *meaning* of the antithetical style. The neatly balanced clause, sentence, and paragraph should

[76] *Op. cit.*, p. 379.
[77] *Op. cit.*, pp. XV-XVI.

not be dismissed, says G. Wilson Knight, as a verbal extravagance. These devices represent not merely ornament but essence – that is they express an awareness of opposites, of contradictions – thereby denying Croll's contrast between Lyly and Bacon. G. Wilson Knight includes the dramas of Lyly, too, to illustrate his views. In *Euphues,* as in Lyly's several dramas, the central problem is love. Lyly is aware of its complexities and expresses his understanding by balancing one point of view against another. In *Campaspe* Alexander the Great, the man of action, is contrasted with Apelles, the artist. In this manner Lyly asks the question debated in Castiglione's *Il Cortegiano* and in the *Libro áureo*: What is the desirable humanistic existence? In the course of action, Apelles gains Campaspe's love, and Alexander, as a generous hero, seems to renounce love and go on to greater conquests. We might think that we have Lyly's answer – the warrior, the man of action, deserves the admiration of the Elizabethan author more than the poet and philosopher. However, *Campaspe* ends with this remark of Alexander's: "And, good Hephaestion, when all the world is won, and every country is thine and mine, either find me out another to subdue, or, of my word, I will fall in love." So the problem of *summum bonum* remains unsolved, and the complexity of existence is formalized in the balanced structure.[78]

Jonas A. Barish further elucidates the line of reasoning undertaken by G. Wilson Knight. He also finds Croll's characterization of euphuistic style too narrow and vigorously challenges Croll's statement that the antithetical arrangement is not meant to reveal a new and striking relation between things. Barish believes that antithetical structure is an instrument whereby the author acquires an insight into the laws of nature and into the motives that govern the actions of men. Everywhere one turns, one encounters contradictions, ambiguities, and paradoxes that baffle the mind.[79]

Barish distinguishes among three types of antithesis found in euphuistic style. Since his observations are fully applicable to Guevara's prose, too, we shall cite examples from the Spanish instead of the English author. The most frequent type of antithesis occurs when in the description of a thing its opposite is also mentioned. The basis for this procedure is easily explained – to know a thing completely, all angles should be explored. One cannot understand heroism fully unless one is aware of the extent of cowardice. The philosopher Anatharsus rejects the presents sent by Croesus with these words: "En los estudios de grecia no aprendemos a mandar sino a ser mandados: no a hablar sino a callar: no a

[78] "Lyly," *Review of English Studies,* XV (1939), pp. 146-163.
[79] "The Prose Style of John Lyly," *English Literary History,* 23 (1956), pp. 14-35.

resistir sino a obedescer / no adquirir mucho sino contentarnos con poco: no a vengar ofensas sino a perdonar injurias: no a tomar lo ageno sino a dar lo nuestro proprio: no a ser honrrados sino trabajar de ser virtuosos: finalmente deprendemos a aborrecer lo que los otros aman / que es la riqueza: & aprendemos a amar lo que los otros aborrecen que es la pobreza." [80]

The second type of antithesis suggests not so much the evocation of the opposite but rather a possible choice between opposites. The formula in this case is *más... que*: "...los principes & grandes señores mas quieren ser loados con mentira que ser reprehendidos con verdad." [81]

The third kind of antithesis calls attention to the differing qualities coexisting in one and the same object. While Petrarch pointed out contradictions in love (*amor amaro*, for example), in Guevara and Lyly paradoxes seem to lurk everywhere and become the expression of their view of life. The most frequent one "mundo inmundo" or "mundo que no eres mundo" is only a recapitulation of that which the bishop of Mondoñedo experiences all the time and expresses frequently in terms of antithesis like the following: "...quanto mas como / mas me muero de hambre: quanto mas beuo / tengo mas sed." [82] Lyly developed antithesis to a greater extent in order to demonstrate the incongruities found in nature as well as in human behavior. Barish claims that "this commanding insight is perhaps the chief thing that distinguishes Lyly from his predecessors in Euphuism, and one of the chief things he passed on to his imitators." [83] If it is correct to say that Lyly did not learn the employment of antithesis (for the purpose of stylistic ornament and to point out a paradox in logic) from English prototypes and, furthermore, if it can be demonstrated that Guevara did use antithesis in both form and meaning, then Landmann's suggestion that Guevara served as a model for Lyly becomes more convincing.

We may add, before leaving the discussion of the Landmann theory, that Bond noticed certain peculiarities in Lyly's structure and content but apparently did not relate them to the subject at hand. Since nobody has linked these peculiarities to the Landmann theory, we should like to discuss them in this context. The first point concerns the use of the letters. In the *Libro áureo*, the greater part of the epistles of Marcus Aurelius appear at the end of the book; in the second version, the *Relox de príncipes*, the letters that are not omitted are rather deftly interwoven with

[80] *Relox de príncipes*, I, fol. 73v.
[81] *Ibid.*, I, fol. 39r.
[82] *Ibid.*, III, fol. 164v.
[83] *Op. cit.*, p. 24.

the structure of the work and are not presented as a separate unit. Bond sees the same plan in the two parts of Lyly's work – ". . . the letters, which in Part I were almost thrown into a batch at the end, are now interwoven with the tale and minister to its interest." [84]

Another parallel not previously noted is the wavering between using the expression "gods" that would fit the pagan background and referring to God whom Christians worship. In one of his soliloquies Euphues exclaims: "Wilt thou be so impudent Euphues, to accuse the *gods* of iniquitie? . . . Neyther is it forbidden vs by the *gods* to loue . . ." [85] On the other hand, Lucilla reasons in this fashion about the modest qualities of her newest admirer, Curio: ". . . I thinck *God* gave it me for a iust plague, for renouncing Philautus, & choosing thee. . . ." [86] The same type of hesitation occurs in the *Libro áureo*: "Ser ayos de principes enla tierra, es tener un officio delos *dioses* que *esta* enel cielo." [87] Earlier in Boccaccio's *Fiametta* similar examples can be found: "– Voi, turba de vaghe giovani, di focosa libidine accese, sospingendovi questa, vi avete trovato Amore essere Dio al quale più giusto titolo sarebbe Furore; . . ." and on the following page: "– O vecchia, taci, e contro alli Dii non parlare." [88]

The *Libro áureo* frequently portrays Marcus Aurelius as not only the wisest but also the most experienced man. The implication is, of course, that the counsels he offers are born of personal experiences. Nevertheless, when he recalls events of the past, the personal touch is missing. We have already quoted the stereotype that fits Calisto more than Marcus Aurelius: "Quando yo aguardaua cantones, ruaua calles . . ." [89] We must add, however, that apparently in the *Epístolas familiares* the author has outgrown the fear of personal references. The bookish atmosphere changes into the outlines of the real world.

Lyly's *Euphues and his Ephoebus* also claims that the writer learned what he knows more by experience than from books: "I was hereof a studente of great wealth, of some wit, of no smal acquayntance, yet haue I learned that by Experience, that I shoulde hardly haue seene by learning." [90] Lyly's intention is to show what path children should follow and how fathers should proceed, and he pleads that they not reject his counsel because it is given by someone who had been lewd. Such lewdness manifests itself in excesses similar to the ones quoted above from the

[84] *Op. cit.*, I, p. 163.
[85] *Ibid.*, p. 208.
[86] *Ibid.*, p. 238.
[87] See p. 53.
[88] See pages 67 and 68.
[89] *Ibid.*, pp. 290-291.
[90] Bond, *op. cit.*, I, p. 261.

Libro áureo, namely in frequenting taverns, dally with ladies, gambling, haunting undesirable districts, etc.[91] Lyly's account, like Guevara's, does not have an authentic ring.

Guevara employs the technique of criticizing contemporary events with Marcus Aurelius or someone else as a spokesman, the most famous among them being the episode of the *Villano del Danubio.* Gilman analyzes as well the attack directed against "cruel judges" (possibly referring to Lucerno and other merciless inquisitors) in the *Libro áureo* and the *Relox de príncipes* in a study entitled "A Sequel to the *Villano del Danubio"* published in Angel del Río memorial issue of the *Revista Hispánica Moderna* (XXXI, 1965, pp. 175-185). The point we are making is that under one guise or another, using frequently an untutored foreigner, the bishop was able to get his message across without hurting anybody's feelings. These foreigners turn up every once in a while – one of them visiting in Rome from Elia Capitolina (Jerusalem), another attending an Olympic game, etc., and deliver their messages of condemnation. Lyly uses the same technique. Instead of Marcus Aurelius bemoaning the corruption of Rome which is not Rome any more (*O Roma sin Roma . . .*), here Euphues laments the fate of Athens (Oxford) which is in complete disarray, where instead of studying the students "quaff drinkes," play at dice, and behave more like "stageplayers" than students.[92] Instead of an unshod barbarian, here a Spartan visits Athens and sees there only banqueting and licentious behavior. Upon his return to

[91] *Ibid.,* p. 269.

[92] *Ibid.,* pp. 273-274. In connection with Guevara's exclamation *O Roma sin Roma,* attention should be called to an article of María Rosa Lida in which she traces the origin of a very similar phrase in Quevedo's sonnet *Buscas en Roma a Roma ¡oh peregrino!* ("Notas para las fuentes de Quevedo," *Revista de Filología Hispánica,* I [1939], pp. 369-375). She finds them in the Latin distichs of Janus Vitalis who may be identical, she conjectures, with the Hungarian humanist Janus Pannonius, 1434-1472. These distichs dealing with the topic of permanence and decay were translated, María Rosa continues, into French by Joachim de Bellay in the third sonnet of his *Antiquitez de Rome,* 1558:

> Nouveau venu, qui cherches Rome en Rome,
> et rien de Rome en Rome n'apperçois,
> ces vieux palais, ces vieux arcz que tu vois,
> et ces vieux murs, c'est ce que Rome on nomme.
> Voy quel orgueil, quelle ruine: et comme
> celle qui mist le monde sous ses loix,
> pour donter tout, se donta quelquefois,
> et devint proye au temps, qui tout consomme.
> Rome de Rome est le seul monument,
> et Rome Rome a vaincu seulement.
> Le Tybre seul, qui vers la mer s'enfuit,
> reste de Rome. O mondaine inconstance!
> Ce qui est ferme, est par le temps destruit,
> et ce qui fuit, au temps fait resistance.

his home, he is asked how things were in Athens. He replies that in Athens everything is considered good.

But perhaps the most relevant coincidences between Guevara and Lyly are to be found in the area of anecdotes told in connection with historical personages and allusions to classical mythology. Bond's Introductory Essay cites historical inaccuracies and the creation of fictitious personages in Lyly. Sometimes the historical person is authentic but the story is fictitious. Sometimes the author embellishes a true story with details of his own invention or adds one little imaginary incident to an otherwise completely authentic story.[93] As we have previously noted, similar commentary has been made regarding Guevara's writings.[94] However, interestingly enough, Bond does not relate these data to Guevara although he does speak of him in other contexts. Some of the classical allusions are either invented or simply taken from Pettie, Bond points out. Mercury and Vesta (I, p. 150) are invented. The allusions taken from Pettie are listed in Douglas Bush's *Lyly's Petty Pilferings from Pettie*.[95] All these coincidences indicate that perhaps Landmann's theory has some merit. However, in our considered judgment, what Lyly learned from Guevara was more in the area of subject matter and methods and not so much in that of style. The research of John Dover Wilson, Arturo Farinelli, and Albert Feuillerat indicates convincingly that the raw material from which euphuism was formed was present, as we have seen, in English literature before Lyly's time.

[93] We find these items in Bond's Introductory Essay (I, pp. 130-131) which, as we mentioned before, lists them without relating these data to Guevara. First of all there are the historical inaccuracies: Themistocles is made contemporary with Philip of Macedon, and Demosthenes, the orator, with Lais. Among the personages invented by Lyly are: Asiarchus and Biarus, Theocrita, and the poets Daretus and Mizaldus. In the following the historical figure is real but the anecdote connected with him is spurious: Apelles in the Epistle Dedicatory to *Euphues*; Phidias in the Epistle Dedicatory to *Euphues and his England*, etc. Illustrations of the embroidering of an authentic story are: Diophantus and Themistocles, and Praxiteles and his statue of Flora.

[94] See the section of Pedro de Rhua in this study, pp. 32-42.

[95] New York, 1955.

V. GUEVARA'S SUCCESS

A. POPULARIZATION OF KNOWLEDGE

We have seen so many references to the enormous success of the bishop's books that the question asked by Castro and María Rosa Lida among others arises: What was the reason for the unusual demand for Guevara's writings? This is a legitimate question in connection with any writer, but it is especially pertinent in the case of one who has fallen out of favor after his time. Thus, for example, Louis Clément ponders: "Or Guevara, n'avait pas mis dans son observation assez d'humanité, assez de vérité supérieure pour que toute une époque s'y reconnut au vif. Comment donc expliquer sa fortune?" [1]

As might be expected, there are several proposed explanations of this puzzling situation. In fact it was usual for individual critics to advance more than one supposition. Costes emphasizes Guevara's role as a popularizer. The bishop's works brought within reach of the general public the histories and the teachings of the great men of classical antiquity in the vernacular. And he did it in the most pleasant form, in the form of anecdotes. Some of these anecdotes are short; some attain the length of a short story (Camma and Sinorix). This was the first time, Costes continues, that the treasure house of the tales of antiquity was opened to people who generally were accustomed only to stories of Oriental inspiration.

Costes then touches upon what is perhaps the most valid explanation while failing to spell it out completely: "Il [Guevara] vulgarisait les philosophes, les grands et les petits, mettait l'histoire ancienne à la portée de tous, et le grand public qui n'était point *científico* et hésitait à lire Suetone ou les autres historiens dans les premières éditions latines de la Renaissance, depuis le plus humble gentilhomme de la cour jusqu'au connétable de Castille, allait pouvoir, sous la forme la plus attrayante,

[1] "Antoine de Guevara. Ses lecteurs et ses imitateurs français au XVIᵉ siècle," *Revue d'histoire littéraire de la France,* VII (1900), p. 590.

sous la forme anecdotique, connaître a son tour les beaux gestes, les belles paroles des grands hommes de l'antiquité.[2] Two observations are missing here, we believe, which are supplied by Gilman's article, "A Sequel to the *Villano del Danubio*," and such books as Marshall McLuhan's *The Gutenberg Galaxy* and Febvre and Martin's *L'Apparition du livre*. First, it was the unprecedented new instrument, the printing press, that created both a public address system for those who used the vernacular and a general reading public.[3] We need not repeat here the well-known fact that before and even for decades after Gutenberg manuscripts were hard to get, expensive, and many of the copies were carelessly done. With the introduction of printing, books were mass-produced and initiated a revolution resembling that which in our days resulted from the marketing of mass-produced automobiles. Guevara brought within reach not only of "gentlemen of the court" but also of that new entity, the general public, stories from Plutarch, Aulus Gellius, and others. He thus anticipated such more accurate works as Amyot's translation of Plutarch into French and North's reproduction of Amyot's excellent translation in English.

The second point we should make here is that the public was eager to read not only the wisdom of Antiquity but also the anecdotes of the Middle Ages. Only the meticulous humanists were able to read the original texts. The masses were quite satisfied with the medieval reworking of the stories of Antiquity, since this material was, to a large extent, new to them. As Marshall McLuhan points out: "During the first two centuries of print, until the end of the seventeenth century, the great body of printed matter was of medieval origin. The sixteenth and seventeenth centuries saw more of the Middle Ages than had ever been available to anybody in the Middle Ages. Then it had been scattered and inaccessible and slow to read." [4]

If anyone imagines that the public was anxious to read only the productions of the humanists, he should examine the statistics offered by Febvre and Martin. The largest demand by far was for the medieval romances of chivalry, shepherds' calendars, illustrated breviaries, and books of hours, these statistics show.[5]

[2] *Antonio de Guevara. Son oeuvre*, pp. 62-63.

[3] Gilmore's statement that Erasmus' career "would have been impossible without the standardization and wide dissemination of the printed page," we believe, applies to Guevara as well. The diffusion of his work was in large part due to the creation of a new mass media of communication. Myron P. Gilmore, *The World of Humanism* (New York, 1962), p. 189.

[4] *The Gutenberg Galaxy*, p. 142.

[5] *L'Apparition du livre*, pp. 283-285.

Guevara, like Erasmus, was among the first to realize the possibilities of the extension of personality that the invention of printing brought with it. When someone read a manuscript in the Middle Ages, in most cases he was not interested in the personality of the author. He felt that the author or copyist only perpetuated the great body of knowledge, "auctoritas," handed down from former generations. All this changed with the culture of typography. The author's works could be endlessly reproduced and his fame be assured for generations to come. It is Guevara's concern with his own fame, we feel, that explains many of the puzzling peculiarities in his procedures.

In Goethe's *Dichtung und Wahrheit* there is a peculiar mixture of true autobiography and poetic elaboration of each important landmark in his career, such as his student years, his first love, and his first realization that he should dedicate himself to writing. It seems that the famous author wished to create a nimbus about his own personality or, in other words, to establish his own mythology. Centuries before Goethe's time Guevara attempted to do the same thing. What kind of image of himself did fray Antonio wish to perpetuate? In the *Epístolas familiares,* the bishop refers several times to his lineage. Guevara was a member of a distinguished family of the *Montaña.* In one of his letters to Don Iñigo de Velasco, Constable of Castile, the author boasts "primero hubo condes en Guevara que no reyes en Castilla." [6] Needless to say, as the bishop himself remarks, in those days lineage was a most important consideration: "Según está hoy el mundo, sobre quien sois vos, mas quien sois vos, no me paresce que puede uno tener mejor alhaja en su casa que ser y descender de sangre limpia, porque el tal terná de que se loar y no habrá de que le motejar." [7]

At the age of twelve, Guevara says in his prologue to the *Menosprecio de corte,* his father took him to the court of the Catholic Kings where he led a life stultified by vices. There would normally be no reason to doubt the number twelve which is very significant since Jesus was taken to Jerusalem at the same age. What makes this piece of information somewhat suspicious is the following: It is difficult to believe that in Isabel's rather austere court, adolescents of tender years would have been encouraged in vice. The phrase sounds more like a stereotype or a formula, for he continues that God awakened him from his spiritual drowsiness when the prince Don Juan (1497) and Queen Elizabeth (1504) died and made him turn from the pleasures of this world and become a Franciscan monk in Valladolid. Thus Guevara connects his personal

[6] *Epístolas familiares,* I, p. 73.
[7] *Ibid.,* p. 75.

history with decisive events of his country. J. Gibbs suggests that possibly Guevara's uncle and protector, Ladrón de Guevara, passed away in 1503 and this may have prompted the change in his career.[8] After having resided eighteen years in the monasteries of Arévalo, Avila, and Soria, the Emperor called him back to the court to become his chaplain (*predicador*) and chronicler. During this time, continues Guevara in his autobiographical references in the above-mentioned prologue, he visited the courts of Emperor Maximilian, the Pope, the kings of France and England, and saw the dominions of Venice, Genoa, Florence, and the courts of all the princes and potentates of Italy. This reminds one of the New Testament phrase of knowing "the powers and principalities" of the earth. He mentions these visits in order to make certain that the reader accept as true whatever he says in this book (*Menosprecio de corte*), because he saw history "with his own eyes" and "touched it with his own hands." (We have previously noted the importance attributed to being an eyewitness to events.) [9]

Guevara attributes exaggerated importance to his own intervention in the War of the *Comunidades* (1520-21). He claims to have persuaded Pedro Girón with his eloquence to separate himself from the cause of the rebels, and this fact supposedly led to the failure of the whole movement.[10] We find another illustration of the self-aggrandizement in

[8] *Vida de Fray Antonio de Guevara*, p. 22.
[9] See p. 25 of this study.
[10] H. J. Seaver maintains that the bishop's role of mediator, as claimed in the *Epístolas familiares,* has no historical basis. See *The Great Revolt in Castile* (London, 1928), p. 206. Menéndez Pidal and Paul Merimée are inclined to give more credence to fray Antonio's account. The Spanish medievalist's article, "Fray Antonio de Guevara y la idea imperial de Carlos V," ends with this sentence: "Guevara sin duda trataba su propia biografía con el mismo desenfado que la de Marco Aurelio, pero eso no nos autoriza para negar siempre sus afirmaciones; hay en éstas mucho más de cierto que lo que hasta ahora suele concedérsele." (In *Miscelánea histórico-literaria*, Colección Austral, No. 1110, p. 145). Merimée suggests that the bishop may have worked with the mediators, and, in recalling the events, he magnified his own contribution. See his "Guevara, Santa Cruz et le 'razonamiento de Villabrájima'," in *Hommage à Ernest Martinenche* (Paris, 1949), pp. 466-476. Morel-Fatio and Gibbs agree with Seaver. Morel-Fatio says: "Tous les historiens modernes, sauf de rares exceptions, ont cru à ce récit comme à bien d'autres détails soidisant historiques que renferme l'Épistolaire. Très à tort, pensons-nous. Comment admettre qu'un religieux connu seulement alors par son talent de sermonnaire, et qui n'avait d'autres titres à se mêler d'affaires d'État que sa parenté avec le conseiller D. Fernando, ait pu être chargé d'une mission si délicate et de si graves conséquences? Mais ce qui surtout doit inspirer des doutes sur la véracité du P. Antonio, c'est qu'on ne découvre dans les écrits de l'époque, relations historiques ou pièces d'archives, aucune trace du rôle qu'il s'attribue soit à Villabrájima en janvier 1521, soit en d'autres circonstances de cette époque si troublée." (*Historiographie de Charles-Quint* [Paris, 1913], pp. 29-30.) Gibbs believes: "Claro es que la influencia que ejerció Guevara en el

his alleged correspondence with the leading Spanish figures of his time. Six of his letters are addressed to Don Iñigo de Velasco, Constable of Castile, four to Admiral Don Fadrique Enríquez, one each to the famous *Gran Capitán* and to the Duke of Alba (Don Fadrique de Toledo). The outstanding ecclesiastical leaders of the period are also on the list of his correspondents: Alonso de Fonseca, Bishop of Burgos; Alonso Manrique, Archbishop of Seville and General Inquisitor; Fadrique de Portugal, Bishop of Zaragoza; and many other persons of greater or lesser importance. We could multiply these evidences to prove our point – Guevara understood the technique of extension of personality through the medium of the printing press in the same way that El Greco would later project it on canvas.

By speaking of extension of personality, we do not mean to accuse Guevara of bad faith. On the contrary, we do not doubt for a moment the sincerity of his intentions in this regard. All we are saying is that the author of the *Libro áureo* realized that, through the medium of the printing press, his life story could stand as an everlasting *exemplum*, to use a medieval term. Such an *enxiemplo* was more understandable if it

curso de la historia no era tan grande como trata de probar. Esta tendencia a la exageración y a veces a una falta absoluta de veracidad se nota también en otros escritos suyos, y hay que contar con ella al hacer uso de sus propias palabras. Probablemente exageró sin darse cuenta de lo que estaba haciendo, o es posible que trataba de ponerse en buena luz con sus compañeros en la Corte y al último caso, con el Emperador. Lo esencial es que no hay que fiarse demasiado de sus propias descripciones de sí mismo." (*Op. cit.,* pp. 25-26).

José Antonio Maravall's recent book *Las Comunidades de Castilla* claims that it is incorrect to interpret the *comunero* movement as a reversion to medieval traditions and feudal privileges initiated mainly by rural elements. He believes that it was one of the first modern revolutions undertaken by urban elements in the direction of democracy aiming at public participation in the government, popular representation in the *Cortes,* and guarantees against abuses on the part of rulers. Maravall enlists certain statements in Guevara's letters to *comunero* leaders (such as Antonio de Acuña, bishop of Zamora, and Juan de Padilla) for the purpose of fortifying his own arguments. In fact, he takes these statements out of context to bolster his theory. Here is a case in point. Maravall states that Guevara knew exactly that equal taxation was one of the demands of the rebels and quotes part of a sentence in the bishop's letter to Juan de Padilla: "También, señor, os dixe que me parescía gran vanidad y no pequeña liviandad lo que se platicava en aquella Junta, y lo que pedían los plebeyos de la república, es a saber, que en Castilla todos contribuyesen, todos fuesen iguales, todos pechasen y que a manera de señorías de Italia se gobernasen . . ." (*Epíst. fam.,* I, p. 305).

The author then adds: "Está anunciando en estas palabras todo el contenido revolucionario del movimiento, en el doble aspecto político-social." (*Las Comunidades de Castilla,* pp. 238-239). From what Maravall says it would appear that even though Guevara disapproved of the aims of the rebellion, he was conscious of its egalitarian goals. However, when one reads the letters themselves, it is clear that Guevara considered these slogans as smoke screens to obscure the true motives of the leaders – personal aggrandizement.

followed well-established archetypes. Consequently, he interprets his joining the Franciscan order in terms of a conversion, a pale reflection perhaps of the experience of St. Francis.

B. MORAL WISDOM AND TOLERANCE

In discussing Guevara's works it is inevitable that matters of style should receive undue notice. Such a one-sided interest characterizes much of the writing about his books. George Philip Krapp was the first, to our knowledge, who put this issue in proper perspective and pointed out that Guevara's works did not become popular through their stylistic excellence alone. "The main interest of the work *Libro áureo,* both first and second version, lay in its moral wisdom," says Krapp.[11] He emphasizes this point again and again. Neither one of the English translators, Bourchier and North, had any definite feeling for the elaborate prose that the bishop cultivated. "It was not Guevara the stylist who excited their deepest interest, but Guevara the preacher and moralist." [12] Krapp sees the *Libro áureo* and the *Relox de príncipes* as conduct books of the Renaissance which were designed to instruct and guide both the great and the humble in their joys and sorrows. He stresses the idea that a modern reader may scoff at moral platitudes, but well-presented instruction was, according to Krapp, as interesting in the sixteenth century as a clever plot is in a modern novel.[13]

A quick look at the postscript to Bourchier's *Golden Boke of Marcus Aurelius* (1535) and the dedicatory preface of North's *The Diall of Princes* (1557) will bear out Krapp's contention. The postscript to the *Golden Boke* recommends it to princes, governors, ministers of justice, and also to the "common people" for the profound sentences, wholesome counsels, and sound defences contained therein against the machinations of fortune. Moreover, it offers salutary doctrines and an example of virtuous living.[14] Thomas North also cites in his dedication to Queen

[11] *The Rise of English Literary Prose* (New York, 1915), p. 320.

[12] *Ibid.,* p. 325.

[13] *Ibid.,* pp. 314-315. We shall see in the following section that Américo Castro does not accept the idea that moral doctrine was a vital factor in Guevara's success: "It has been stated that the great popularity of these works was due to the fondness of the sixteenth century for moralizing – a manifest fallacy since one may quite as justly assert that the moral theme aroused interest by the form in which Guevara presented it. The truth is that pure moralists are usually boring, attracting more saints than sinners..." *Antonio de Guevara. El Villano del Danubio y otros fragmentos* (Princeton, 1945), p. VI.

[14] John Bourchier, *Golden Boke of Marcus Aurelius,* ed. José María Gálvez (Berlin, 1916), pp. 442-443. The Introduction to Bourchier's translation is actually Gálvez' doctoral dissertation for the University of Berlin (1910).

Mary the salutary effect of the doctrines of his translation of the *Relox de príncipes,* entitled *The Diall of Princes*: "... there is no author [the sacred letters set apart] that more effectually setteth out the omnipotency of God, the frailty of men, the inconstancy of fortune, the vanity of this world, the misery of this life and finally that more plainly teacheth the good which mortal men ought to pursue and the evil that all men ought to fly, than this present work doth." [15] Let us note the phrase, "the good which mortal men ought to pursue and the evil that all men ought to fly." It will clear up another frequent misconception and will enable us to understand better the attitude of Guevara's contemporaries. A racy narrative was frequently justified on the ground that it was just as necessary to hold up examples of evil to be avoided as it was to illustrate commendable actions.[16] Besides, to instruct entertainingly was always considered desirable.

We shall add two instances to underline this important point. In an unpublished doctoral dissertation Carlton L. Iiams studies the South German Counter Reformation thought toward the end of the sixteenth and the beginning of the seventeenth centuries and Aegidius Albertinus' activities therein.[17] He notes that between the years 1562 and 1582 Johann Anton Fugger has his agents in Spain buying Spanish books. They shipped back to Bavaria three hundred volumes of which a third were the works of Spanish ascetics and moralists. These books were placed in the court library which was under the charge of Albertinus. Albertinus, Iiams says, was the driest and strictest kind of moralist without any sense of humor (p. 42). Nevertheless, he translated several of Guevara's works, considering them proper tools for internal moral reform. Albertinus also translated and adapted Mateo Alemán's famous picaresque novel under the title *Gusman der Landstörtzer* (Munich, 1615), for he felt that the

[15] K. N. Colvile, ed., *Selections from the Diall of Princes by Don Anthony of Guevara,* translated by Sir Thomas North (London, 1919), pp. 4-5.

[16] *La Celestina* is a well-known case in point. Bataillon maintains: "Mieux vaudrait dire que ce fut l'interprétation universelle pendant plusieurs siècles, l'intention morale de l'auteur n'étant même pas mise en doute par les puritains qui jugeaient l'oeuvre offensante pour des chastes oreilles." ("Gaspar von Barth, interprète de *La Célestine,*" *Revue de Littérature Comparée,* 31 (1957), p. 321). See also the same author's *La Célestine selon Fernando de Rojas* (Paris, 1961), *passim.* According to Bataillon the didactic intention, in many ways the key to Rojas' creation, is not understood today and consequently other interpretations are sought. María Rosa Lida de Malkiel questions Bataillon's conclusion and calls attention to the psychological insight of Rojas as an explanation for the extraordinary success and "modernity" of *La Celestina. Cf. La originalidad artística de La Celestina* (Buenos Aires, 1962), pp. 292-316.

[17] "Aegidius Albertinus and Antonio de Guevara," University of California (Berkeley, 1956).

didactic element was strongest in the book and the novel was a kind of frame upon which to hang a series of sermons. True, he drastically cut the narrative sections, but the point is that the lurid adventures of Guzmán did not prevent Albertinus from presenting the book as an example of how a man's fate changes and of how he may, despite previous evil conduct, be converted. (It is interesting to note that *Gusman* was so popular it had nine editions. The popularity of *Guzmán* was widespread throughout Europe, and it was highly praised for its moral teachings.) Johannes Wanckelius translated the *Relox de príncipes* into Latin (1611), prepared an index of thirty-two pages pinpointing the most important moral *sententiae* of the work, and filled the margins with thousands of quotations. He treated Guevara's book as if it had been a work of one of the church fathers. True, Wanckelius is considered by many to be naive. However, Albertinus was a serious propagandist for the Counter Reformation, and his estimate of Guevara as a moralist certainly carries weight.

The above-mentioned Thomas North, translator of the *Relox de príncipes* owes his fame to the translation of Plutarch (1579) mainly through Amyot's French version. F. O. Matthiessen who attributes a great part of the English Renaissance to the translations that were done during the Elizabethan period, asks himself the question: What was it that drew North to Guevara's work? He finds the answer in interpreting *The Diall of Princes* as a plea for moderation in politics and behavior: "With the cardinal assumption that the Prince is the fountainhead of all moral excellence as well as the soul of honor, it emphasizes the need of orderly government, and – although Guevara was an inquisitor – of religious toleration." [18]

Guevara's understanding of the position of the Indian has already been pointed out by Américo Castro and others. His censure of "cruel judges" is discussed in Gilman's article, "A Sequel to the *Villano del Danubio.*" His addresses to the "comunero" rebels (whether he actually delivered them or not) also demonstrate his middle-of-the-road position. He admits that there may be legitimate grievances against the ruler, but they do not justify disobedience to a crowned monarch. The correct approach to reform is his own way – trying to educate the prince to be a just, wise, and merciful ruler. He asks for pardon for the rebels on the occasion of the victory over the French and the capture of Francis I: "En remuneración de tan gran vitoria, no os aconsejaré yo que offrezcáis a Dios joyas ricas como los romanos, ni plata, ni oro como los griegos, ni vuestra sangre propia como Mithrídates, ni aun a vuestros hijos como

[18] *Translation, An Elizabethan Art* (Cambridge, Mass., 1931), p. 62.

Jethé, sino que le offrezcáis el desacato y inobediencia que os tuvieron los Comuneros de Castilla, porque no hay a Dios sacrificio tan acepto como es perdonar el hombre a sus enemigos." [19]

A similar tolerant approach characterizes the bishop's attitude toward the relationship between husband and wife. He expounds his views in a letter to a newly married couple, Mosén Puche and Marina Gralla.[20] The titles of the sections of the letter indicate the tenor of his counsel. One recommends lenient treatment of the wife; another warns the husband against being excessively jealous. One would expect a bishop to advise women to visit the church frequently, donate candles, and confess their sins. Instead here are samples of his counsel which explain the popularity of his writings: "¡Qué placer es verla hacer su colada, lavar su ropa, ahechar su trigo, cerner su harina, amasar su masa, cocer su pan, barrer su casa, encender su lumbre, poner su olla y, despúes de haber comido, tomar su almohadilla para labrar o su rueca para hilar!" [21] Guevara contrasts the activities of a busy housewife with those of her counterpart, a lady of leisure: "No estoy bien con las mugeres que no saben otra cosa sino acostarse a la una, levantarse a las once, comer a las doce, y parlar hasta la noche, y más y allende desto, no saben sino armar una cama a do se echen, y aderezar un estrado a do negocian; de manera que las tales no nascieron sino para comer y dormir, holgar y parlar." [22]

In this same letter there is one small phrase where the bishop advises against too much talking and especially nagging on the part of the wife because it may occasion cool relations between her and her husband. Unhappiness results frequently not from what women do but "lo que dicen de sus lenguas." (p. 372) This mild and reasonable phrase is translated into German by Albertinus: "von ihrer bösen / gifttigen vnd vngewaschenen Zungen wegen." [23] This difference in tone is worth noting.

O. F. Matthiessen alluded above to Guevara's religious tolerance. Let us make it perfectly clear that the bishop believed uncompromisingly in

[19] *Epístolas familiares*, I, p. 9.

[20] *Ibid.*, I, pp. 363-390.

[21] *Ibid.*, I, p. 389. If one wished to split hairs, he might claim that the last chapter of the Book of Proverbs, which similarly portrays the praiseworthy woman as being in full charge of the activities of a large household, inspired this passage in the *Epístolas familiares*. However, a glance at practically any page of the *Menosprecio de corte,* where Guevara describes in detail aspects of country life, would convince one that the bishop wrote the above-mentioned passage from personal observation rather than from his study of the Old Testament.

[22] *Loc. cit.*

[23] Cited by Iiams from Albertinus' *Güldene Sendtschreiben,* an adaptation of Guevara's *Epístolas familiares, op. cit.,* p. 93.

the religious unity of the country. He considered Spain a Catholic country and would not have permitted the existence of non-Catholic groups on Spanish soil. He believed that those who still followed Mohammedan rites should be converted by persuasion and propaganda, if possible, or by force if other methods did not achieve the desired results. As a matter of fact, he was a member of a commission appointed by the Emperor in 1524 for the specific purpose of the conversion of the Moriscos of the Valencia area. All this is narrated and documented by P. Angel Uribe's article, "Guevara, inquisidor." [24]

Making allowances for all the above-mentioned facts, one must still admit that fray Antonio was willing to take an unpopular stand when he wrote his letter (again, regardless of whether or not he actually sent the letter to the addressee or simply used the epistle as a literary form) to a secret friend regarding Cidi Abducarim and others who found themselves in a position similar to Abducarim's.[25] The issue concerned the accusation of insincerity directed against Moors and Jews converted to Christianity or, to use Guevara's simple words, calling them *perro moro* and *judío marrano* after they had been baptized. The bishop attacks such practices with heavy artillery: "¿Por ventura sois vos el Dios de quien dice el profeta *Scrutans corda et renes* [the kidneys were supposed to be the seat of thoughts], para que sepáis si Cidi Abducarim es moro renegado, a cristiano descreído? . . . Por ventura tenéis ya de Dios finiquito de vuestros pecados y tenéis póliza para que os registren con los justos, pues a Cidi Abducarim condenáis por moro, y a vos dais por buen cristiano?" [26] Then the bishop spells it out and asks: Since both you and Abducarim are baptized, go to church, confess your sins, observe the holidays, and profess Jesus as your Lord, on what basis do you call him a Moorish dog and consider yourself a great Christian? The consequence of all this will be, the bishop continues, that it will make the task of conversion of the Moriscos more difficult. (We have to keep in mind that he dates this letter from the 22nd of May, 1524, the year in which he began his work among the Moriscos of Valencia.) In addition, the same people who taunt others frequently get into trouble: ". . . porque jamás vi a hombre lastimar a otro hombre, que no le pesquisasen la vida que hacía, y aun que no le espulgasen la sangre de do venía. [Note Guevara's contempt for the process of examining one's lineage shown in the

[24] See *Archivo Ibero-Américano*, (2ª época), 6 (1946), pp. 185-281. This volume has a series of articles dedicated to Guevara on the occasion of the four-hundredth anniversary of his death.

[25] *Epístolas familiares*, II, pp. 375-382.

[26] *Ibid.*, p. 378.

phrase, *espulgasen la sangre.*]" [27] In the end, the taunter will find that because he accused the living, his dead relatives will be investigated.

It is well known that such investigations were carried out in Guevara's time, and judging from the tone of this letter, no one can accuse the bishop of approving of such procedures. On the contrary, one of his remarks indicates that possibly some taint is attached to everyone's lineage: "No sin misterio digo esto, señor; porque a la hora que llamastes a Cidi Abducarim perro moro, digo a mis oídos uno: 'Yo juro a Dios y a ésta que es cruz, que si Cidi Abducarim desciende de moros, que están tambien allí tus bisabuelos en los osarios.' " [28] We are well aware that, according to J. Gibbs, branches of the bishop's family may have intermarried with *conversos* but do not believe that the bishop's attitude can be entirely explained by that fact.[29] We feel that this is just another facet of his generally tolerant views. Such tolerance did not enjoy great popularity in his time.

The tale of Androcles and the lion in the *Epístolas familiares* advocates moderation and kindness in the treatment of servants.[30] The story derives from Aulus Gellius' *Noctes Atticae* as Guevara himself indicates at the end of the letter.[31] A comparison of the two accounts demonstrates what fray Antonio wants to stress – the cruelty and cupidity of the master and the suffering of the slave. The original story allots only one sentence to this aspect: " 'Cum provinciam,' inquit, 'Africam proconsulari imperio meus dominus obtineret, ego ibi iniquis eius et cotidianis verberibus ad fugam sum coactus et, ut mihi a domino, terrae illius praeside, tutiores latebrae forent, in camporum et arenarum solitudines concessi ac, si defuisset cibus, consilium fuit mortem aliquo pacto quaerere.' " [32] In our author's version, the description of the misery of the slave occupies more than a full page. It is worth noting that the greed of the proconsul does not appear at all in Aulus Gellius' version, whereas it occupies an important place in that of the bishop. This shifting of emphasis to greed leads one to believe that Guevara had in mind the rumors and complaints which were raised because of the treatment of the

[27] *Ibid.,* p. 381.

[28] *Ibid.,* pp. 381-382.

[29] "The birthplace and family of fray Antonio de Guevara," *Modern Language Review,* 46 (1951), pp. 253-255.

[30] I, pp. 170-182.

[31] Guevara mentions Apion, too, the Alexandrian grammarian who flourished in the first half of the first century, A. D. The oldest version of the story of Androcles and the lion, preserved in Aulus Gellius, is found in Apion's *Aegyptiaca.* See Encyclopaedia Britannica, 11th ed., article Apion.

[32] Aulus Gellius, *Noctes Atticae,* ed. John C. Rolfe, I (New York, 1927), p. 424. (Book V, ch. 14 in the *Noctes Atticae.*)

Indians rather than the ruthless actions of Roman proconsuls. The slant
that fray Antonio gives the story makes it a counterpart of the *Villano
del Danubio*. It is true that other details of the story are also amplified;
as a matter of fact, Guevara himself apologizes for expanding Aulus
Gellius' version of Androcles and the lion. The author of the *Epístolas
familiares* could have easily dismissed the slave's reasons for fleeing to
the desert in one sentence as was done by Aulus Gellius. The fact that
he chose to dwell upon this item in the tale indicates his desire to evoke
an emotional response supporting humane action. Thus he adds another
appeal for moderation and understanding. In spite of all the rhetorical
embellishments, these incidents show his authentic moral preoccupation.

C. THE APPEAL OF SUBJECTIVITY

Américo Castro approaches the explanation of the success of Guevara
from an entirely different angle. The prose of the bishop catches the
attention and conscience of the reader neither by the information it
contains nor by moral instructions it imparts but by its subjective tone.
The reader senses, thinks Américo Castro, behind the artificial rhetoric
and moral preaching the authentic confession of a soul torn by anguish,
reminding one of what Goethe once said about himself, namely that all
his writings were "Bruchstücke einer grossen Konfession": "This ex-
plains the fabulous success of the works of Guevara in sixteenth-century
Europe. His style bursts its bounds and asserts itself by denying the sound-
ness of the behavior of others; for that affected and surprising style of
his is the direct expression of his otherwise frustrated life and his craving
for salvation." [33] Unable to duplicate the glory of a Gran Capitán, he
veils his unsatisfied dreams with contrasting, staccato sentences which
communicate to the reader his inner struggle and desperation. Just as
Guevara sometimes expresses his own opinions about contemporary
events and customs by hiding behind a famous name of Antiquity, so
does he conceal his resentment against the world by attacking the very
things in which he himself wished to participate but could not, such as
the conquest of the New World.

 Whence came these dreams of unfulfilled glory? Castro explains that
fray Antonio, being a younger son, had to be satisfied with the name and
consciousness of being a Guevara while his older brother inherited the
family fortune. While the discovery of the Western Hemisphere opened
new horizons for the properly placed young noblemen, he could not hope
to attain military victories, like so many of his peers. Instead of achieving

[33] Introduction to *El Villano del Danubio*, p. V.

importance, he had to assume importance. Since other avenues of success were closed to him, Guevara had only one choice left which still meant a certain amount of prestige – to join a monastic order. In his heart he remained a courtier and a lover, as some of the bishop's remarks indicate to Castro.[34] Fray Antonio was unable to combine the old Islamic ideal, exemplified by outstanding monarchs, of deep religious faith, chivalry, and learning into a harmonious whole.[35] Thus in the *Villano del Danubio* he gives vent to his violent antagonism to imperialistic conquests in which he was unable to take part. His forgeries and imaginary addresses are, in the opinion of Castro, manifestations of his constant drive for compensation and the tug-of-war that was going on within his soul between being a bishop and a courtier.

Américo Castro devotes special attention to the significance of the plea for humaneness and pacifism evidenced in the *Villano del Danubio* episode. He is aware, of course, also of the numerous chapters and pronouncements of Guevara in favor of pacifism. He relates this to the intellectual current apparent at the court of Charles V, resulting from the teachings of Erasmus' *Querela pacis* and Thomas More's Utopian ideas. Thus Castro ranks Guevara among those who dreamed of a Golden Age of peace amidst the conquest of imperial armies and who, along with Las Casas, defended the Indian against exploitation. In agreement with Menéndez Pidal's suggestion that fray Antonio wrote the speech which Charles V delivered in Madrid (1528) before he left for Italy, Castro suggests that the Emperor's speech before Pope Paul III (1536) also reveals Guevara's style.[36] This peroration has the pathetic exclamation: "que quiero paz, que quiero paz, que quiero paz." [37] The

[34] Castro has in mind such passages as the following from a letter of the bishop to his sister, Francisca: "Y porque ya ha vergüença mi pluma de hablar más en esta materia, desde agora digo y adevino que dirán muchos de los que leyeren esta carta: '¡Rabia que le mate al fraile capilludo, y cómo debía ser enamorado, pues también habla en amores y en las penas de enamorados!' In the first part of the same letter Guevara writes: 'También decís en vuestra carta que todas las damas os rogaron me rogásedes mucho les quisiese decir y declarar qué cosa es amor, pues *presumo de muy leído y me prescio de gran cortesano*.' *Epístolas familiares*, II, pp. 268-271 and Castro, Introduction to *El Villano*, pp. XIII-IV.

[35] Castro finds that some Spanish rulers, such as Alfonso X, were able to fuse faith, chivalry, and learning into a harmonious whole following the Islamic pattern: "In this way of life, exemplified by the most lofty of Mussulman monarchs, everything found organic unity – something very far removed from the 'uòmo universale' in Italy. But in the soul of Guevara the elements of that variegated ideal of life – knighthood, human wisdom, religion, worldliness – found themselves incompatible and without possible fusion." Introduction to *El Villano del Danubio*, pp. VIII-IX.

[36] *Ibid.*, p. XX.

[37] *Loc. cit.*

author of *España en su historia* offers three explanations for the bishop of Mondoñedo's insistent advocacy of a "pax christiana" that should be established in the New World. We have already seen the first one – Guevara's yearning for greatness, the impossibility of fighting as a knight and as a "Guevara,' 'turned into a condemnation of conquest. The second one is the special Messianic imperialism of the Church: "Without denying the Christian humanitarianism of Las Casas, Guevara, and their kind, we still think that under their violent attack against the Spanish Conquest, and behind all the discussion of the rights of the Crown to the conquered lands, lies the plan, very natural in Spain, to erect a spiritual power, over against that of the State: you conquer with the sword, but we, with our doctrine, shall govern you and the Indians." [38] This was the expression of deep-rooted tradition in Spain which was realized, to a large extent, in the work of the missions in some of the newly conquered lands. (Castro cites the example of the Jesuits in Paraguay.) [39]

The third explanation has to do with the literary vision of Guevara. Castro notes that fray Antonio has a tendency to turn the spotlight every once in a while on the repugnant aspects of life.[40] Such inclination toward naturalism, as Castro calls it, usually harbors a resentful spirit, bent on reducing outwardly noble phenomena to their lowest denominators. The inversion of perspective makes the bishop call attention to the soiled feet as he discusses the courteous salutation "bésoos los pies" and uncovers the stark reality of the mistreatment of Indians behind many a glorious conquest. (This kind of vision, by the way, characterizes some of the picaresque novels, according to Castro.)

Leo Spitzer disagrees with Castro's interpretation that Guevara's prose reflects inner conflicts, repressions, and compensations. He believes that what may be valid about contemporary writers, such as Joyce and Proust, cannot be applied to the literary productions of the sixteenth and seventeenth centuries. It was only after the eighteenth century (when the rights of the original creative genius were recognized) that writers felt free from the traditional norms of writing and insisted on individual ways of expressing themselves. This does not mean, adds Spitzer, that they did not have the same kind of complexes that modern writers sometimes transmit; it only means that they would not think of "sublimating" their repressed desires through the channels of self-expression. To use Spitzer's

[38] *Ibid.*, p. XVII.
[39] *Loc. cit.*
[40] One of the numerous examples is the naturalistic description of Marcus Aurelius' last hours: "A tiempos alçaua los ojos / otras vezes juntaua las manos / callaua siempre y sospiraua continuo: tenia la lengua gruessa / a que no podia escupir . . ." *Relox de príncipes*, III, fol. 202r.

own words: "Imaginar que el elemento subconsciente de un autor del siglo XVI corría, subterráneo, para, disimulado, emerger en rasgos estilísticos propios de tal autor es, creo yo, desconocer las relaciones, todavía sólidas en aquella época, entre el escritor y la tradición literaria. Entonces, lo mismo que hoy, existían iguales complejos; pero no se los vertía en literatura y, lo que es más, ni siquiera se era consciente de ellos." [41]

Spitzer cites a more modern example of the employment of antithesis and parallelism in writing, the prose of the Danish minister, Kierkegaard. The antitheses of the Danish philosopher serve to point up the contrast between true and false Christianity, between the State and a Christian community, between a genius and a Christian, between the theatre and the church, etc. Kierkegaard harbored many resentments, Spitzer continues; he never knew genuine happiness and love, and felt that he was surrounded by meanness and mediocrity. This would fit Castro's description of a moralist – someone who is torn by complexes. However, the parallel with the supposed repressed ambitions and desires stops here; for Kierkegaard uses the techniques of style only in his messages to the public, whereas in his more personal writings such devices are absent. This subtle differentiation should prove, according to Spitzer, that there is no connection between inner problems and staccato style.

After refuting Castro's explanation, Spitzer offers his own: "Yo no creo de ninguna manera que sea el resentimiento personal el que pueda explicárnoslo sino más bien la visión del mundo, esencialmente b a r r o c a [Spitzer probably meant pre-barroca] en Guevara, como un contraste permanente de engaño y desengaño, ilusión [mentira] y verdad, pecado y virtud." [42] Spitzer sees the importance of Norden's arguments which stress the classical origin of ornamental prose reaching back to Isocrates and Seneca. He accepts wholeheartedly the results of María Rosa Lida's investigations which derive the bishop's style in a direct line from the medieval oratory of St. Isidore and St. Ildefonsus. In other words, Guevara's system of "pièces rapportées," as he calls it, is basically a revival of medieval oratory and does not have traces of personal creation as Castro would have it. He also admits María Rosa Lida's contention regarding the "virtuosismo" of such prose. At the same time, Spitzer believes that the bishop uses this "performance" in the service of the art of persuasion and that the message of Guevara, the moralist,

[41] "Sobre las ideas de Américo Castro a próposito de *El Villano del Danubio* de Antonio de Guevara," *Boletín del Instituto Caro y Cuervo*, VI (1950), pp. 1-14. The quote is to be found on pp. 3-4.

[42] *Ibid.*, p. 10.

should be taken seriously. The revival of medieval prose and thought forms in Guevara, demonstrated beyond a shadow of a doubt by María Rosa Lida, means for Spitzer the raising of a larger question – the survival and revival of medievalism in the baroque art and the spiritual relationship between the two epochs.

Juan Marichal continues, to a certain extent, the line of reasoning undertaken by Américo Castro. Investigating the "function" of Guevara's style, he finds that "... el obispo castellano, que se sentía un *déclassé,* como se ha de ver inmediatamente, aspiraba a incorporarse espiritual y literariamente a la aristocracia al identificar su exhibición personal con los privilegios de la sangre." [43] Basing himself on Doña María de Guevara's statement (noted in J. Gibbs's article) that the bishop descended from an illegitimate father, Marichal finds in this fact an explanation for Guevara's insistent affirmations of his aristocratic origin, his constant effort of identifying himself with the nobility in order to improve his marginal position, and his nomination to the non-lucrative bishoprics of Guadix and Mondoñedo.[44] The inferiority complex, implied by Américo Castro, would thus have a factual basis. Even fray Antonio's frequent allusions to his own sins represent, continues Marichal, "pecados de clase"; in other words, they also serve to make himself a part of the nobility.

So far as Guevara's attacks on the court are concerned, Marichal interprets them as "un obligado gesto táctico de participación social, sin ningún fundamento sincero." (P. 119) The bishop's efforts to obtain the canonry of Valladolid and his building several houses in that center of court life provide the proof of the hollow nature of the censure of the court. In addition, was not Guevara a favorite among the courtiers, as is evident from García Matamoros' remark "llevado en palmas por los cortesanos"? The bishop's position in the rebellion of the *comuneros* also shows him as a spokesman of the nobility when he reaffirms the theory of the traditional tripartite division – *oradores, defensores,* and *labradores.* To sum up, fray Antonio's originality rests on converting his literary personality into a "yo estamentario."

Joseph R. Jones in his doctoral dissertation ("Antonio de Guevara's *Una Década de Césares,*" University of Wisconsin, 1962) devotes some space to Guevara's genealogy and the "inferiority complex" stemming

[43] "Sobre la originalidad renacentista en el estilo de Guevara," *Nueva Revista de Filología Hispánica,* IX (1955), pp. 113-128. The quote is found on p. 116.
[44] "The Birthplace and Family of Fray Antonio de Guevara," *Modern Language Review,* XLVI (1951), 253-255. Doña María de Guevara's statement is from the *Memorial de la casa de Escalante y servicios de ella* (Valladolid, 1656), says Gibbs on p. 253.

from the alleged illegitimacy of the bishop's father. Jones reaches several conclusions. Regardless of whether Guevara's father was illegitimate or not, it is admitted by everybody that by the year 1528 Guevara's literary success was an accomplished fact. By the time Guevara published the *Epístolas familiares* (1539) on which many of the conclusions discussed above are based, he was one of the most famous writers of Europe – in fact, one of the few writers who was fortunate enough to see his works admired and translated all over Europe in his own lifetime. His family's importance is not exaggerated by Guevara; his brother was a member of the council of Castile and a knight of the order of Santiago. The bishop himself wrote speeches for Charles V and preached at the funeral of the Emperor's wife. The fact that Guevara was parodied by Francés de Zúñiga proves more than anything else his importance at the court.[45]

Let us reiterate our conviction, before leaving this subject, that inferiority complexes, repressions, and all other forms of psychological problems played just as much a part in previous centuries as they do today. The fact that the technical terms were not in general use does not alter the situation. Nevertheless, before seeking an explanation of Guevara's exaggeration of his own role and importance in the realm of the subconscious, it may be advisable to search for clues in the daily surroundings of the bishop. He lived in a period of Spanish history when, for reasons too well known to detail here, thousands were scurrying around falsifying documents and bribing officials for the purpose of "improving" their lineage. The same thing occurred on the national level. With the emergence of national states, political genealogy reached a fever pitch. The determination of outdoing rival states in antiquity of descent spread all over Europe. Raimundo Lida's study "Sobre Quevedo y su voluntad de leyenda" presents the whole European diffusion of the genealogical mania.[46] In it we see that writers of practically every category sometimes indulged in this practice.[47]

Even cities claimed legendary origin, he points out. Lisbon's original name was supposed to be Ulisabona, testifying to the connection of

[45] See especially p. V, n. 10. The published version (Chapel Hill, North Carolina, 1966) does not contain these observations.

[46] See *Filología*, María Rosa Lida de Malkiel Memorial issue, VIII (1962). especially the section entitled "Los fabulosos chistes," pp. 299-306.

[47] Prof. Lida cites, among others, two lines from Ronsard's *Franciade,* alluding to the privileged position the French enjoyed with Jupiter:

Favorisant les François, qu'il estime
Enfant d'Hector, sa race legitime.

Hector was supposed to have a son named Francus or Francion, the *heros eponymos* of France. Astianacte, Prof. Lida explains, was conveniently changed into Francion. P. 301, n. 96 and p. 302.

Ulysses with the city's origin. Hercules was supposed to have built the city of Barcelona with the help of shipwrecked men who traveled on the ninth boat of his fleet (Barcanona) and were able to save themselves.[48] In such an atmosphere self-aggrandizement flourishes even without the additional generating force of repressions, especially if we consider that Guevara was anxious to leave a definite impression of himself to posterity. In one of his letters as an expression of this Unamunian desire he describes in detail his physical appearance.[49] We feel that the bishop's yearning for fame was typical of the Renaissance period and that it is not necessary to look for further motivation. The curious thing about it is his peculiar, individual way of seeking renown.

D. GUEVARA'S SENSE OF HUMOR

It is surprising to note that aside from the authorities mentioned in José López Sáiz's thesis "El humor en la obra de Guevara" written for the University of British Columbia under the direction of Francisco Márquez Villanueva about the time this study was completed, we know of no other writer who discusses Guevara's sense of humor. This facet of his character is important in forming a fuller and more accurate picture of Guevara, the writer and the man. His humor fits into the general appreciation and application of *agudeza* in this period evident in López de Villalobos, Francés de Zúñiga, and in such collections as the *Sales españolas*. Aside from the rich vein of humor in fray Antonio's works, there are explicit statements which underline the importance he attributed to wit. We shall cite one example where his own wit is also transparent: "Averiguado esta que mas peca el que peca con una fea que no con una hermosa: & el que se emborracha con mal vino que no con bueno: & por semejante de mayor culpa son dignos los que pierden tiempo con juglares *frios* que con juglares *graciosos*." [50] When it came to writing and style, in the bishop's vocabulary *frío* signifies serious criticism.[51]

Jokes about professions can probably boast of a millennial tradition. We shall meet a number of them in Guevara's books. In the *Prólogo general* of the *Relox de príncipes* the author lists five things that found acceptance in the world, such as laws, the alphabet, the building of cities and states, and barbers. The bishop quotes the seventh book of Pliny as saying that the great Scipio Africanus and Emperor Augustus were the

[48] *Ibid.,* pp. 304-305.
[49] *Epístolas familiares,* I, p. 56.
[50] *Relox de príncipes,* III, fol. 196r. The italics are ours.
[51] See, for example, the Prologue to *Una Década de Césares.*

first to have been shaved in Rome. He adds that the purpose of Pliny in mentioning this was to applaud their courage, for it required just as much boldness to let the razor touch their throats as it took for Scipio to fight with Hannibal in Africa or for Augustus to face Sextus Pompeius in Sicily.

Physicians receive their share of banter. Guevara addresses a letter to Doctor Melgar in which he advocates "natural" cures for diseases.[52] In the course of this letter, the bishop jokingly complains about the wrong diagnosis Dr. Melgar made of his ailment: "Pues mi mal no está de la cinta arriba, sino de la espinilla abajo . . . y yo no sé porqué castigastes mi estómago, teniendo la culpa el tobillo."[53] The bishop tells of another experience that he had in Burgos with Dr. Soto which deals with the well-known habit of physicians' not following their own prescriptions. Dr. Soto gave him some repugnant concoction to cure his sciatic fever. Later, when Guevara noticed that the same doctor cured his own ailment with a goodly cup of delicious wine and an orange, he asked for an explanation. Dr. Soto retorted that Ypocrás (Hippocrates) enjoined the physicians to heal themselves with *fumus cepa* (whiff of vine) and their patients with different cures. Apparently Guevara harbored a certain amount of jealousy toward the royal physicians, for in the first book of the *Relox de príncipes* (Chap. 43) he tries to impress upon the mind of the Emperor the greater importance of having wise men surrounding him than of looking for expert medical men ("mayor prouecho haze vn consejo maduro que cien purgas de ruybarbo").

The *aposentadores* were frequently the subject for jokes. Guevara's personal experiences may have prompted him to make this group the butt of his wit. He paints a vivid picture of the troubles the less affluent courtiers have with them in his *Aviso de privados* (Chap. II, "Del trabajo que padecen los cortesanos con los aposentadores sobre los aposentos"). In the *Epístolas familiares* the bishop says that St. John the Baptist preferred remaining in the desert rather than having to deal with the *aposentador*.[54]

In a period when authentic military glory carried the fame of the Spanish soldier into all corners of the inhabited earth, his inevitable counterpart, the *miles gloriosus*, stepped out of the plays of Plautus into *La Celestina* as a living figure. Guevara, who thundered against war, could not fail to show up this caricature of the real hero in a letter of Marcus Aurelius to his friend Cornelius. Once in the army the braggart

[52] *Epístolas familiares*, I, pp. 342-362.
[53] *Ibid.*, p. 343.
[54] I, pp. 117-118.

forgets his humble beginnings and imagines himself to be the Roman Emperor. He braids his beard, makes his hair bristle, speaks in a resonant voice, and revolves his eyes in order to appear ferocious. One day, Marcus Aurelius (the thinly veiled pretense of this happening in Roman times is kept up but this incident is significantly placed in Naples), unseen by the captain, overheard him shouting at his old landlady: "Vosotros los villanos aun no conosceys capitanes de exercitos: pues sabed si no lo sabeys madre: que jamas tiembla la tierra, sino quando es amenazada de algun capitan de Roma: y nunca los dioses embian rayos: sino do nosotros no somos obedescidos." [55] Believe it or not, continues Marcus Aurelius, this same captain was the first to run away in a fierce battle and to abandon his flag. It is an infallible rule that the braver they make themselves appear, the more cowardly they are, says Marcus Aurelius. Guevara presents the braggart once more in his *Menosprecio de corte*. There he is a rustic who has spent some time in the court and then returns to the village. He calls his fellow villagers uncouth churls, dresses carefully, and boasts of his adventures both military and amorous. He claims to have taken part in the famous battles of the Gran Capitán Antonio de Leiva, and Andrea Doria whereas in truth he spent his time in the favorite haunts of ruffians, such as the Zocodover of Toledo and the Potro of Córdoba. (These places remind one of the "chivalresque" adventures of the innkeeper who knighted Don Quijote.) [56]

Finally among the professions most censured and ridiculed by Guevara is that of the *truhán*. In this stand he follows in the footsteps of medieval mentors of princes. We have already seen that Alfonso de Valdés also excludes them from Polidoro's Utopian kingdom.[57] Many years before, another Franciscan, Fray Iñigo de Mendoza – another courtier priest who was in some ways a precursor of our bishop – objected to the generosity displayed toward them:

> Traen truhanes vestidos
> de brocados y de seda,
> llamanlos locos perdidos,

[55] *Libro áureo*, p. 213 and *Relox de príncipes*, III, fol. 166v. María Rosa Lida de Malkiel studies the figure of the *miles gloriosus* in *La Celestina*, his antecedents, and his successors in *La originalidad artística de la Celestina*. Buenos Aires (1962), pp. 693-720.

[56] *Menosprecio de corte*, pp. 143-145. Some other places rivaling these were the Triana and Compás of Seville, the Calongía of Segovia, the Corrillo of Valladolid, etc.

[57] *Diálogo de Mercurio y Carón*, p. 191.

mas quien les da sus vestidos
por cierto más loco queda.[58]

A look at Velásquez' painting *Las meninas* is sufficient to indicate the
fact that the court beginning with Philip II, if not earlier, swarmed with
jesters, *locos,* dwarfs, and black boys employed as servants. As the ways
of the world go, it was probably much more important to have a famous
truhán in one's court than a learned chaplain. This may explain some of
the animosity of spiritually inclined men against them.[59]

Old age and the combination of old age and love are time-honored
subjects for humor. In the fifth chapter of his *Menosprecio de corte y
alabanza de aldea* every paragraph begins with the formula "Es privilegio
de aldea" and there follows the enumeration of the advantages rural life
offers as against city life, such as fresh air, delicious food, quiet and
dignified existence, enough leisure time, etc. The same formula is em-
ployed in quite a different way in his "Letra para Don Alonso Espinel,
corregidor de Oviedo, el cual era viejo muy polido y requebrado, a cuya
causa toca el auctor en como los antiguos honraban mucho a los
viejos." [60] The letter begins in the habitual manner, that is, quoting Greek
philosophers' and Roman authors' opinions concerning the dignity and
wisdom that age carries with it. Then he continues with a list of fifty
advantages that old people have, using the formula "Es privilegio de."
What are some of these privileges? "Es previlegio de viejos ser cortos
de vista, y tener en los ojos lagañas, y muchas veces no hay nubes en los
cielos, y tiénenlas ellos en los ojos, y sola una candela paresce ser dos
candelas, y aun otras veces desconoscen al amigo y hablan por él al
estraño." (P. 389) Or "Es previlegio de viejos de nunca estar sino quexán-
dose, ora que les duele la rodilla, o que tienen el hígado escalentado, o
que sienten el baço opilado, o que el estómago les fatiga, o que la gota,
les mata, o que la ciática los desvela . . ." (P. 394).

The bishop directs two satirical letters to Luis Bravo and one to Mosén
Rubín demonstrating the disadvantages they will encounter if they go
through with their plans of marrying young women – a commonplace in
Guevara's times. Fray Antonio gives free rein to his ebullient humor
when he discusses the effect of love not merely on old men but on old
philosophers. He may have had in mind the embarrassment of Virgil,

[58] Cited by José Moreno Villa, *Locos, enanos, negros y niños palaciegos*
(México, 1939), p. 24.
[59] Moreno Villa states that within a century and a quarter there were a hundred
twenty-three of these persons in the court of Philip II and his successors. *Ibid.*,
pp. 15-16.
[60] *Epístolas familiares,* II, pp. 383-399.

a well-known tale in the Middle Ages, and amplified it by using the list of the Seven Wise Men of Greece and showing how every one of them was discomfited by a love experience. The humor is heightened by making old philosophers the heroes of the anecdotes. Pithacus left his own wife for the sake of a slave girl he brought from the war. Periander killed his wife at the request of his *amigas*. Cleobolus, an octogenarian mentioned before, found his death while trying to scale the walls of a lady's house.[61] The importance of these adventures rests, it appears to us, in the method of amplification – taking a motif and carrying it *ad absurdum*.[62]

From his very first publication, the *Libro áureo*, fray Antonio insisted on depicting Marcus Aurelius not only as a Stoic philosopher and a wise ruler but also as an *enamorado*. This facet of the Emperor's character enables the bishop to explore and utilize for humor the shadowy realms of love. The author of the *Libro áureo* had already held up examples of heroic and noble love, such as the story of Camma and Sinorix which, according to Rafael Lapesa, anticipates in some ways the sentimentalism of the pastoral novel.[63] It is important to keep in mind that the humorous love letters are placed in a separate collection (after the biography of Marcus Aurelius) and are not a part of the book itself. Furthermore, this first version never carried his name; he was supposed to be only an interpreter. When the second version bearing his name was published, these letters were omitted. With all these precautions he secured for himself freedom of movement and entered the fascinating world of the *alcahuetas*, their victims and their clients. The first letter to the courtesans is occasioned by a public celebration during which the Emperor was represented by the *enamoradas* as holding a book upside down portraying him as a fake scholar, with his tongue far out to symbolize his propensity for talking too much, and several more such features of an insulting nature.

[61] *Libro áureo*, pp. 309-310.

[62] Guevara follows a similar procedure in the case of the Ship of Fools motif. The allegory of life as a sea voyage is an ancient and universal *topos*, James B. Wadsworth explains (*Op. cit.*, pp. 98-101). Its unusual popularity at the end of the fifteenth century, Wadsworth says, was due to the combination of the moral lesson of sinners hurrying to their eternal damnation with the *États du monde* idea. Guevara takes this gloomy image of life and uses it in a humorous way by giving it a literal interpretation. His Ship of Fools carries to Hellespontus actual and professional fools, not representatives of capital sins. *Libro áureo*, pp. 265-270, *Carta XI*. The idea of putting jesters, strolling minstrels, drinkers, and men of similar character together on a ship and deporting them was a familiar one during the Middle Ages. Allegedly such a voyage, starting from Aachen, was actually undertaken and formed the basis of the poem, "Das Schif der Flust," by the Austrian Heinrich Teichner (about 1360). See Edwin H. Zeydel's translation of Brant's *Ship of Fools* (New York, 1944), pp. 11-12.

[63] Introduction to the Clásicos Castellanos edition of Montemayor's *La Diana*, p. XX.

Not satisfied with this, the *enamoradas* built a statue of the Emperor in which every part of his body was formed of a different material (to symbolize his duplicity) and had it hanging upside down the whole day. Marcus Aurelius addresses the ladies of easy virtue individually, recalling their weaknesses. Toringa attempted to count her lovers one day in front of Marcus Aurelius and found that her fingers proved insufficient and ordered a sack of chick-peas to be able to finish the count. Rotoria spent two years of her youth on a pirate's boat, committing immoralities with the whole crew. Camilla learned all the languages of the earth through personal contact with foreigners.[64] Several half-humorous and half-ironic letters follow which were, no doubt, instrumental in securing success for the author.

A humorous combination of love and religion was also a traditional avenue for winning the applause of the readers. Guevara did not fail to exploit this area. The *Epístolas familiares* contain an epistle addressed to Don Enrique Enríquez in which "el autor cuenta la historia de tres enamoradas antiquísimas; y es letra muy sabrosa de leer, en especial para los enamorados." [65] An inquiry on the part of Don Enrique prompted this missive. He bought what he believed was an icon with three feminine figures called Sta. Lamia, Sta. Flora, and Sta. Laida. Then the bishop continues: "Queríades agora vos, señor don Enrique, saber de mi quiénes fueron estas tres mugeres, de dónde fueron, en qué tiempo fueron, a dó murieron y qué martirio pasaron; porque, según me escribís, las tenéis en vuestro oratorio colgadas y les rezáis cada día ciertas avemarías." [66] Guevara is apparently greatly perturbed by this inquiry and, were it not for the inexperienced age of the inquirer, he would have considered it an affront to be consulted on such mundane matters. His indignation forms part of the humorous situation for the author, after such strong protest, goes ahead to relate in a light and witty manner the life stories of the three famous courtesans, even though he knows that he should rather describe the life stories of three *santas* instead of three *rameras*.[67] Flora, Guevara says, excelled over Lamia and Laida in "sangre y generosidad, porque fue de sangre muy limpia." The *limpieza de sangre* manifested

[64] *Libro áureo*, pp. 281-289, *Carta* XIII.

[65] I, pp. 435-448.

[66] *Ibid.*, I, p. 438.

[67] Guevara's protest against the inquiry is worth recording: "En mi hábito, por ser de religioso; en mi sangre, por ser de caballero; en mi profesión, por ser de teólogo; en mi oficio, por ser predicador, ni en mi dignidad, por ser de obispo, no se sufre semejantes vanidades preguntar, ni menos platicar, porque el hombre de bien no sólo ha de mostrar su gravedad en las obras que hace, mas aun en las palabras que dice y en las pláticas que oye." *Epístolas familiares*, I, p. 437.

itself in three ways. First, she had a sign on her door which announced that no one under the rank of *quaestor* is permitted to knock and enter. The second was her generous attitude: "Layda y Flora fueron en las condiciones muy contrarias, porque Layda primero se hacía pagar que se dexase gozar, y la Flora, sin hacer mención de la paga, se dexaba tratar la persona." [68] Should any reader have missed the point about the *limpieza de sangre*, Guevara mentions it again before he explains how it affected the possessor of such distinction: "Esta enamorada Flora siempre tuvo respeto a la buena sangre que heredó, y a la nobleza en que se crió, porque, si vivía como enamorada, siempre se trataba como señora. El día que ella cabalgaba por Roma, dexaba qué decir un mes en toda ella . . ." [69]

Even though we have been concentrating our attention on fray Antonio's secular works, it should be emphasized that Guevara could not resist introducing humor even into his religious writings. Francisco Márquez Villanueva is the first scholar to point out this fact. He studies the daring nature of the bishop's humor, its significance for the history of pulpit oratory, and its sociological function in the establishment of personal contact between the modern reader and writer.[70]

Imitation of foreign dialects, especially Portuguese, offered many opportunities for humor. We encounter them in the letters of Doctor Villalobos, in the *Crónica burlesca* of Zúñiga, and in Antonio Paz y Melia's *Sales españolas* collection (particularly in "Las glosas al Sermón de Aljubarrota," attributed to Diego Hurtado de Mendoza). Guevara avails himself of this rich vein of wit. The occasion that prompts the bishop's "essay" (to use an anachronistic expression) on tombstones and inscriptions is an alleged inquiry by Admiral Don Fadrique who wished to be informed about the historical background of different forms of burial and the marking of graves. After a serious beginning, the bishop quotes the statement of the guardian of Santarem according to which his monastery has the tombstone of a renowned hidalgo with the following inscription:

> Aque yaze Basco Figueyra
> muyto contra su voluntade.[71]

[68] *Ibid.*, I, p. 446.
[69] *Loc. cit.*
[70] "Fray Antonio de Guevara o la ascética novelada," pp. 15-66. See especially subsections entitled "La pasión según Guevara" and "Humor y predicación."
[71] *Ibid.*, I, p. 468. Herrero-García's *Ideas de los españoles del siglo XVII* (Madrid, n. d.) has a chapter dealing with the attitude of Spaniards toward Portuguese. Chapter III, pp. 125-168.

Guevara remarks that he had seldom if ever heard such words of wisdom and perspicacity. They bear witness to the judicious spirit and penetrating insight of the Portuguese noblemen. Upon reflecting for a minute, he says, one will have to admit the correctness of the observation; anyone should prefer even a narrow hut to a magnificent mausoleum. It is certain that not only does Basco Figueyra lie buried against his will but so do the pharaohs in their pyramids, Cyrus under the obelisk, and many others. He predicts that his correspondent, Admiral Don Fadrique, will also be carried to his sepulchre against his wishes, even though a superb and richly decorated chapel will be waiting for him.

Another inscription, involving the dialect of the Mondoñedo region, is quoted in the same letter:

> Aqui yace Vasco Bello,
> home boo y fidalgo,
> que, trazendo espada,
> a ningem mato con ela.[72]

The bishop was sent to Granada by Charles V (1526) to investigate the Morisco problem there since he had gained experience in dealing with it during his work in Valencia as a member of a commission, named by the Emperor to solve the Morisco issue.[73] During his stay in Granada, the bishop heard the story of the last Moorish king related to him by an old Morisco. In his letter to Garcisánchez de la Vega (*Epístolas familiares*, II, pp. 251-254) Guevara parodies the way the old Morisco speaks Spanish: "Si querer tú, alfaqui, parar aquí poquito poquito, a mí contar a ti cosa a la grande que rey Chiquito y madre suya facer aquí." (P. 252).

Although we have mentioned the witty addresses fray Antonio uses in his missives before, they may be listed again as a form of humor. We cite two examples taken at random: "Honrado y obstinado judío" (II, p. 277) and "Especial señor y sospechoso amigo" (II, p. 439). The word plays, such as "es aseada y aun deseada" (II, p. 292), "no es el hospital de Burgos tan frecuentado de romeros como lo es vuestra casa de rameras" (I, p. 471), and the frequent "absoluto y dissoluto" foreshadow the future *conceptismo*. There are numerous unclassifiable instances of humor in the works of Guevara which, no doubt, promoted their acceptance by the reading public.

Several other reasons have been offered to explain Guevara's popularity. J. Gibbs suggests that the bishop was fortunate in publishing his

[72] *Epístolas familiares*, I, p. 468.
[73] See P. Angel Uribe's study "Guevara, inquisidor del Santo Oficio," *Archivo Ibero-Americano*, VI (1946), pp. 185-281.

works during a period when there was relatively little else available to read.[74] On the other hand, Louis Clément believes that Guevara was merely riding the crest of popular currents. *Gli Asolani* and *Il Cortegiano* had awakened interest in court life and in high society. The public that delighted in *Amadís* and *Orlando furioso* received with enthusiasm fray Antonio's novel of Antiquity. The *Libro áureo* and the *Relox de príncipes* offered a combination of history, moral instruction, and interesting letters. All this "séduisit la foule des demi-lettrés et des ignorants." [75] While we freely admit that Guevara's works reflect all currents of thought of the period, such as interest in the classics, the preparation of a courtier, navigation, escape from city life, and even mysticism, we still believe that merely negative factors (ignorance of the masses) would not have produced a success which is characterized by Farinelli in these words: 'Otro éxito prodigioso, que hoy día apenas se concibe, es el de los escritos filosófico-morales de Antonio de Guevara. No había biblioteca de Francia, algo importante, donde faltaran el *Relox de príncipes* y *El libro de oro de Marco Aurelio*.' [76] The factors which we have discussed are not mutually exclusive. They all contributed to Guevara's success.

[74] *Vida de Fray Antonio de Guevara*, p. 12.
[75] *Op. cit.*, pp. 590-591.
[76] "España y Francia" in *Ensayos y discursos de crítica literaria hispano-euro-pea*, p. 320.

VI. GUEVARA AND THE ENLIGHTENMENT

The reaction of the critics to Guevara in this period was understandably limited, since with the passage of time interest in his works slackened. If García Matamoros viewed disapprovingly the popularity of the bishop among the courtiers, Pierre Bayle (1647-1706), whose opinions about fray Antonio will form the greater part of this chapter, expresses astonishment at the fact that Guevara was translated into so many languages and tries to shift most of the blame for this onto Spanish shoulders: "On ne saurait assez admirer l'empressement que les étrangers ont eu de traduire en diverses langues quelques-uns de ses ouvrages ... je montrerai que si les Français sont blâmables d'avoir fait beaucoup de cas d'un pareil livre, les Espagnols, qui l'ont encore plus estimé, sont plus dignes de risée." [1] As evidence, Bayle points to the Prologue of the *Relox de príncipes* where Guevara relates how the manuscript was copied by many hands, and unauthorized editions of the whole work appeared in Seville, Portugal, and Aragon. At the same time, he admits that many Frenchmen were duped, and the *Horloge des Princes,* as it was called in the French version, enjoyed great popularity.

Bayle's long article on Guevara would remain puzzling if one did not take into account some penetrating explanations in the studies of such modern experts as Ernest Cassirer, Paul Hazard, and Elisabeth R. La-

[1] *Dictionnaire historique et critique,* 16 vols. (Paris, 1820), art. GUEVARA *in corp.* In notes F and H of this article Bayle spells out clearly what he has in mind. He is defending his compatriots against the remarks of Andreas Schott, published in his *Hispaniae Bibliotheca.* The Dutch Jesuit accused the French of too much eagerness to translate the bishop's works. Schott also criticizes the French (in article PETRUS RHVA NVMANTINVS of his *Bibliotheca*) for calling the *Epístolas familiares* golden, that is *Épîtres dorées.* This censure of Schott is only another version of Montaigne's statement that he would dissent from the judgement of those considering these letters of Guevara golden. See *Essais,* I, ch. XLVIII, p. 365.

brousse.[2] One should keep in mind, Cassirer warns the reader, that Bayle had certain preferences which prompted him to choose the subjects to be discussed and those which should be omitted. As a matter of fact, Bayle's original purpose was to publish a lexicon in which the errors and the pro-Catholic slant of Moréri's *Grand Dictionnaire Historique* (Paris, 1674) would be corrected. Bayle also planned to exclude subjects that were already properly covered by Moréri and other compilations.[3] It is also important to be aware of the fact, these experts remind us, that Bayle had a burning interest in certain topics, such as reason and faith, superstitions, tolerance, and ancient and Renaissance history, and he would use every opportunity to present his views on such topics. With these provisos in mind, it becomes clearer why the great pioneer of the Enlightenment should have expatiated on Guevara.

The bishop of Mondoñedo above all gives Bayle an opportunity to attack the falsification of history – continuing in new terms the dismay of Pedro de Rhua. This is an especially important issue with Bayle, since he feels that the distortion of true facts is one of the main reasons for the perpetuation of the cruelties, oppressions, and abuses that those in power are able to perpetrate with impunity. It is for this reason that he is determined to correct the lies of Moréri and to preserve for eternity the exact places and dates of the crimes of unjust rulers, a true record of the ambitions and abuses of ecclesiastical authorities, and symbolically to erect a historical marker at every place where innocent people were brutalized by their tormentors. Bayle realizes that this is an almost hopeless task for the powerful always find willing lackeys who, under the guise of scholarship, are ready to lie: "Il n'y a point de mensonge, pour si absurde qu'il soit, qui ne passe de livre en livre et de siècle en siècle. Mentez hardiment, imprimez toutes sortes d'extravagances, peut-on dire du plus miserable lardonniste de l'Europe, vous trouverez assez de gens qui copieront vos contes, et, si l'on vous rebute dans un certain temps, il naîtra des conjonctures où l'on aura intérêt de vous faire ressusciter." [4] Guevara is thus another Moréri in the eyes of the author and, as a matter of fact, Bayle applies exactly the same strong term of condemnation to both Moréri and Guevara, "empoissonneur public." [5] That phrase still possessed a great deal of emotional content; accusations of the poisoning of public wells were not as remote as they are in our days.

[2] Ernest Cassirer, *The Philosophy of the Enlightenment* (Princeton, 1951), pp. 202-203; Elisabeth R. Labrousse, *Pierre Bayle*, 2 vols. (La Haye, 1964); and Paul Hazard, *La crise de la conscience européenne* (Paris, 1961 ed.), pp. 90-105.

[3] Cassirer, *op. cit.*, p. 202.

[4] *Dic.*, art. CAPET, note Y.

[5] For Guevara see Art. GUEVARA, note B; for Moréri art. CALIUS, note D.

Kenneth R. Scholberg explains Bayle's strong censure of fray Antonio in the following manner: "Although Guevara held the post of chronicler to Charles V, he really was not a historian, but rather a moralist, putting his concept of society into literary forms that would be agreeable to his readers. Bayle was utterly incapable of comprehending such a purpose and treated Guevara only as a historian. Therefore his judgment of him is probably the harshest he ever wrote of any author." [6] While we partially agree with Scholberg's reasoning, we feel that there is more to it than meets the eye. We would be more inclined to say that elements other than misunderstanding played an important role in Bayle's treatment of the bishop. First of all, Bayle gathered most of his information about Guevara from Nicolás Antonio's *Bibliotheca Hispana Nova* (as is evident from the footnotes) which lists many of the condemnations of the bishop by the humanists for mishandling history. Second, the French polygraph underlines the word *chroniqueur* of Charles V, thus indicating his right to expect only factual reporting of events. Finally, we have to consider additional factors which we feel influenced Bayle's thinking.

We are referring to the fact that Guevara was a Spaniard, a Franciscan monk, held the office of bishop, and was even connected with the Inquisition. Bayle was interested in Spanish theological developments and especially in the practices of the Holy Office. Since according to Scholberg "little or nothing has appeared about his [Bayle's] attitude toward Spain and his opinions of the writers of the Iberian Peninsula," we shall explore this area somewhat.[7] In his article on Japan, Bayle takes to task a Jesuit missionary, Father Crasset, who wrote a history of the Church of Japan in 1689 in which he admires the profound judgment of God in permitting martyrs, blood to flow for the expansion of Christianity and the addition of numerous Christian converts just as had happened in the first three centuries of the history of the Church. Bayle protests against such a comparison and raises the whole question of missions and specifically why there is such a difference between the immediate success of the primitive Church and the diminished results of the proselytizing efforts of sixteenth-century missionaries. The answer according to Bayle, lies in the nature of the Church as it was in its beginnings and that of the present Church. The primitive Church represented a humble and patient religion which did not aspire to temporal power and was willing to obey the sovereign. In contrast, he continues: "... le Christianisme, qui fut

[6] *Pierre Bayle and Spain,* p. 20.
[7] *Ibid.,* p. 1. Pierre Courtines' article "Spain and Portugal in Bayle's *Dictionnaire,*" is no more than a list of about forty Spanish and Portuguese entries discussed by Bayle. It is in *Hispania,* XXIV (1941), pp. 409-415.

annoncé aux infidèles au XVI^e siècle, n'étoit plus cela. C'étoit une Religion ambitieuse, sanguinaire, accoutumée au carnage depuis cinq ou six cents ans. Les buchers, les bourreaux, le tribunal effroyable de l'Inquisition . . . étoient les moyens ordinaires qu'elle employoit contre ceux qui ne se soumettoient pas à ses ordres." [8]

It is by such methods, Bayle claims, that the Spaniards introduced Christianity into the Western Hemisphere. He corroborates his statement by relating what a naive and frank Spaniard answered when he was questioned by the king of Tossa about how the king of Spain was able to conquer such a vast expanse of land both in Europe and in the Western Hemisphere. The Spaniard replied that the king of Spain first sends missionaries to preach the Evangelium to the uncivilized nations; once a good number of pagans are converted, he sends his troops who, together with the newly won Christians, subjugate the land.[9]

Bayle's article on Bartolomé de Carranza affords him an opportunity to give vent to his inner anguish while ostensibly he was only attacking the methods of the Spanish Inquisition. First of all, he dwells on the innocence of the prelate persecuted by the Inquisition. Considering the harrassments Bayle himself had to suffer on account of his religious views and the many statements that had to remain unsaid in order to avoid even more bitter accusations, the French apostle of religious tolerance marvels at the restraint of the Archbishop of Toledo in refusing to blame his accusers, even though he was convinced of his own innocence. He tells how Carranza, having a presentiment that his death was near, protested with tears in his eyes in the presence of the holy sacrament and all the monks of the Convent of Minerva in Rome that he had never committed a mortal offense in matters of faith; nevertheless, he regarded the sentence meted out to him as just in view of the allegations and proof brought against him. The common people were so deeply convinced of his innocence that on the day of his funeral all businesses were closed as if it had been a holiday.

[8] *Dic.*, art. JAPON, note E. The difference between the primitive Church and the present one is a favorite topic. Pierre van Paassen says that the victory of the Church in the days of Constantine the Great represents the unholiest hour in the history of Christianity. See *The Forgotten Ally* (New York, 1943), p. 40.

[9] *Dic., loc. cit.* In spite of this popular accusation, Scholberg points out, Bayle did not accept the *leyenda negra* which, by that time, spread all over Europe. Scholberg calls attention to article PIERRE CIEÇA DE LEÓN whose *Historia del Perú* Bayle had read in the Italian translation of Agustin de Gravaliz (1555). Convinced of the accuracy of this account, Bayle thinks that it is unjust to maintain that Spain had corrupted the natives of the Western Hemisphere; they were depraved enough when the Spaniards encountered them. See Scholberg, *op. cit.*, p. 7.

As is known, the Archbishop of Toledo was called to the deathbed of Charles V. On account of this fact there was speculation about the possible secret sympathies of the Emperor with the tenets of the Reform. In order to stop any such conjecture, Bayle continues, historians were ready to falsify facts and claim that the Archbishop was summoned only that he might be upbraided by the Emperor for his doubtful allegiance to orthodox views. Bayle finds Count de la Roca and Sandoval, both historians of Charles V, most guilty of such distortions.[10] As far as Carranza is concerned, Bayle is convinced of his innocence because of his own bias against the Inquisition, just as many other writers unquestioningly accept the verdict of guilty because the Holy Office convicted him. It is worth noting that the controversy concerning Carranza is still continuing.[11]

As for Bayle himself, it is well known that he was torn between the conflict of faith and reason. This division in his soul is so evident that students of Bayle are still attempting to determine whether to consider him a sceptic or a believer.[12] If we accept the view, proposed by Delvolvé, that Bayle was desperately and sincerely trying to retain his faith even though tormented by doubts, his sympathy for the Archbishop of Toledo becomes very understandable. He saw in the imposing figure of the Archbishop a man who experienced persecution because he was seeking the truth. As a matter of fact, when the Walloon consistory demanded the modification of some of his controversial articles, Bayle made a statement which reminds one of Carranza's protestations of innocence: "Je n'ai jamais eu dessein d'avancer comme mon sentiment aucune doctrine qui fût contraire à la confession de foi de l'Église Réformée dont je fais pro-

[10] Dic. art. CARRANZA, in corp. and note C.

[11] Two of the more recent opinions are contained in the collection of articles in Corrientes espirituales en la España del siglo XVI, Juan Flors, ed. (Barcelona, 1963). Since P. Beltrán de Heredia gives a summary of his views, we shall quote therefrom: "En síntesis repito lo que he dicho muchas veces: a mi parecer, Carranza ni fue hereje ni vehementemente sospechoso de herejía. Fue solamente incauto sobre toda ponderación, temerario, terco en sumo grado y refractario a los consejos de la prudencia. Si a estas cualidades añadimos lo peligroso de aquellos tiempos, la oscuridad de su estilo, su falta de precisión y sus encarecimientos reconocidos por sus mismos partidarios, tendremos materia sobrada para explicar el drama de su proceso y condenación." See his article "Espiritualidad dominicana en Castilla del siglo XVI," pp. 177-202. P. José Ignacio Tellechea Idígoras, on the other hand, sees in Carranza one of the genuine reformers of the Catholic Church and compares his figure and his activities with those of the Beato Juan de Ávila. See his article entitled "Ideario ascético-pastoral de Bartolomé Carranza, O. P.," pp. 203-245.

[12] See E. D. James' "Scepticism and Fideism in Bayle's Dictionnaire," French Studies, XVI (1962), pp. 307-323 and H. T. Mason's "Pierre Bayle's Religious Views," French Studies, XVII (1963), pp. 205-217.

fession et dans laquelle je demande à Dieu la grâce de me faire vivre et mourir. S'il se trouve donc dans mes ouvrages quelque doctrine de cette nature, je la désavoue, et je la rétracte entièrement dès aujourd'hui." [13]

The veneration accorded Carranza by the people elicits another resigned comment from Bayle. It is not enough, he says, that the people should perceive the innocence of the persecuted; it is necessary that they express their indignation against this iniquitous Tribunal and brand the evil judges with the mark of infamy so as to prevent an innocent man from being ruined because of miserable denouncers. However, Bayle concludes, this might be too much to expect of the people: "Mais ce seroit exiger trop de choses à la fois de la multitude. C'est aux sages à voir cette double iniquité, – à respecter humblement la providence, qui permet non seulement que le Tribunal de l'Inquisition, véritable abomination introduite dans les Lieux saints, triomphe – régne depuis si long-temps en plusieurs lieux de la Chrétienté; mais aussi qu'il allonge peu-à-peu ses phylactères, – qu'il répande ses fibres – ses racines de toutes parts." [14]

In Constantino Ponce de la Fuente, Bayle also sees a congenial spirit. Although Dr. Constantino was a celebrated orator, he could not reveal all his sentiments, for that would have delivered him to enemies. Instead, he put down in writing the thoughts he could not communicate in his sermons. These writings of Dr. Constantino supposedly dealt with the true Church as against that of the Pope whom he calls the Antichrist; the sacrament of the Eucharist; the Holy Mass which was invented for the purpose of mesmerizing the ignorant; the justification by faith; papal bulls and indulgences, etc. These writings fell into the hands of the Inquisitors who put him in prison. There he died a horrible death as the result of cruel treatment and unbearable conditions in the furnace-like prison of Seville. The agents of the Inquisition spread a rumor that Dr. Constantino had committed suicide in order to avoid the ignominy of being burned at the stake. They even composed songs for school children about the matter. On the day of the planned execution, a straw figure was dressed up to represent his body as naturally as possible; in other words, they burned him in effigy. Since Bayle mentions in the article about Constantino Ponce de la Fuente that he had read Reinaldo González de Montes' (Reginaldus Gonsalvius Montanus) *Sanctae Inquisitionis Hispanicae Artes aliquot detectae* (Heidelberg, 1567), there is no doubt about the source of this anecdote which, by the way, Bataillon considers of doubtful value.[15]

[13] Quoted by H. T. Mason, *op. cit.*, p. 207.
[14] *Dic.* art. CARRANZA, note D.
[15] *Dic.* art. PONCE and Bataillon, *Érasme et l'Espagne*, p. 568.

We have cited these examples to show Bayle's preoccupation with the victims of the Inquisition and his tendency to identify himself with the persecuted. Keeping these points in mind, we surmise that part of the venomous attacks on Guevara by Bayle should be attributed to the fact that the bishop was associated in his mind with the hated persecutors of heretic thoughts. Bayle was surely enough of a scholar to know that Guevara was not alone in taking liberty with historical facts and clothing his anecdotes with the authority of respectable authors. Since he comments so many times on historians' lack of integrity, we feel that these additional factors account for his particularly severe censure of the bishop.[16]

Bayle praises Pedro de Rhua for attacking fray Antonio's statement about the uncertainty of any history except that which is contained in the Holy Scriptures: "Il [Guevara] se servit de cette excuse, quand il se vit poussé à bout par le docte Pierre Rhua. . . . Rhua ne laissa point jouir de ce subterfuge; il écrivit contre lui pour la certitude de l'histoire." [17] It is intriguing to see the workings of two minds as different as those of Pedro de Rhua and Bayle. While Rhua fills whole columns with detailed quotations about the importance of history in the abstract, Bayle clears up the issue in a few sentences. He almost seems to correct Rhua when he explains what the issue is. Whether or not Guevara was a historical Pyrrhonist is relatively unimportant. What matters, Bayle says, is that no one has the right to attribute to Caesar or Cicero what he himself has invented. No author can presume to make private rules for himself; he has to conform to accepted standards. These standards require that one accept as true that which is stated by serious authors of Antiquity and reject as fable all that recent authors allege concerning Antiquity which cannot be substantiated by the testimony of respected ancient historians. If he does not conform to these rules, he should be treated as a "séducteur public." [18]

It is apparent from the above that by the time of the Enlightenment there was no genuine interest in Guevara's works as such. The reasons for such a development are understandable; serious scholars carried on the work begun by Renaissance pioneers. The reading public's taste had changed, and they were not interested any more either in collections of ancient and medieval lore or in moralistic teachings of a bygone century. As María Rosa Lida explains, Guevara's style hastened the decline of

[16] Note D of art. GUEVARA has an instructive anecdote about three falsifiers of history. Bayle suggests that Guevara could join the triumvirate.
[17] *Loc. cit.*
[18] *Loc. cit.*

interest in the bishop's writings.[19] As far as Bayle is concerned, he availed himself of the bishop's writings as a vehicle for espousing the cause of the humanists and for censuring the bishop, Moréri, and other historians for misstatements, misattributions, and lack of integrity. Because Bayle is such a renowned author and because so much has been said about him by others, we have limited ourselves largely to exploring those areas about which little or nothing has been previously written – areas which help us understand better his attitude toward Guevara.

The other major author of this period who showed a certain amount of interest in the bishop's works was Fray Benito Jerónimo Feijoo. There are only a few references in Feijoo's works to Guevara; all were briefly commented upon by María Rosa Lida.[20] We shall focus our attention on these passages in somewhat more detail after a few general reflections. One of the best ways to study the Benedictine monk's approach to writers of the past, we believe, is to read his discourse on "Glorias de España" and to note whom Feijoo admires and whom he omits or criticizes.[21] Needless to say, Guevara, together with many others such as Quevedo, does not appear among the authors whom the Galician monk considers as bright stars in the firmament of Spanish literary fame. It is sufficient to peruse the list of those whom he does esteem in order to explain his reaction. Among the humanists the names of Vives, García Matamoros, Antonio Augustín, and Nicolás Antonio loom large. They were honored not only in their own country, he points out, but also earned the praise of foreigners. As we have seen before, all three sixteenth-century humanists mentioned by Feijoo censured Guevara.[22] It has been observed that Feijoo, in many ways, carried on the work begun by Vives and others of the same bent of mind.[23] By not listing fray Antonio among the Renaissance humanists, even though the bishop was as well known outside of his country as any of them, Feijoo by his silence expresses his disapproval of the author.

Another discourse of Feijoo, "Reflexiones sobre la historia," analyzes the difficulties that prevent a historian from being objective. Material gain, fear of a powerful potentate, nationalistic passion, and religious bias militate against accurate reporting of events and very few chroniclers are ready to become martyrs for the truth. Feijoo illustrates this statement with examples from the past. In view of all these hindrances, he

[19] *Op. cit.*, pp. 346-347 and 385-386.
[20] *Ibid.*, pp. 386-387.
[21] *Teatro crítico*, IV, pp. 348-462.
[22] See ch. II in this study.
[23] See Luis Sánchez Agesta, ed., *Escritos políticos de Fray Benito Jerónimo Feijoo* (Madrid, 1947), Introduction, p. XXXV.

feels it is very difficult for a historian to escape rebuke: "¿Quién, a vista de esto, tomará la pluma sin temblarle la mano para escribir una Historia? ¿Quién, viendo censurados estos supremos Historiadores, se juzgará esento de censura?" [24] The Benedictine author follows the procedure of the sixteenth-century humanists and their successors in treating fray Antonio as a historian. The paragraph immediately before Guevara discusses Paulo Emilio and Nicolao Cansino. While praising their courage and sincerity, Feijoo finds that they could not resist the temptation of embellishing their reports with their own inventions. The paragraph that comes after Guevara, deals with the fictitious account of Dictys of Crete, the forgeries of Annius of Viterbo, and the Codex of Magdeburg cited by Ruxner. The mere physical location is enough to indicate that Feijoo reproaches the bishop for inventing details that have absolutely no basis in reality and serve only to entertain his readers. By mentioning entertainment, Feijoo actually comes closer to the modern view of the author of the *Relox* as almost anything but a historian.

As we shall see, from a certain point of view it was actually a sign of respect on the part of Feijoo to treat Guevara primarily as a historian. The most extensive reference to fray Antonio in the *Teatro crítico* is in the ninth volume which contains the supplements, additions, and corrections. In volume seven a lengthy footnote, identical to the section on Guevara in the ninth volume, indicates that it was added later. This central reference placed the bishop not in the company of historians but among those who spread old wives' tales, such as Juan Bautista Helmoncio and Gayot de Pitaval.[25] The discussion centers around "causas de el amor," and the purpose of the supplement is to eradicate certain false ideas among the masses concerning love philters because these notions are connected with the belief in witches and witch burning. The contrast between – let us say – what Pedro de Rhua attacks in Guevara and Feijoo's objections is in itself significant. Rhua concentrated on rectifying the literary references from the classics; Feijoo is more concerned about correcting the superstitious beliefs of the masses that lead to concrete acts. The Galician monk emphasizes several times the result of such misconceptions.[26] If there are such things as love philters, then there must be witches who prepare and possibly administer them; and it is also necessary to ferret out these witches and punish them. That is the reason for Feijoo's strong rebuke of an actually insignificant item from the *Relox de príncipes* which tells about the Emperor's familiarity with

[24] *Teatro crítico*, IV, p. 165.
[25] *Suplemento de el Teatro crítico*, pp. 321-326.
[26] *Ibid.*, pp. 313-314.

the extraordinary properties of the herb called *Flavia* that grows on the island of Lethir on the mountain of Arcadia. The Emperor supposedly touched a woman with the herb and aroused in her a love that endured until her death.

The larger implications of such superstitions prompt Feijoo to bring forward the testimony of several critics of Guevara. The witnesses Feijoo cites are Nicolás Antonio, Antonio Agustín, Andreas Schottus, Gerard Voss, and Pierre Bayle. Their statements, as we know from previous chapters, add up to the fact that the bishop's *Libro áureo* is not the work of Marcus Aurelius but the brain child of Guevara's mind and deserves no credibility.[27] Feijoo, like García Matamoros before him, regrets that the illustrious bishop is rejected by these great authorities, but the duty of enlightening the common people, he feels, outweighs his esteem for the otherwise worthy and respected churchman: "No sin dolor he manifestado el concepto que reyna entre los Eruditos, de la poca veracidad histórica de el Ilustríssimo Guevara, Varón por otra parte muy digno de la común veneración. Pero fuera de que la obligación de desengañar al Público, debe prevalecer a qualquiera particular respeto, pertenece con propriedad al assumpto de mi Obra impugnar la estimación, que se da a las noticias Históricas de el Ilustríssimo Guevara, por ser dicha estimación, o el concepto en que se funda la estimación, un error común, y popular.[28]

Fray Soto y Marne intended to rehabilitate Guevara and to prove the bishop's complete veracity, as evident from the full title of his *Reflexiones Crítico-Apologéticas sobre las obras del RR. P. Maestro Fr. Benito Geronymo Feyjoo: en defensa de las milagrosas flores de S. Luis del Monte: de la constante pureza de Fè, admirable Sabidurìa, i utilissima Doctrina de el Illuminado Doctor, i Esclarecido Martyr, el B. Raymundo Lulio: De la gran Erudicion, i sòlido Juicio del Clarissimo Doctor, el V. Fr. Nicolao de Lyra: De la Famosa Literatura, i constante Veracidad Historica de el Ilmo, i V. D. Fr. Antonio de Guevara: i de otros Clarissimos Ingenios, que ilustraron el Orbe Literario.* It would go beyond the limits of this book to follow the whole controversy between Feijoo and Soto y Marne especially since it is discussed in detail in G. Delpy's *Feijoo et l'esprit européen* and involves issues as complex as Spain's position in the community of the nations of Europe, faith versus reason, progress and reaction, the backwardness of science in Spain, differences between the Benedictine and Franciscan orders, etc.[29] All that concerns us is that

[27] *Ibid.*, pp. 320-321.
[28] *Loc. cit.*
[29] See chapter entitled "La polémique," pp. 227-268.

Soto y Marne's planned defense of Guevara was never published because of the *Real Cédula* of November 17, 1748. This royal decree prohibited Soto y Marne from printing the third volume of incriminations against Feijoo because of the services rendered by the Benedictine monk as a royal counselor and because the king was displeased with the first two volumes.[30] All we can do is to speculate about the line of argument Soto y Marne might have followed. We shall take as a model the reasoning he employs in trying to prove the authenticity of the Sibylline Oracles because in some respects the situations are parallel. Soto y Marne would have stated, we believe, that those who tried to impugn the correctness of Guevara's statements were only undermining the authority of the Church and facilitating the progress of heretical beliefs. He might have pointed to Bayle and Gerard Voss, important critics of fray Antonio and members of the Protestant camp, and have equated those who agreed with them in regard to Guevara with what he considered the dangerous enemy. Then he might have called attention to the unswerving patriotism and orthodox views of the bishop and his merits in converting the Moriscos. This is the type of argumentation Soto y Marne practices throughout the two volumes of his *Reflexiones*.[31]

However, the important thing to remember in this connection is that during the period of Enlightenment, even though Guevara's works were used as vehicles in what today we would call "ideological" struggles and did not draw the attention of the public as interesting reading matter, at least there was a certain amount of discussion of them. In the nineteenth century there were only occasional references to the bishop, mostly without merit, as María Rosa Lida shows.[32] In our days, Guevara forms the subject of several penetrating articles, as we have noted throughout this study. In addition, certain aspects and influences of the illustrious bishop's works are studied in doctoral theses, such as his influence on Aegidius Albertinus and the sources of his *Década*. However, this should not be taken as a significant revival of Guevara, comparable to that enjoyed by Góngora. Historians of literature and culture may differ in their interpretations of fray Antonio's works and in their evaluation of his place as a writer, but there are no more burning issues surrounding his writings.

[30] A detailed account of the *Memoriales* of Soto y Marne, their contents and their accusations against Feijoo is found on pp. 256-268 of Delpy's *Feijoo et l'esprit européen*. He also gives a résumé of Feijoo's answer in the *Justa repulsa de iniquas acusaciones* (Madrid, 1757). This is written, as is known, in the form of a letter to a friend of his.

[31] See *Reflexión* 13, vol. II, pp. 169-204, concerning the Sibylline oracles. Soto y Marne goes so far as to attack the Dictionary of Moréri because it "promueve el temerario Systhema de Blondelo, Vossio, Du Pin y otros Novatores." (p. 207).

[32] *Op. cit.*, pp. 387-388.

CONCLUSION

Following the reactions to Guevara through the centuries was a lesson in historical awareness. In order to explore the most relevant antecedents of the *Libro áureo*, we found it necessary to go back to the historiography of the declining days of the Roman Empire. We caught a glimpse of the deterioration of authentic biographies into collections of anecdotes and noted how factual reporting gradually disappeared – Antiquity yielded its place to the Middle Ages.

When fray Antonio's first work appeared, public response to it was strongly divided. At least a handful of people felt that the author did something decidedly wrong in disregarding historical truth and accuracy and in making a Stoic philosopher his spokesman for declaiming fifteenth-century moral teachings, even if it was done for the purpose of giving more prestige and authority to such pronouncements. The humanist Pedro de Rhua delivered the sharpest attack. In the eyes of some Rhua represents the exacting, modern scientific man while others regard him as a narrow-minded pedant who misunderstood the nature of the work.[1] The great masses enjoyed the anecdotes, were moved by the bishop's invectives against the world, agreed with his search for solitude, and delighted in the author's wit. In his day fray Antonio was admired not only in Spain but soon became a writer of international stature.

The criticism which was limited to a small elite in the Renaissance reappeared in a different form in the time of the Enlightenment. As far as the critics of the Enlightenment were concerned, Guevara was no more a rival who claimed the attention of the readers deflecting their thoughts from serious contemplation and obscuring their vision of the truth; he was rather a representative of all they were against – errors, superstitions, falsifications of history, and the Inquisition. Their con-

[1] See Fray Juan Bautista Gomis' Introduction to Guevara's *Oratorio de religiosos* in *Místicos franciscanos españoles,* II, p. 446.

demnation of fray Antonio thus provided an example of how the eighteenth century looked back to the sixteenth for inspiration and instruction.

As far as the reading public was concerned, it had become evident already in the middle of the seventeenth century that the taste of the readers had changed considerably, and the once celebrated author's writings gradually receded into oblivion. The critics likewise tended to lose interest in the bishop's works. Nevertheless, every once in a while the curiosity of experts again turns the spotlight on Guevara. One such occasion was the appearance of Landmann's study which sought to prove that fray Antonio was the leading mentor of Lyly, the architect of euphuistic style. The debate on this point presented a typical nineteenth and twentieth century spectacle. We saw that the interplay of national prejudices was part of the academic debates. The protagonist of the theory of Guevara's overwhelming influence on the origin of euphuism was in part only repeating age-old accusations against Spain as being the corruptor of good taste. Some Italians vied for the dubious honor of claiming for their predecessors the influencing of John Lyly.

The fourth centenary of Guevara's death (1945) provided another opportunity for scholars to focus their attention on the bishop. Aside from the Memorial Volume of the *Archivo Ibero-Americano*, María Rosa Lida's article and Américo Castro's study appeared at that time. These have been followed intermittently by several contributions of merit up to our own days.

Since our generation is witnessing a new era in communications, we are in a most advantageous position to evaluate Guevara's insight and to understand the reasons for the amazing success that his books enjoyed. Guevara stood at the watershed of oral and visual cultures. He recognized the potential impact of the invention of printing. There was a need for bringing the hitherto inaccessible classical and medieval lore to the masses and to satisfy their curiosity about ancient history and the wisdom of Antiquity. Fray Antonio was ready to meet this need with his *Libro áureo, Relox de príncipes,* and *Una Década de Césares.* With the institution of the modern monarchy becoming more and more important, Guevara wrote a guidebook for courtiers. The discoveries aroused interest in navigation; the bishop could tell the public about that, too, in his *Arte de marear.* There was a deep yearning in the hearts of Guevara's contemporaries to seek refuge from the noise and confusion of the cities in the quiet purity of nature, as evidenced by the popularity of the pastoral novels. The bishop made his contribution in this area by writing the *Menosprecio de corte y alabanza de aldea.* Finally, there was a

search among the devout for a more intimate and personal religion. Fray Antonio sensed this and wrote his *Oratorio de religiosos* and *Monte Calvario*. This unusual awareness of what the public wanted explains Guevara's spectacular success as a writer.

Whether the bishop should be called one of the first novelists in a modern sense, as Francisco Márquez Villanueva claims, may be debatable.[2] But the fact that fray Antonio was one of the great Spanish pioneers is incontrovertible. He may not have conquered foreign lands, but his essays did serve as a model for Montaigne's; he is considered the spiritual father of the picaresque novel;[3] and, if Marcel Duviols is right, Guevara was the first modern reporter.[4]

[2] "Fray Antonio de Guevara o la ascética novelada" in his *Espiritualidad y literatura en el siglo XVI*, pp. 58-66.

[3] *Ibid.*, p. 37.

[4] "L'illustre seigneur don Antonio de Guevara, évêque de Mondoñedo, prédicateur et historiographe de Charles-Quint, membre du Conseil de Sa Majesté, ne fut pas seulement le plus aimable des moralistes et le plus brillant des écrivains de son temps, il peut être considéré comme le premier en date des journalistes ou, pour être plus exact, des reporters." "Un reportage au XVIe siècle" in *Hommage à Ernest Martinenche: Études hispaniques et américaines*, p. 424.

BIBLIOGRAPHY

Antonio, Nicolás. *Biblioteca Hispana Nova*. Madrid, 1783.

Augustini, Sancti Aurelii. *Opera Omnia*, ed. Monachorum ordinis Sancti Benedicti. Paris, 1841.

Barish, Jonas. "The Prose Style of John Lyly," *English Literary History*, XXIII (1956), 14-35.

Bataillon, Marcel. *Érasme et l'Espagne*. Recherches sur l'histoire spirituelle du XVIᵉ siècle. Paris, 1937.

—. "Gaspar von Barth, interprète de *La Célestine*," *Revue de Littérature Comparée*, 31 (1957), 321-340.

Bayle, Pierre. *Dictionnaire historique et critique*. 16 vols. Paris, 1820.

Bellezza, Angela. *Historia Augusta*, I. Genoa, 1959.

Beltrán de Heredia, Vincente. "Directrices de la Espiritualidad dominicana en Castilla durante las primeras décadas del siglo XVI," in *Corrientes Espirituales en la España del Siglo XVI*, ed. Juan Flors. Barcelona, 1963, 177-202.

Biondo, Flavio. *Italiae illustratae* libri VIII. Rome, 1474.

Blanco García, Vicente. *San Ildefonso, Tratado de la perpetua virginidad de Sta. Maria*. Zaragoza, 1954.

Blanco Garcia, Vicente and José Orlandis Rovira. *Textos Latinos Patrísticos, Filosóficos, Jurídicos*. Pamplona, 1954.

Boccaccio, Giovanni. *Opere minori*, ed. Adriano Salani. Firenze, n.d.

Bonilla y San Martin, Adolfo. *Luis Vives y la filosofía del Renacimiento*. Madrid, 1903.

Bourchier, John. *Golden Boke of Marcus Aurelius*, ed. José María Gálvez. Berlin, 1916.

Canedo, Lino G. "Las obras de Fray Antonio de Guevara," *Archivo Ibero-Americano*, VI (1946), 441-601.

Cano, Melchor. *De locis theologicis*. Bassani, 1946.

Cervantes Saavedra, Miguel de. *El Ingenioso Hidalgo Don Quijote de la Mancha*, ed. Clásicos Castellanos. 8 vols. Madrid, 1958.

Child, Clarence Griffin. *John Lyly and Euphuism*. Erlangen and Leipzig, 1894.

Cirot, Georges. *Les Histoires Générales d'Espagne entre Alphonse X et Philippe II (1284-1556)*. Bordeaux, 1904.

Clavería, Carlos. "Guevara en Suecia," *Revista de Filología Española*, XXVI (1942), 221-248.

Clément, Louis. "Antoine de Guevara: ses lecteurs es ses imitateurs français au

XVIᵉ siècle," *Revue d'Histoire littéraire de la France*, VII (1900), 591-602, and VIII (1901), 214-233.

Collilieux, Eugène. *Étude sur Dictys de Crête et Darès de Phrygie*. Grenoble, 1886.

Costes, René. *Antonio de Guevara. Sa Vie*, Bibliothèque de l'École des Hautes Études Hispaniques, Fascicule I, 1. Paris and Bordeaux, 1925. First appeared in *Bulletin Hispanique*, XXV (1923), 305-360 and XXVI (1924), 193-208.

—. *Antonio de Guevara. Son Oeuvre*, Bibliothèque de l'École des Hautes Études Hispaniques, Fascicule X, 2. Paris and Bordeaux, 1926.

Correa Calderón, Ernesto. "Guevara y su invectiva contra el mundo," *Escorial*, XII (1943), 41-68.

Crane, William G. *Wit and Rhetoric in the Renaissance*. New York, 1937.

Croce, Benedetto. *La Spagna nella vita italiana durante la Rinascenza*. Bari, 1917.

Curtius, Ernst Robert. *European Literature and the Latin Middle Ages*, translated from the German by Willard R. Trask. New York, 1953.

—. "Mittelalterlicher und Barocker Dichtungsstil," *Modern Philology*, XXXVIII (1941), 325-333.

Delpy, Gaspar. *Feijoo et l'esprit européen*. Paris, 1936.

Delvolvé, Jean. *Religion, critique et philosophie positive chez Pierre Bayle*. Paris, 1906.

Dictys Cretensis et Dares Phrygius: *De bello trojano*, ed. Anna Tanaquillus Faber. London, 1825.

Duff, John Wight. *A Literary History of Rome in the Silver Age*. London, 1927.

Duviols, Marcel. "Un reportage au XVIᵉ siècle: La cour de Charles-Quint vue par Guevara," *Hommage à Ernest Martinenche: Études hispaniques et américaines*. Paris, n.d., 242-247.

Farinelli, Arturo. "España y Francia," *Ensayos y discursos de crítica literaria hispano-europea*, II (1925), 303-355.

—. "John Lyly, Guevara y el 'Euphuismo' en Inglaterra," *Ensayos y discursos de crítica literaria hispano-europea*, II (1925), 425-442.

Febvre, Lucien and Henri-Jean Martin, *L'Apparition du livre*. Paris, 1958.

Feijoo, Benito Jerónimo. *Escritos políticos de Fray Benito Jerónimo Feijoo*. Selección, Estudio Preliminar y Notas de Luis Sánchez Agesta. Madrid, 1947.

—. *Ilustración apologética*. Madrid, 1761.

—. *Teatro crítico universal*. 8 vols. Madrid, 1778.

Feuillerat, Albert. *John Lyly*. Cambridge, 1910.

—. "Review of *John Lyly* by John Dover Wilson," *Modern Language Review*, I (1906), 330-334.

Foulché-Delbosc, Raymond. "Bibliographie espagnole de Fray Antonio de Guevara," *Revue Hispanique*, XXXIII (1915), 301-384.

Froissart, Jean. *Huon de Bordeaux*, translated by Sir John Bourchier, Lord Berners, and printed by Wynkyn de Worde about 1534. Early English Text Society, extra series. London, 1882-87.

Gálvez, José María. *Guevara in England*. Berlin, 1916. Pages 1-96 contain the discussion of Guevara in England; 97-444 contain a paleographic edition of Lord Berner's translation *The Golden Boke of Marcus Aurelius*.

García Matamoros, Alfonso. *Pro adserenda Hispanorum eruditione*. Edición, estudio, traducción y notas de José López de Toro. Madrid, 1943.

Gellius, Aulus. *Noctes Atticae*, ed. John C. Rolfe, I. New York, 1927.

Gibbs, J. "The Birthplace and Family of Fray Antonio de Guevara," *Modern Language Review*, XLVI (1951), 253-255.

—. *Vida de Fray Antonio de Guevara* (1481-1545). Valladolid, 1956.

Gilman, Stephen. *The Art of La Celestina.* Madison, 1956.

Gilmore, Myron P. *The World of Humanism,* Harper Torchbooks ed. New York, 1962.

González Palencia, Ángel y Eugenio Mele. *Vida y obras de Don Diego Hurtado de Mendoza.* 3 vols. Madrid, 1941.

Granada, Fray Luis de. *Guía de pecadores,* Clás. Cast. ed. Madrid, 1929.

—. *Ecclesiasticae rhetoricae, sive De ratione concionandi libri sex.* Olysippone, 1576.

Guevara, Antonio de. *Aviso de privados; ó Despertador de cortesanos.* Paris, 1912.

—. *El Villano del Danubio y otros fragmentos.* Selections with an Introduction by Américo Castro. Princeton, 1945.

—. *Libro áureo de Marco Aurelio,* publié d'après un manuscrit à l'Escurial par R. Foulché-Delbosc, *Revue hispanique,* LXXVI (1929), 1-319.

—. *Libro de los inventores del arte del marear.* Pamplona, 1579.

—. *Libro llamado Monte Caluario.* Salamanca, 1582.

—. *Libro primero de las epístolas familiares.* Edición y prólogo de José María de Cossío. 2 vols. Madrid, 1950-52.

—. *Marco aurelio con el Relox de príncipes.* Seville, 1543.

—. *Menosprecio de corte y alabanza de aldea;* edición y notas de M. Martínez de Burgos. Madrid, 1915.

—. *Oratorio de religiosos y exercicio de virtuosos.* Antwerp, 1569.

—. *Oratorio de religiosos y ejercicio de virtuosos,* ed. Fray Juan Bautista Gomis in *Místicos franciscanos españoles,* Biblioteca de Autores Cristianos (Madrid, 1948), II, 443-760.

—. *The diall of princes: by Don Anthony of Guevara;* translated by Sir Thomas North, being select passages now set forth with an introduction and a bibliography by K. N. Colville. London, 1919.

—. *Una Década de Césares,* ed. Joseph R. Jones (Chapel Hill, 1966), University of North Carolina Studies in the Romance Languages and Literatures, No. 64.

—. *Vida de los diez emperadores romanos que imperaron en los tiempos de Marco Aurelio.* Madrid, 1669.

Hazard, Paul. *La crise de la conscience européenne 1680-1715.* Paris, 1961.

Herrero-García, M. *Ideas de los españoles del siglo XVII.* Madrid, n.d.

Hijas y Cuevas, Victor and Zamora Lucas, Florentino. *El Bachiller Pedro de Rúa, humanista y crítico.* Madrid, 1957.

Huizinga, Johan. *Erasmus and the Age of Reformation.* Tr. by F. Hopman, Harper Torchbook ed., no. 19. New York, 1957.

Hurtado de Mendoza, Diego. *Carta del Bachiller de Arcadia y Respuesta del Capitán Salazar,* edición crítica con introducción y notas por Lucas de Torres. Madrid, 1913.

Iiams, Carlton Laird. "Aegidius Albertinus and Antonio de Guevara." Dissertation, University of California, Berkeley, 1956.

Jeffery, Violet M. *John Lyly and the Italian Renaissance.* Paris, 1928.

Jones, Joseph R. "Fragments of Antonio de Guevara's Lost Chronicle," *Studies in Philology,* LXIII (1966), 30-50.

Jones, Joseph Ramon II. "Antonio de Guevara's *Una Década de Césares.*" Dissertation, University of Wisconsin, 1962.

Karl, Louis. "Note sur la fortune des oeuvres d'Antonio de Guevara à l'étranger," *Bulletin hispanique*, XXXV (January-March, 1933), 32-50.

Knight, G. Wilson. "Lyly," *Review of English Studies*, XV (1939), 146-163.

Krapp, George Philip. *The Rise of English Literary Prose*. New York, 1915.

Landmann, Friedrich. *Der Euphuismus, sein Wesen, seine Quelle, seine Geschichte. Beitrag zur Geschichte der englischen Literatur des sechszehnten Jahrhunderts.* (Inaugural-Dissertation der philosophischen Facultät der Universität Giessen). Giessen, 1881.

—. "Shakspere and Euphuism," *The New Shakspere Society's Transactions*, Part II (1880-85). London, n.d., 241-276.

Langlois, Ernest. "Archipiada" in *Mélanges de philologie romane dédiés à Carl Wahlund*, Mâcon, 1896, pp. 173-179.

Laso de la Vega, García. *Las églogas*, con anotaciones de Fernando de Herrera. Paris, 1913.

Lee, Sidney L. (Sir). "Euphuism," *The Athenaeum*, II (July 14, 1883), 49-50.

—. "Lord Berners and Euphuism," *The English Charlemagne Romances*, VII. London, 1882-1887, 785-788.

Leto, Pomponio. *De antiquitatibus Urbis Romae*. Argentorati, 1515.

Lida de Malkiel, María Rosa. "Fray Antonio de Guevara. Edad Media y Siglo de Oro español," *Revista de Filología Hispánica*, VII (1945), 346-388.

—. *La originalidad artística de La Celestina*. Buenos Aires, 1962.

—. "Notas para las fuentes de Guevara," *Revista de Filología Hispánica*, I (1939), 369-375.

Lida, Raimundo. "Sobre Quevedo y su voluntad de leyenda," *Filología*, VIII (1962), 273-306.

López de Villalobos, Francisco. *Algunas obras del doctor Francisco López de Villalobos*, ed. La Sociedad de Bibliófilos Españoles. Madrid, 1886.

—. *Los Problemas de Villalobos*. Biblioteca de Autores Españoles, XXXVI. Madrid, 1871.

Lucian de Samosata. *The Works of Lucian of Samosata*, ed. H. W. & F. G. Fowler, II. Oxford, 1905.

Lyly, John. *Euphues: The Anatomy of Wit. Euphues and His England*, ed. Morris William Croll and Harry Clemons with an introduction by Croll XV-LXIV. London, 1916.

—. *Euphues. The Anatomy of Wyt*, ed. R. Warwick Bond. 2 vols. Oxford, 1902.

Madoz, José. *San Ildefonso de Toledo a través de la pluma del Arcipreste de Talavera*. Madrid, 1943.

Map, Walter. *De nugis curialium distinctiones quinque*, ed. Thomas Wright. London, 1850.

Marañón, G. *Las ideas biológicas del Padre Feijoo*. Madrid, 1934.

Maravall, José Antonio. *Las Comunidades de Castilla*. Madrid, 1963.

Marichal, Juan. "Sobre la originalidad renacentista en el estilo de Guevara," *Nueva Revista de Filología Hispánica*, IX (1955), 113-128. This article forms part of *La voluntad del estilo*, Barcelona, 1957, 79-101.

Márquez Villanueva, Francisco. *Espiritualidad y literatura en el siglo XVI*. Madrid, 1968.

Martínez de Toledo, Alfonso, Arcipreste de Talavera. *Corvacho, o reprobación del amor mundano*, ed. Lesley Byrd Simpson. Berkeley, 1939.

Mason, H. T. "Pierre Bayle's Religious Views," *French Studies*, XVII (July, 1963), 205-217.

Matthiessen, Francis Otto. *Translation, An Elizabethan Art.* Cambridge, Mass., 1931.

McLuhan, Herbert Marshall. *The Gutenberg Galaxy.* Toronto, 1962.

Menéndez Pidal, Ramón. "El lenguaje del siglo XVI," *Cruz y Raya* (1933), 7-63.

—. "Fray Antonio de Guevara y la idea imperial de Carlos V," *Miscelánea histórico-literaria,* Colección Austral, Madrid (1940), 7-35. Previously published in the *Revista Cubana,* XI (1937).

—. *Los españoles en la historia y en la literatura.* Madrid, 1951.

Menéndez y Pelayo, Marcelino. *Historia de los heterodoxos españoles.* 4 vols. Santander, 1946-47.

—. *Orígenes de la novela.* I. Madrid, 1905.

Merimée, Paul. "Guevara, Santa Cruz et le razonamiento de Villabrájima, en *Hommage à Ernest Martinenche.* Paris, 1949, 466-476.

—. *L'influence française en Espagne au dix-huitième siècle.* Paris, n.d.

Mézières, Alfred. *Prédécesseurs et contemporains de Shakspeare.* Paris, 1863.

Miranda, José. "España y Nueva España en la época de Felipe II," in Germán Somolinos e'Ardois' *Vida y obra de Francisco Hernández,* I. México, 1960.

Montaigne, Michel de. *Essais,* ed. Didot. 5 vols. Paris, 1802.

Montesinos, José F. "Algunas notas sobre el *Diálogo de Mercurio y Carón,*" *Revista de Filología Española,* XVI (1929), 225-266.

Morel-Fatio, Alfred. *Historiographie de Charles-Quint.* Paris, 1913.

Moreno Villa, José. *Locos, enanos, negros y niños palaciegos.* México, 1939.

Morley, John. "On Euphuism," *Quarterly Review,* CIX (1861), 350-383.

Müller, J. G. *Des Flavius Josephus Schrift gegen den Apion.* Basel, 1877.

Nash, Thomas. *The unfortunate traveller,* or *The life of Jack Wilton.* London, 1892.

Norden, Eduard. *Die Antike Kunstprosa.* 2 vols. Leipzig and Berlin, 1909.

Pauly-Wissowa. "Historia Augusta," *Real-Encyclopädie der klassischen Altertumswissenschaft,* XVI. Stuttgart, 1913, 2051-2110.

Paz y Melia, Antonio. *Sales españolas ó agudezas del ingenio nacional.* 2 vols. Madrid, 1890.

Peter, Hermann. *Die Scriptores Historiae Augustae.* Leipzig, 1892.

Rhua, Pedro de. *Cartas censorias.* Biblioteca de Autores Españoles, ed. Eugenio de Ochoa, XIII. Madrid, 1850, 229-250.

Ringler, William. "The Immediate Source of Euphuism," *PMLA,* LIII (1938), 678-686.

Robinson, Howard. *Bayle the Sceptic.* New York, 1931.

Ros, Fidèle de. "Guevara, auteur ascétique," *Archivo Ibero-Americano,* VI (1946), 339-404. Reprint of an article from *Études franciscaines,* L (1938), 306-332 and 609-636.

Rostovtzeff, Michail. *Gesellschaft und Wirtschaft im Römischen Kaiserreich,* II. Leipzig, n.d.

Sáinz y Rodríguez, Pedro. *Las polémicas sobre la cultura española.* Madrid, 1919.

Salas Barbadillo, Alonso Jerónimo de. *La ingeniosa Elena, hija de Celestina.* Madrid, 1907.

Salisbury, John of. *Policraticus: sive De nugis curialium, & vestigiis philosophorum libri octo.* Lugduni Batavorum, 1595.

Scholberg, Kenneth R. *Pierre Bayle and Spain.* University of North Carolina Studies in the Romance Languages and Literatures, XXX. Chapel Hill, 1958.

Schott, Andreas. *Hispaniae Bibliotheca.* Francofurti, 1608.

Schweitzer, Christoph E. "Antonio de Guevara in Deutschland. Eine kritische Bibliographie," *Romanistisches Jahrbuch*, XI (1960), 328-375.

Scriptores Historiae Augustae, ed. and Introduction by David Magie, The Loeb Classical Library. 3 vols. New York, 1921.

Seaver, H. J. *The Great Revolt in Castile*. London, 1928.

Silvio, Aeneas. *De curialium miseriis epistola*, ed. Wilfred P. Mustard. Baltimore, 1928.

Smith, Preserved. *A Key to the Colloquies of Erasmus*. Cambridge, 1927.

Soto y Marne, Fray Francisco de. *Reflexiones crítico-apologéticas sobre las obras del RR. P. Maestro Fr. Benito Gerónymo Feyjoo*. Salamanca, 1749.

Spitzer, Leo. "Sobre las ideas de Américo Castro a propósito de *El Villano del Danubio* de Antonio de Guevara," *Boletín del Instituto Caro y Cuervo*, VI (1950), 1-14.

Tate, R. B. "An Apology for Monarchy: A Study of an Unpublished 15th-Century Castilian Historical Pamphlet," *Romance Philology*, XV (1961), 111-123.

Tellechea Idígoras, José Ignacio. "Ideario ascético-pastoral de Bartolomé Carranza, O. P. Estudio doctrinal de una obra inédita," in *Corrientes Espirituales en la España del Siglo XVI*, ed. Juan Flors. Barcelona, 1963, 203-246.

Thomas, Henry. "The English Translations of Guevara's Works," *Estudios eruditos in memoriam de Adolfo Bonilla y San Martín*, II (1930), 369-374.

Tiraboschi, Girolamo. *Storia della letteratura italiana*. 8 vols. Milano, 1824.

Tomitano, Bernardino. *Ragionamenti della lingua Toscana*. Florence, 1573.

Troki, Isaac. *Hizzuk Emunah*, ed. M. Wechsler. New York, 1933.

Underhill, John Garrett. *Spanish Literature in the England of the Tudors*. New York, 1899.

Uribe, P. Angel. "Guevara, inquisidor del Santo Oficio," *Archivo Ibero-Americano*, VI (1946), 185-281.

Vaganay, Hugues. *Antonio de Guevara et son oeuvre dans la littérature italienne. Essai de bibliographie*. Firenze, 1916.

Valdés, Alfonso de. *Diálogo de las cosas ocurridas en Rome*. Edición y Notas por José F. Montesinos. Madrid, 1928.

—. *Diálogo de Mercurio y Carón*. Edición y Prólogo por José F. Montesinos. Madrid, 1929.

Van Paassen, Pierre. *The Forgotten Ally*. New York, 1943.

Van Praag, J. A. "Ensayo de una bibliografía neerlandesa de las obras de Fray Antonio de Guevara," *Estudis universitaris catalans, Barcelona*, XXI (1936), 271-292.

Vives, Juan Luis. *Opera Omnia*, ed. Gregorio Mayans. 6 vols. Valencia, 1785.

Wadsworth, James B. *Lyons 1473-1503. The Beginnings of Cosmopolitanism*. Cambridge, Mass., 1962.

Wilson, John Dover. *John Lyly*. Cambridge, 1905.

Wilson, Thomas. *The Arte of Rhetorique*, ed. G. H. Mair. Oxford, 1909.

Zamora Lucas, Florentino. "El Bachiller Pedro de Rúa," *Archivo Ibero-Americano*, VI (1946), 405-440.

Zúñiga, Francesillo de. *Crónica burlesca*, Biblioteca de Autores Españoles, XXXVI. Madrid, 1855, 9-62.